PARANORMAL
DEVON

DANIEL CODD

AMBERLEY

First published 2013

Amberley Publishing
The Hill, Stroud
Gloucestershire, GL5 4EP

www.amberley-books.com

British Library Cataloguing in Publication Data.
A catalogue record for this book is available from the British Library.

ISBN 978 1 84868 166 8

Typeset in 10pt on 12pt Sabon.
Typesetting and Origination by Amberley Publishing.
Printed in the UK.

Contents

Acknowledgements

In many ways, this book concerns a non-Devonian's exploration of the county's most supernatural and phenomenal places. The people of this county have been extremely forthcoming in sharing their knowledge of folklore, the supernatural and the paranormal with an 'outsider' – it being said on numerous occasions that the record of a non-Devonian might provide an interesting perspective on the mysteries of the county. Therefore I would like to thank enormously my many friends and contacts in this part of the United Kingdom who have quoted vague stories to me in one form or another, which I have subsequently attempted to trace to their origins, or else told me their first-hand knowledge. Among them are: Jade Oliver, for putting me up; Martin Jones of the Minerva Inn, Plymouth's oldest inn (*see www.minervainn.co.uk*); David Youle, of South Tawton's church house; Lorinda Legge, churchwarden, South Tawton; administrators at Berry Pomeroy; staff at Museum of Dartmoor Life, Okehampton; Debbie Batchelor, Pack O'Cards at Combe Martin (*see www.packocards.co.uk*); administrators at St Mary's church, Chagford; Philip Armitage, curator of Brixham Heritage Museum (*see www.brixhammuseum.org.uk*); administrators at Buckland Abbey; Ann Fawssett Atkin, of West Putford Gnome Reserve & Wild Flower Garden (*see www.gnomereserve.co.uk*); Kane M. Clarke at the Old Church Inn, Torbryan, for information on the monk that inhabits this thirteenth-century inn (*see www.oldchurchhouseinn.co.uk*); Paul Rendell, editor of *Dartmoor News*, for allowing me to draw on Pauline Greenwood's article concerning the ghost at the Tors, Belstone. (*Dartmoor News often draws upon local folklore, ghosts and colouring for its content, please see www.dartmoornewsmagazine.co.uk for more information.*) Thanks also to Mike Deacon (and Lola) for acting as a guide on the moors! Thanks also to Kirsten Harford, Group Marketing and PR Manager for Boringdon Hall, for providing info on its haunted bedrooms (*see www.boringdonhall.com*). Many thanks to Kathryn Hope, Centre Manager at Moretonhampstead Development Trust (*see www.moretonhampstead.com*). Also to Jon Downes, for allowing me to draw upon his remarkable book *Monster Hunter* (*more information on the unique work of the Centre for Fortean Zoology, Woolfardisworthy, can be found at www.cfz.org.uk*); Mandy Betts, Parish Office, St Eustachius' church (*for more info on Tavistock's ancient landmark, see www.tavistockparishchurch.org.uk*). Thanks to Rob Crawford at the Watermans Arms, Ashprington, for agreeing to talk to me. Also to Christine McIntyre, Halberton Parish Council Clerk, for allowing me to advertise for information in the *Halberton Newsletter*; Alison Young, for allowing me to advertise in the *Bridestowe & Sourton Extra*; Tom

French, reporter for the *Okehampton Times*, also for allowing me to advertise for information; Pam and Simon Jeffrey at Northlake Bed & Breakfast, Stockley EX20 1QH; John Finch of Plympton, for information on the Hardwick ghost, whose website dedicated to this part of Plymouth can be found at www.plympton.info; many thanks to Mrs Alison Gordon of Tiverton Castle, for allowing me to reproduce some of its ghostly tales (*see www.tivertoncastle.com*); staff at the White Hart, Bridestowe and the Well House, Exeter, for their general information. Finally to Sally at the Highwayman Inn, Sourton, for information on the Green Man (*see www.thehighwaymaninn.co.uk*).

Many thanks also to Diane Ware for telling me about the ghost – 'William' – who haunts her house in Bridestowe (whose story space sadly precludes me from mentioning), as well as the other ghostly stories she recounted. Finally, thanks to Nicola Stone for unfailing support.

This book is the culmination of years of research. With this in mind, I am thankful for the kindness and generosity I have been shown at scores of libraries, museums and tourist attractions, large and small, during the course of my research across Devon over the last few years – within such places lie the half-hidden origins of books like this.

All photographs are copyright of Daniel Codd, except: Okehampton Castle 'ghost', copyright of Paul Saunders (many thanks for allowing me to use this).

Foreword

The beautiful county of Devon – the fourth largest in England – is so many things to so many people. For lovers of picturesque scenery its extensive landscape, extending across 2,585 square miles from the Bristol Channel to the English Channel, presents some of the most breathtaking views in the whole of England; the northern coast offers sandy beaches, stark cliffs and bracing winds, while palm trees and sub-tropical flowers grow along the famous south coast, geographically not far from the boggy, rock-strewn heights of inland Dartmoor. There can be a feeling of remoteness still, especially in certain parts of the county where high, open roads can contrast dramatically with the primitive sunken lanes, which wind towards villages so cut off that the bright lights of metropolitan Exeter and Plymouth might as well be non-existent. Devon is also a historian's dream; its peoples and places frequently feature in the kind of conflict and drama that defines a nation, not just a county. From the ravages of Danish attacks in the Dark Ages to the devastation inflicted by the German Luftwaffe only four generations ago, everywhere there are relics of Britain's distant, even prehistoric, past. The Bronze and Iron Ages have left us barrows, cairns, standing stones and hut circles scattered across the landscape. These places now stand as silent testimony to those who populated Devon centuries before the first Roman had ever even heard of these islands.

Devon is without doubt one of the most mysterious places in Britain. And this book is concerned not so much with the impressive history of the county as it is with another dimension of its development: its folklore, supernatural legends, paranormal mysteries and eerie secrets. The observation that Devon has for centuries been a place of storytelling, myth and mystery is perhaps a good starting point. We see in certain ancient legends a clear indication that the county was believed by local people to be a place where the fantastical could – and indeed might – have happened. For instance, Hartland Point, a striking, sea-lashed 350-foot-high rocky eminence, 3 miles north-west of the village of Hartland, occupies the angle at which the northern Devon coastline strikes dramatically to the south-west. Around AD 138 this landmark was described by the geographer Ptolemy as the 'Promontory of Hercules'. The area at the time was inhabited by the primitive towns and stations of the Damnonii tribe, and it is supposed that the 'Promontory of Hercules' earned its name thanks to the ancient Phoenicians, whose galleys must have passed this way during their exploratory voyages. Evidently, they saw the Pillars of Hercules (that guarded the Mediterranean) reflected in the

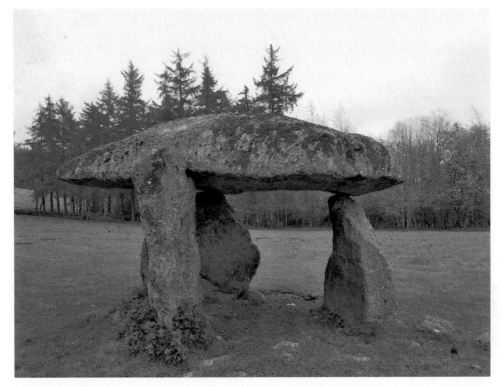

Spinster's Rock burial chamber on Shilstone Moor. Tradition says that three spinsters put it up early one morning, and that at one time there were stone circles and avenues near it: but these have disappeared entirely.

headlands of Hartland and Lundy, which early writers apparently called Herculea. Because of this, one of Devon's oldest myths tells us that the god Hercules sailed from Gaul to Devon on a golden bowl and settled at Hartland Point, where his prodigious strength enabled him to battle a race of giants that inhabited Britain and thereafter to successfully govern the whole island for several years.

The antiquity of many strange Devon tales can be understood from early sources, such as the writing of Mrs Anna Eliza Bray, wife of a Tavistock clergyman and surely one of the town's greatest daughters, whose volumes of correspondence in the early nineteenth century provide the first written glimpses of many traditions that we are now fully conversant with. These include stories concerning pixies and numerous ghostly manifestations, as well as superstitions linked to many mid-Devon landmarks. Her legacy was embraced by others, noticeably the Revd Sabine Baring-Gould of Lewtrenchard Manor, southwest of Okehampton, and then in the twentieth century by Ruth St Leger-Gordon and the late Theo Brown, who have all, in their own way, drawn upon local lore and made observations about certain phenomena that are nowadays repeated verbatim.

Our book is concerned with all that falls under the broad umbrella term of the 'paranormal' and will hopefully allow the reader to observe the different forms that the strange and mysterious have taken in the past, in comparison with the stories that are

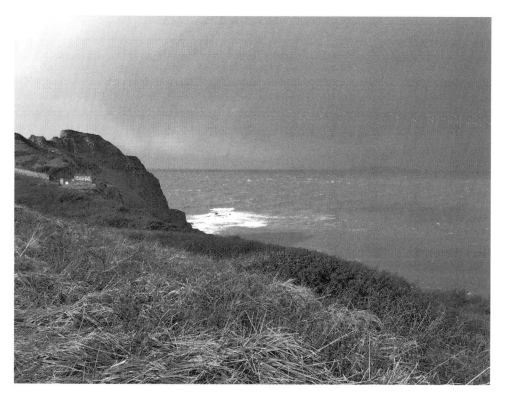

The Romans knew this dramatic place as the 'Promontory of Hercules'.

reported and repeated throughout Devon these days. By necessity of space, there are many elements of the mysterious that we have had to gloss over: criminal riddles are not featured in any great depth, although the newspaper archives are full of intriguing tales – like the mysterious disappearance on 18 March 1912 of Miss Leticia Fitchard, for instance, a forty-year-old schoolmistress from Welcombe whose headless body was found washed up on the shore near Babbacombe Cliff, or the equally mysterious disappearance from the *Kaiser Wilhelm II* of an American diplomat, Kent Loomis, just before that vessel docked in Plymouth. Loomis had left New York carrying dispatches of the utmost importance from the Secretary of State to the US ambassador in Paris. His body was washed up at Thurlestone near Kingsbridge on 16 July 1904, a month after his disappearance. An open verdict was returned, with many believing Loomis had been assassinated. (It sounds like the plot of a Sherlock Holmes story.) Of course, sensational crimes and mysterious deaths are the origin of many 'ghost stories' in this county.

Concerning crime, it is reflective of Devon's reputation as having something of a semi-lawless past that many traditions revolve around murderous outrages. A lot of stories insist that criminal gangs once ranged Devon with complete impunity, and the tales of bloodthirsty criminals and daring highway robbers owe more than a little to fact. The depredations of the Doone clan along the Devon/Somerset border during the time of the Commonwealth entered folklore, and a century later it is clear there was on occasion a state of near warfare between organized smuggling gangs and customs men. The *Monthly Magazine and British Register*, Issues 1–5, record one battle:

In the late [March 1796] affray at Torpoint, between the boat's crew of the *Viper* cutter, and a large party of armed smugglers, one midshipman and two sailors were dangerously wounded, and one smuggler killed, and two others wounded. The sailors carried away 20 casks of spirits; the horses, however, so laden with them, were rescued by the smugglers.

A typical legacy of these lawless days can be found on Burgh Island, 20 miles from Plymouth, where the Pilchard Inn (dating to 1395 and said to have been the home of the notorious pirate Tom Crocker) is located. Crocker cleverly evaded capture for many years, until he was trapped and seized, and the *Western Morning News* reported in 1945: 'A pirate flag and a carving bearing the likeness of Crocker are still to be seen in the Pilchard Inn … to commemorate this event.' He reputedly hid treasure somewhere in the vicinity, and there is a legend that once every year on a certain Friday the spirit of Tom Crocker encircles the island. In the 1930s this story even spawned an annual 'pirate party' at the Burgh Island Hotel in commemoration.

Plundering of wrecked ships along remote stretches of coastline was considered a duty, the haul washed ashore being considered 'God send', bestowed upon the villagers by Providence. According to George Tugwell's *The North Devon Handbook* (1857), such activities were a long time dying out and Tugwell assures us: 'This barbarous custom is now, happily, extinct; the last recorded instance happened about six years

Bigbury Bay, site of callous murder and supernatural retribution in the 1770s.

ago at Welcombe, near Hartland, when a vessel and her crew were sacrificed to the ferocity of the latest Devon wreckers.' Too frequently we are led to believe this callous looting was accompanied by the murders of any survivors who struggled ashore and feebly tried to defend their property. Foggy memories of such activities have defined Devon in a strange kind of way, and many stories of the supernatural are woven around the activities of criminals from long ago.

According to one well-known tale, a Mrs James Burke escaped the thunderous waves that caused the destruction of a vessel called the *Chantiloupe* in Bigbury Bay, off the coast of Thurlestone – only to be barbarically murdered by 'savage people' from adjacent villages who saw her washed ashore in her richest clothes and jewellery. These people tore the earrings from her ears and hacked off her fingers to get her rings, before stripping her and miserably leaving her to perish. This occurred around 1772, with Sarah Prideaux Fox recording in *Kingsbridge Estuary* (1864): 'The men who were principally concerned in the plundering, and most likely murdering her, seemed from that time marked men, even in the rude neighbourhood that they lived, and what is singular, they all three came to awful and untimely deaths.' Although Thurlestone's church registry bore no entry for the dead woman's burial, it was believed that at a later date her body was exhumed and taken to London. In the minds of elderly locals, the story was most definitely true … Ms Fox even observed that in her time a piece of the victim's dress was in the possession of a Mrs J. B. Cranch. This was presented to her grandfather by one of the wreckers on the evening following the murder and ever after preserved. It was 'a beautiful specimen of finely embroidered muslin'.

This story, with its implication of dire supernatural judgement on the murderers, is an apt place to begin; our first chapter concerns the many forms and guises that the phenomena of 'ghosts' have taken through the centuries, right up to and including the twenty-first century. Here we begin our exploration of paranormal Devon: a journey into this part of Britain's hidden corners, its supernatural heritage, strange mysteries and unexplained phenomena of every shape and form.

CHAPTER ONE

The World of Ghosts, Spirits and Poltergeists

Introduction

This chapter is an exploration of Devon's ghosts, poltergeists and other manifestations of spectral phenomena. As numerous folklorists and writers have observed before myself, Devon is – and always has been – an extremely haunted county. In the early days, ballads, pamphlets and tracts played on readers' fears of the impossible and the supernatural. Thus we learn, for example, of a Stuart-era broadsheet ballad entitled 'A Warning For Married Women'. Sung to an old West Country tune, this lamentable tale explained how one Jane Reynolds, born near Plymouth, 'plighted her troth' to a seaman named John Harries. She thought him lost to the waves and so married a carpenter; but Harries' ghostly spirit returned from beyond the grave and carried her off.

Sir John Bowring, an Exeter-born former politician, notes in an 1868 report for the *Devonshire Association For The Advancement Of Science, Literature And Art* (Volume 2) that in his early days, 'Ghost stories were multitudinous … I may own that, such impressions tormented me long after my reason had taught me their absurdity.' For not all 'ghosts' were genuine, and that some county ghosts can be ascribed to superstitious misunderstanding is a clear fact. The writer Nathan Hogg observed in 1866 that a few years since, he had himself seen panic sweep a village 'not seven miles from Exeter' when the horror-struck locals turned out nightly to see a strange light in the window of a house where an old lady had recently passed. This turned out to be the moon reflected, and nothing supernatural.

It is also clear that in the past criminals utilised the average Devonian's superstition to their benefit, for, as Sir John Bowring also tells us:

> In a field near Matford Lane (Exeter) … was a ruined house which had the reputation of being haunted. I believe it was the resort of smugglers, who availed themselves of the horrors which the evil reputation of the place inspired to carry on their deeds of darkness. Supernatural sounds were frequently heard – shrieks and the clanking of chains, and as nothing is so prudential as prudence, people generally determined to keep out of danger's way.

One particularly ingenious trick is depicted by Bowring, who also wrote:

In those days [around eighty years earlier] a ghost, clad in white, was reported to come out of the graves in the churchyard opposite the Devon County Hospital, and to look over the gate, which opened upon what was then called Narrow Southernhay Lane. Passengers avoided the spot; and it was only after a drunken man had seized the ghost by the beard – it was a goat, that had been trained by some mischievous wag to stand on his hind legs and put his head over the gate – that the way became frequented again.

In Tavistock, Anna Eliza Bray recorded a piece of local lore she had been told, whereby a troop of Parliamentary soldiers were terrified away from the King's Arms tavern by an awful apparition in the wine cellar. This was in fact the vintner's daughter, who suffered from consumption and had wrapped herself in a winding sheet to frighten the invaders away. This was during the Civil War, and the owners of the King's Arms were staunch royalists. Mrs Bray learned this tale from a direct descendent of the family concerned.

A singularly amusing incident is reported much later in the *Western Times* (9 February 1909), whereby a woman in a white nightdress and slippers was found wandering, zombie-like, along a 'North Devon road' while in a sleepwalking trance. Evidently two cyclists, who encountered her at 8.30 p.m., thought her a ghost and abandoned their bicycles, fleeing into adjacent fields!

The important lesson here is that for such events to have the demonstrated effect there must have been a sincere and widespread belief in apparitions among the general populace in the first place. Despite tricks and misunderstandings like these, which imply that the phenomenon of ghosts belongs to a bygone age when superstition lurked on every corner and the average Devonian feared each and every shadow, the subject of spectral and spiritual phenomena remains a mysterious enigma that (of course) continues to split opinion, even in these cynical and technological times. Death and the afterlife are still such a fixture of the popular imagination that fascination concerning the possibility of ghosts is unlikely ever to leave us, the hereafter being the great unknown that it is. As we shall see, 150 years after the Victorian rationalisation of Hogg and Bowring, the possibility of spiritual entities remains as intriguing, tantalising and thought-provoking as ever.

Numerous stories of the supernatural are still as familiar to us today as they were then. In 1851 when *Murray's Handbook for Devon* was compiled, for instance, the authors recorded this legend for the benefit of the visitor: 'The infamous Jeffries presided as judge at Lidford (Lydford), and the inhabitants affirm that his ghost to this day occasionally visits the old courtroom in the shape of a black pig.' But perhaps the most familiar anecdote in central Devon is that told of Lady Howard, the wife of Sir Richard Grenville, one of the king's generals in the west during the English Civil War, and the mythology of her restless spirit is perhaps a good starting point. According to *Murray's Handbook for Devon*:

She was the daughter and heiress of Sir John Fitz, and, according to the tradition, a mysterious person, who, by some unknown means, had disposed of three husbands in succession before she was wooed and won by Sir Richard Grenville. Whatever

were her crimes, she is now believed to run nightly as a hound from the old gateway of Fitzford House (on the western skirts of Tavistock, of which all that remains is the gatehouse) to the park of Okehampton, between the hours of midnight and cockcrow, and then return to the place whence she started with a single blade of grass in her mouth, and this, it is said, she is to repeat until every blade is picked.

When this task is completed, apparently the world will end.

In Mrs Anna Eliza Bray's time, a plausible story doing the rounds concerned two young men visiting Fitzford House in the very early hours of a Sunday to see their sweethearts, who were domestics there. The two young men opted to hide under the stairs to frighten the two girls, whom they knew fervently believed Fitzford was haunted. However, the men's joke backfired, for they were forced to stay hidden until cockcrow after sighting 'two very large black dogs, with eyes as big as saucers, and fiery tongues, which hung out of their mouths.' These two creatures quitted the premises at daylight; the two servant girls, after rising for work at dawn, had to be stopped from resigning their posts when the men explained what they had seen. Mrs Bray had also heard a first-hand testimony from a Tavistock lady who had happened to pass the Fitzford gates some years earlier and seen a sinister hound appear as though starting its journey to Okehampton, just as the church clock struck twelve.

Some believed that Lady Howard drove from the portal in a coach made of bones, each corner surmounted by the leering skull of one of her dead husbands. There is even an old ballad that further adorns this grisly story by representing Lady Howard as stooping forth from her coach and inviting passers-by to ride with her!

Bizarre as it sounds, however, there are reports suggesting Lady Howard's phantom coach was actually witnessed. Mrs Bray compiled much of the content of her famous correspondence utilising information gleaned from one Mary Colling, a veritable treasure trove of information about the Tavistock region. Mary told her around 1833 that everyone in Tavistock knew of Lady Howard's restless spirit: 'Some have seen her in the shape of a calf; others as a wool-sack full of eyes, rolling along from Fitz-ford.'

The allegation that Lady Howard rode in a coach of bones, although absurd, was not an invention, despite it featuring notably in Mrs Bray's historical novel *Fitz Of Fitzford*. She had been previously informed by Dr Jago, the clergyman of Milton Abbot, that 'occasionally she [Lady Howard] was said to ride in a coach of bones up the West-street towards the moor.' Furthermore, Mrs Bray also explained: 'An old man of this place told a friend of mine the same story, only adding that "he had seen her in it scores of times!"'

One resident of Okehampton, a retired schoolteacher, has lately told me that she also grew up with the story that Lady Howard made her endless journey between Tavistock and Okehampton 'in a carriage surmounted by the skeletons of her four husbands', or else as a black hound that could be glimpsed in the vicinity of the remaining castle portions at Okehampton. This lady, a former tutor in history, believed neither of these stories – an opinion based on their historical inaccuracy, for records concerning the real-life Lady Marie Howard suggest she was no murderess, although a cruel mother. She died on 17 October 1671. Historians, however, concede that her father, Sir John Fitze, was a turbulent, dangerous man, and very ready with his sword on all occasions.

Nonetheless, I am always intrigued when there is a new development to an old folkloric story like this. I was kindly passed a singular photograph of Okehampton Castle, which depicts, at the very least, what appears to be an interesting simulacrum. Okehampton Castle is a lofty, impressive ruin, and the photograph depicts nothing so much as a wraith-like woman standing on the grass against one of the exterior corners. She would appear to have a white hood and a white shawl/dress. At first I thought the image was a coincidence of brickwork patterning – except that the spot where 'she' stands is an inward corner, which is fully in shadow bar the mysterious 'figure', who appears to stand 'apart' from the wall. Paul Saunders, who sent me the original photographs of this odd scene, commented: 'Taken while out walking the dogs in Old Park, Nov 2010. I did not notice anything out of the ordinary at the time. A friend of ours spotted the "figure" when the photos had been developed. We did have the photograph blown up as you can see. I think people see what they want to see myself.'

These days, many online websites for commercial premises and tourist attractions in Devon actively promote themselves as being haunted, or encourage visits by the numerous regional paranormal concerns that are cropping up; some even organise ghostly 'sleepovers' for charity. The paranormal is big business in Devon, and in some quarters 'ghosts' are taken just as seriously as they ever were. Although there is a natural area for contention whenever this aspect of the paranormal is discussed, many local stories of ghosts, even the oldest, have a disturbing ring of truth about them – for often the pointlessness of many paranormal encounters somehow paradoxically make them more believable, simply by sheer virtue of their random meaninglessness. This is a trend that continues into the present day, particularly with regards poltergeist phenomena, which often has no 'backstory' to explain the nightmarish outbreaks that can sometimes plague unfortunate homesteads for months. With this is mind, this chapter explores the wide range of ghostly phenomena that have been rumoured, reported and observed in the county, from the earliest stories to the most modern of ghosts and poltergeists. Here, a chronology of ghosts – some famous, others not so well known – is presented, so readers can judge for themselves what they make of these often unnerving supernatural visitations to the county of Devon…

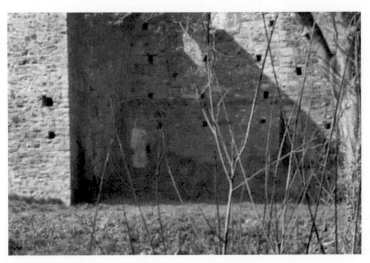

The Okehampton 'ghost'.

PART ONE

'Ghosts Stories Were Multitudinous'

The Haunted Soil

Some of the oldest stories of ghosts indicate a strange veneration – even fear – of the Devon landscape itself, and imply that many natural landmarks were themselves possessed of spirits and somehow supernaturally 'alive'.

Six miles from Sidmouth, the Hare & Hounds Inn can be located at the crossroads called Putts Corner, where Seaton Road joins what is now the A375. The inn was formerly Hunter's Lodge and sits in picturesque countryside surrounded by cairns and the tumuli-dotted Gittisham Hill. Due to its isolated location, it was a frequent haunt of criminals in the seventeenth century and, according to rumour, more than one killing occurred in the inn's murky past. As an example of the crimes that could occur around here, there is a tradition of bloody murder attached to nearby Broad Down. Here, in this inhospitable and wild landscape, a number of customs officers were ambushed by a party of smugglers on 3 November 1787. This happened at Roncombe Gate, and two officers were killed with cutlasses and large stones during the battle. It is a ghoulish fact that the body of one of the victims, William Scott, a supernumerary from the Ottery Division, was left propped in an upright position in a chair at the nearby Turnpike House – where his wife was brought to visit his corpse. The deceased suffered this indignity for two days until the occasion of a coroner's inquest.

In front of the Hare & Hounds sits a huge angular stone, which harbours the grisly allegation that witches used it as a sacrificial altar to slaughter their victims. According to Sidmouth historian P. O. Hutchinson, writing in 1857, it was also said that a huge hoard of riches was buried beneath the stone 'a hundred pounds at a time' by an unnamed person, who probably used its sinister reputation as a means of ensuring people stayed away from it. The strangest fable attached to the stone, however, was that when 'it' heard the clock strike twelve it moved – by itself – into one of the neighbouring valleys to drink, and then returned to its original place!

Strangely, there were other stones with similar legends attached, for as Hutchinson also wrote:

> There is a large stone, about a mile from Sidbury, in the lane leading to Lincombe, on the left-hand side and much sunk in the ground, which turns round three times "when it hears the clock strike twelve"... [and] near Cotleigh, about two miles from Honiton,

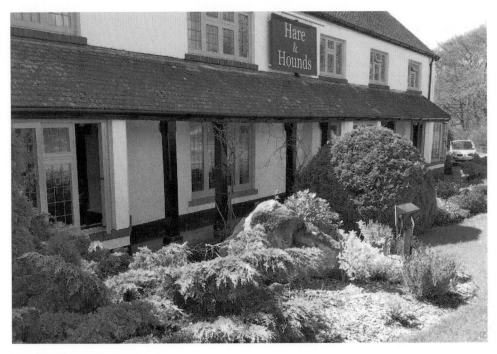

'Witch's Stone', Putts Corner.

on the Chard road, there is a large block of stone standing in a field, standing some five or six feet out of the ground, which goes at midnight down into the valley of Honiton to drink "when it hears the clock strike" that solemn hour. It stands on the hill. It is visible from the Honiton Road. "Grey Stone" and "Grey Stone Field" are the names by which they are known.

But it wasn't just physical things like rocks and tors that harboured mysterious legends. Devonians often believed that the very elements about them were somehow possessed of a supernatural force, and an unusual example of this concerns the sun itself. In 1937 a county newspaper noted a long-dead superstition that at dawn on Easter Day the sun danced and capered joyfully as it appeared above the horizon, before it began to climb into the heavens.

In particular, W. H. K. Wright's *Picturesque South Devonshire* makes it clear that even by the Victorian era county rivers were still viewed almost as living creatures, possessed of intelligence. The spirit of the River Dart went looking for victims:

Dwellers in Dartside solitudes tell strange, true stories of freshets pouring down from the hills and sweeping away men and cattle, and the old rhyme is as true now as ever: River of Dart, oh River of Dart; Every year thou claimest a heart.

On one occasion, according to William Crossing (writing in 1890), a former inhabitant of Rowbrook – a farm near Dartmeet (where the East Dart and West Dart meet) – was was actually led to his death by the river continually calling his name, night after night. This 'superstitious legend' is also recorded at the Tamar, of which Mrs Bray noted in 1833:

'It is averred that ... the river Tamar demands, and will have, the sacrifice of a human life once every year; and that if one year passes without a person being drowned in its waters, the next the river is sure to take two lives in order to make up the number...'

The Endless Chase

In days gone by, folklorists recorded the belief that awful fates awaited sinners in the afterlife. One story, as told by Anna Eliza Bray in correspondence dated 8 January 1833, is unusual in that it concerns differing dimensions of the supernatural: a ghostly white lady, the Devil and a variant on the Yeth Hound legend (of which more later).

Way back in time, an old woman was making her way to Tavistock market in the small hours of the morning when she heard the cry of hounds and observed a lithe hare dart past her. She was at the time riding over Heathfield, a tumuli-dotted wasteland north of the town. The hare stopped before her, so the old woman grabbed it and thrust it into the panniers she had, covered it and rode on.

Almost immediately a terrifying sight appeared out of the early morning gloom: '...a headless horse, bearing a black and grim rider, with horns sprouting from under a little jockey cap; and having a cloven foot thrust into one stirrup. He was surrounded by a pack of hounds.' These had horned heads and great, blazing eyes, while a strong sulphurous scent pervaded the air. This was the Devil himself, out hunting, and he very civilly leaned forward on his saddle and asked the old woman which way the hare had flown. She lied, and said she knew not – and so the Devil, and the hounds, rode on.

When he was gone, the old lady perceived the hare in the pannier begin to move, and in utter astonishment watched it transform into a 'beautiful young lady, all in white', whose ghost gratefully explained all to the old dame. In life, she said, she had committed a great crime, and was destined in death to be pursued by evil spirits forever, or until such time as she 'got behind their tails' and was able to watch them pass on in search of her. Thanks to the old lady, she had succeeded in this task.

It only remains to be said that the ghostly woman granted her preserver a number of gifts: her hens would lay double the amount of eggs, her cows would yield endless milk, and she would win any argument with her husband. The spirit then evaporated before the astonished woman.

More than a mere ghost story, this legend also hints at the very real belief in Satan too – who, we are told, could assume any shape except that of a lamb or a dove – and we shall learn more of the Devil's interest in Devon later.

After-Death Punishment

As the previous story implies, eternal punishment awaited sinners in the afterlife, although it was not always to be chased by the Devil. The rugged coast near Martinhoe is the setting for a widely repeated legend connected with the family of Chichester. Sir Robert Chichester, anciently of Croscombe in Martinhoe, is said to be compelled for alleged crimes to eternally wander the base of a cliff on this desolate and dangerous

shoreline. His task is to form ropes made of sand, fasten them to his spectral carriage, and then drive up the face of the crag through a narrow fissure at the summit locally called Sir Robert's Head. Sir Robert, in life, supposedly met his end when he led a party of mounted robbers in an attack on his manor, which he had let to a farmer. However, the farmer had in turn given shelter to a travelling soldier, who came to his assistance and killed Sir Robert with an arrow as he rode atop a white horse.

Another story is told further west along the northern coast. Crookham Cavern, west of Ilfracombe, was long pointed out by boatmen as the place where Sir William Tracey hid himself for a fortnight after the murder of Thomas Becket, the Archbishop of Canterbury, in 1170. During this time he was brought food by his daughter. After his death around 1189 Tracey's spirit was banished to Woolacombe Sands, to engage itself in the pointless task of making bundles of sand and wisps of the same; on stormy nights, it was said, his spectre might be glimpsed wandering about the shoreline, accompanied by a strange, dismal moaning noise.

Inland, the *Western Times* (13 July 1894) notes other afterlife fates, including parsons 'conjuring ghosts away into Bovacott's ancient crooked oak [on private land, off Bovacott Lane, Holemoor]' … although perhaps the oddest eternal fate is the one reported from Bickleigh Bridge, which crosses the Exe south of Tiverton. According to the *Western Morning News* in 1943, every 24 June, when the church clock chimed midnight, 'a fully armoured knight, or it may be a common soldier, slowly rides a horse across the bridge, carrying his head in the fold of his left arm'.

Tobacco Smoke Used in Exorcism

A very strange ghostly legend is associated with Withycombe Raleigh, which was at one time a distinct village before being assimilated into an expanding Exmouth. Its Perpendicular church was known as St John in the Wilderness, on account of its inconvenient situation, and in 1748 most of the original structure was taken down, excepting the tower and north aisle.

In the early sixteenth century, the bells of this very church are held to have spontaneously tolled upon the death of Sir Roger Whalingham of Withycombe. The late Sir Roger had been in a continual dispute with Sir Hugh de Creveldt of nearby Littleham, stemming from the right to claim wrecks on the shore. Sir Hugh had at that precise moment been wishing all manner of evils upon his enemy, and when he heard the bells tolling he knew his enemy to be dead; yet the victory brought him little peace, for Sir Roger's ghost began to appear so frequently in Sir Hugh's company that it reduced him to a pitiable state of misery. The ghost appeared to him as he walked or at his bedside as he tried to sleep, and gradually Sir Hugh fell so ill his life was despaired of.

Eventually, the sick man was presented with a pipe of tobacco by a Spanish captain who had returned from the seas. Sir Hugh smoked it, and it 'exorcised' his ghostly tormentor. As explained in *Black's Guide to Devonshire* (1864), 'Sir Hugh recovered in a week, and smoked for many a month, and finally taught his neighbour, young Raleigh of Withycombe, to smoke also. From Raleigh the pipe descended to the great Sir Walter, who, there is no doubt, planned his expedition to Virginia on purpose to – fill it!'

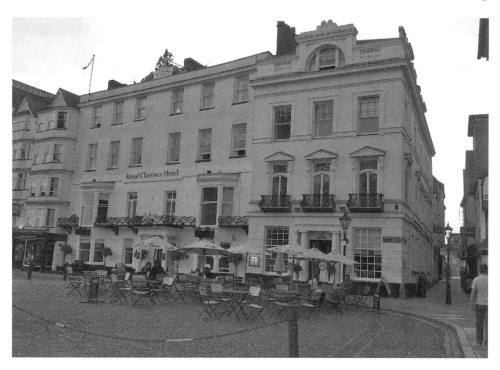

Mysterious coughing is sometimes heard inside the Royal Clarence, Exeter.

Whatever credence one gives this story, it does appear elsewhere in Devon. Sir Walter Raleigh's father supposedly lived in Exeter, and it is said that one day a Dutch sea captain sought out the Raleigh residence, desiring to see the son of the house – Sir Walter himself – who was staying there at the time. The Dutchman had heard rumours that Sir Walter was a far-travelled wizard who breathed smoke from his nostrils like an enchanter; thus deluded, he explained that he felt he had become tormented by the soul of a recently deceased crewman, whose spiritual essence resided on his shoulder. Sir Walter did nothing more than breathe tobacco smoke onto the man's shoulder, but this act (somehow) freed him from his ghostly torment.

This incident is thought to be the explanation for a strange ghostly manifestation at the Royal Clarence Hotel in Cathedral Yard, Exeter, which (when built in 1769) was allegedly constructed on the site of the Raleigh house. It is told of this prestigious, four-storey city landmark overlooking the cathedral that a strange coughing noise has occasionally been heard to emanate from an empty room, or rooms: popular supposition links this to the incident of the Dutch sea captain, although there are differing opinions as to whether the coughs that are heard are his or Raleigh's.

The Legend of Lidwell Chapel

The hamlet of Lidwell, near Teignmouth, derived its name from a spring tapped at a deep well called Lady Well, and has long been haunted by the ghost of a monk-highwayman.

According to a traditional tale entitled 'A Legend of Lidwell Chapel' (recounted in the *Western Miscellany* in 1850), a monk named Simon lived in the chapel beside the well here around 1560. He killed travellers, stashed their wares and sank their bodies down the well – until one day he was himself fatally wounded by one of his potential victims. According to the legend, 'the ghost of St Simon is still said to take his accustomed seat on the well on wild and gusty nights, and all who have seen it declare that it still seems to mourn over the loss of its golden treasure.' Peasants living in the surrounding villages would subdue their children with the threat of calling 'Saint' Simon's ghost from the chapel.

Writer A. H. Norway recorded in 1904 a version of this legend, varying in that it was a priest (not a monk) who decoyed women here and killed them: 'He is very well remembered in the neighbourhood, as is natural, seeing that the ghosts of the poor murdered women and children are to be seen hovering round the opening of the well on almost any night when the moon is not too bright.'

Simon's chapel can still be found within walking distance of the Little Haldon crossroads, a little fenced-in ruin where the ground is wet with water from the adjacent spring. The well, we are told, was covered over with a granite slab. It is unclear if the story is grounded in fact, but this legend does well, at least, to indicate a curiously

This effigy in Tavistock's church is that of Judge Glanvill, who allegedly pronounced sentence on his own daughter for abetting the strangling of her husband in Plymouth. This belief may be mistaken, but the judge is said to have visited the family home, Kilworthy, 'at the dead hour of night' following his death in 1600.

frequent connection between the paranormal and watery places in the minds of the average Devonian in days gone by. It is also worth pointing out that there are still, to this day, rumours of dark, shadowy figures drifting the heath near Lidwell Farm, which are supposedly the wraiths of Simon's victims returning to reclaim their robbed gold, which the wicked monk reputedly hoarded in a secret chest under the altar at the chapel.

The Spiritual Guardians of Challacombe

Many believed that the relics of prehistory were cursed, and there is a story from Widecombe in the Moor that tells how 'in the days of old' a vicar set forth to raid the old graves of Dartmoor in search of the treasures they supposedly hid. His mission was successful; but upon returning home a mighty explosion reduced his house to atoms, killing him instantly and burying him in the ruins. Rachel Evans' *Home Scenes* (1846) relates this dire tale; but it is only a variation on another appearing in Thomas Westcote's *A View Of Devonshire* (c. 1630) – considered one of Devon's earliest first-hand ghost reports.

Challacombe Common, south of Lynton, was in Westcote's day a place of strange reputation, dotted with diverse hillocks of earth and stone (tumuli and barrows), upon which fiery dragons were said to be seen alighting sometimes. However, some seven years earlier, a 'daily labouring man' had experienced an altogether different paranormal phenomenon. He was building a house near one of these mounds, called Broaken Burrow, and was employed in digging deep into the bowels of the tumulus for earth and stones. Deep within, his spade hit a large, walled oven-type construction, which, when he broke through it, was found to contain an earthen pot. As he dug deeper, excited by the thought of gleaming riches, he was suddenly forced to return to the surface upon hearing distinctly the noise of many horses thundering towards him.

Cautiously poking his head over the lip of the hole, he was reassured when he saw no one approaching who might rob him of his discovery. However, the pit ultimately contained only ashes and the small bones of children. Strangely, within a very short time the man fell blind and deaf, and within three months he had died. The implication is that invisible phantom horses visited some sort of curse upon him for disturbing the tumulus, and Westcote wrote: 'He constantly reported this, diverse times, to men of good quality, with protestations to the truth thereof even to his death.'

The site of this incident was, I understand, the tumulus near what is now a private dwelling called Brockenbarrow Farm. Another similar tale is also told by Westcote, concerning the nearby mound of Woodbarrow, near Pinkery Pond on the Somerset border. A conjurer persuaded some men he knew (by means of divination) that Woodbarrow contained a large brass vessel full of treasure. No sooner was an opening forced than a deadly faintness overtook the party, and although they persevered through their sickness they found only an earthen jar containing a quantity of refuse.

It is interesting to note that Challacombe entertained an eerie reputation even 250 years later, for J. L. W. Page's *An Exploration Of Exmoor* (1890) explains that there was a wild combe hereabouts known as Pixie Rocks (Swincombe Rocks, near the Bray Reservoir). In days gone by, the pixies dwelt among the crags jutting from the steep

walls of the glen. Page also noted of Challacombe: 'Superstition yet lives in this semi-moorland village. An old man cannot be persuaded but that every illness entailed by his failing years is the direct result of witchcraft'. We shall look more closely at these fringe elements of the paranormal later on.

A Narrative of the Demon of Spraiton

One of Devon's earliest authenticated ghosts is also one of its most nightmarishly eerie. It was chronicled by, among others, luminaries like John Aubrey and Richard Bovet, who drew on the correspondence of local people who witnessed the events.

In November 1682 there suddenly appeared before a young man named Francis Fry a strange ancient figure. Twenty-one-year-old Fry was employed by a certain Mr Philip Furze, and when the decrepit old figure made his startling appearance in a field near Furze's home in Spreyton, Fry recognised the man as his employer's father. However, the figure – carrying a long pole used for killing moles – was clearly a ghost, for Furze senior had passed on. The ghost asked Fry to arrange the payment of outstanding legacies that it had failed to bequeath upon death, and to this Fry agreed. He accordingly took himself to Staverton to pay one of the debts to Ms Furze, the sister of the apparition that had confronted him; however, this lady flatly refused the payment, claiming it was the Devil's own money.

Nonetheless, Fry lodged the night there; and here old Furze appeared to him once more, telling Fry to go to Totnes and purchase a ring of equivalent value, which his sister would accept. Promising to trouble the young man no more if he did this, Fry did as he was bid and, true to its word, the spectre appeared no more.

During their discourse, the ghost had referred to 'its' second wife, Mrs Furze, also deceased, as 'that wicked woman, my wife', and it seems to have been these comments that damned Fry. For some reason the outraged spectre of this dead woman latched herself on to Fry and hounded him in a frightening and violent fashion.

As Fry rode home from Staverton in the company of one of Ms Furze's servants, villagers noticed the young man carried on the back of his horse a mysterious passenger, whom he evidently did not realise was there. She is described in the report as 'an old gentlewoman', and as they entered Spreyton parish this entity's presence suddenly spooked the horse so badly that Fry was flipped off it and injured on the ground. Upon coming into the yard of the Furze household, the beast jumped a mighty 25 feet, evidently in an attempt to throw the ghostly old woman off its back.

Thereafter the phantom woman took to appearing inside the house before Fry and others, including one Mrs Thomas Gidley, Anne Langdon and a little child who was subsequently rushed from the house to spare her further terror. When it manifested, the entity did so in a number of guises: sometimes as the old woman, sometimes as a black dog that belched fire, sometimes as a horse (that on one occasion leapt through a window, smashing the pane) and also, less impressively, as a little piece of iron. The ghost also reacted violently, on one occasion cramming Francis Fry's head into a tiny cranny between a bed and a wall, where it was so painfully wedged that it took several persons to force him free, bloody and bruised. Fry, in fact, was subject to numerous

invisible assaults, somehow having become the focus of the spirit's rage, for we learn that handkerchiefs and cravats were drawn by an unnatural force so tightly round his throat he was almost strangled. The entity also seemed to have a puritanical hatred of his periwigs, his best of which was 'torn to flitters' despite being hidden in a little box that had its lid weighted down. Shoes were also targeted: the buckles on Furze's shoes fell to pieces, and shoelaces wormed their way out of shoes, with one curling about a terrified maid's arm 'like a living eel'. Clothes worn by Anne Langdon and Fry were 'torn to pieces on their backs', and Fry's gloves were neatly dissected while actually in his pocket. Poltergeist activity also bedevilled the tormented household, with a great barrel of salt 'marching' by itself between two rooms, flitches of bacon flying down the chimney, and the andiron (an iron bar fitted in the fireplace) moving itself about.

There seem to have been many witnesses to these events. By this time Fry himself is stated to have begun suffering violent contortions, whereby his legs became tied about his neck, or entangled in the chair, so that only with great difficulty could he be disengaged. However, the most phenomenal torment laid upon him was the following incident. On Easter eve, when returning from work, the woman spectre grabbed him by the skirts of his doublet and whisked him into the air. A search party later found him waist-deep in a mire, singing and whistling to himself. He appeared – finally – to have lost his faculties, but when he came around he explained that he had been carried so high into the sky that his master's house appeared 'no bigger than a haycock'. He had prayed fervently, and this (it seems) saved him, for he was set down in the quagmire. Afterwards, workmen found his shoes on either side of the house and his periwig hanging from the top of a tall tree.

Because his constitution was now so weak, Fry was conveyed to Crediton to be bled. Shortly afterwards he was found in a fit, with his forehead badly swollen and bruised. This he explained by the fact that a bird had flown through the window, a stone in its mouth, which shot at the tormented young man's forehead and caused the injury. Of course, this story was treated somewhat sceptically – until people looking around the room for evidence found 'a weight of brass, or copper' just under Fry's convalescent bed. Another who looked at this missile found it neither brass nor stone but 'a strange mineral', unidentifiable to all present.

Here the correspondence ends, drawing to a close with the observation that Francis Fry was at the time of writing very ill and much troubled. Lately, his mother had complained that five pins were stuck into his side. The principal others so afflicted by this frightening outbreak had lately left the premises, but their paranormal plague appeared to have followed them, with Anne Langdon suffering fits in which she 'screeches in a most hellish tone'. The writer of these remarkable narratives explained that he would have visited the bedevilled household himself except that 'none but nonconforming ministers' were being consulted, and he feared his presence would be offensive.

Remarkably, in this correspondence there is a reference to a similar phenomenon happening around the same time in Barnstaple. As for the Spreyton affair, the Revd Baring Gould later noted, 'It is pretty obvious that the mysterious and idle youth (Fry) was at the bottom of all this bedevilment.' But, in truth, the affair seems too complex, far-fetched and involving too many people for it merely to be the work of a single 'knavish servant' who, if this were the case, must have had phenomenal good fortune to have fully

Here in Ottery St Mary parish church can be found the effigy of John Coke, of Thorne, *d.* 1632, an armed soldier grasping a sword. Black's 1864 county guidebook says: 'He is said to have been murdered by a younger brother, and his statue, therefore, steps down from its niche at night and stalks through the silent church.'

deceived the people around him, who we suppose must have possessed at least equal intelligence. What we know of the case originally comes from a 1683 tract that drew upon 'a letter from a person of quality in the county of Devon [a Barnstaple clergyman, in fact] to a gentleman of London', and, for the era, the affair does seem to have been reasonably well attested. Perhaps even more remarkably, witchcraft is not inferred, with the correspondence being written in a clearly educated and intelligent narrative.

Cranmere Pool

Cranmere Pool, a difficult to access and dangerously boggy peat depression at West Okement Head on northern Dartmoor, is now effectively drained. This is a strange place, best summed up in Murray's 1856 guidebook to Devon: 'Here (the traveller) may consider the scenery rather dreary; but there are many who will find an indescribable charm in it.' Cranmere is, or was, popularly called the 'Mother of Rivers', but actually the only stream it gives rise to is the West Okement. At one time this was an even more treacherous morass, to which evil spirits were consigned, for when Mrs Bray visited around 1835, and sank up to her ankles, she was told by her guide that 'spirits are here condemned to suffer'.

In 1859, *Notes & Queries* produced its *Choice Notes: Folklore*, which told of one very strange story out here:

An old farmer was so troublesome to his survivors as to require seven clergymen to secure him. By their means, however, he was transformed into a colt; and a servant boy was directed to take him to Cranmere Pool. On arriving at the brink of the pool, he was to take off the halter, and return instantly without looking round. Curiosity

proving too powerful, he turned his head to see what was going on, when he beheld the colt plunge into the lake in the form of a ball of fire. Before doing so, however, he gave the lad a parting salute in the form of a kick, which knocked out one of his eyes.

There was a simultaneous story concurrent among the Devon moor men that one unhappy spirit whiled away the afterlife here, having been condemned to drain Cranmere Pool using a limpet with a hole in the bottom. A revised edition of *Murray's Handbook for Devon* (1865) tells us that this spirit was called 'Bingie' and had been condemned by a conjurer to spend eternity draining the pool with an oat-sieve; however, one day the wandering spirit found a sheepskin on the moor, with which he lined the sieve and successfully completed his task, flooding Okehampton in the process.

'Bingie' is nowadays equated with Benjamin Geare (or Gayer), a Mayor of Okehampton who died around 1701. There has been an almost subconscious effort to tie up these various spiritual elements – *Reader's Digest's Folklore, Myths & Legends Of Britain* (1973) remarks on 'Bengie Geare, a former mayor of Okehampton, whose phantom, in the guise of a black pony, still makes occasional appearances' at the site.

It must have been a slow news day on 26 March 1932 when the *Western Morning News* reported how a man had lost his pen during a hike to Cranmere Pool. Retracing his steps, it seemed to have utterly vanished; yet during another trip he unaccountably found it again in plain sight, although broken. The point is that, when found, the pen was near the 'edge of a patch of burnt heather'. Perhaps the fiery phantom colt had taken a brief interest in this remnant of the mortal coil!

Oddly, this was not a unique type of ghost story in Devon. Hound's Pool was haunted by the spirit of a weaver who was turned into a black hound by a parson and condemned to dip out the water with a nutshell until the pool should be empty, after which he might rest in peace. This pool is formed by Dean Brook, and lies at the foot of a deep hollow in the hamlet of Deancombe, near Dean Prior.

A Mutineer's Ghost

A traditional ghost story from the other side of the county concerns Fletcher Christian, leader of the band of mutineers who took control of the ill-fated *Bounty* and cast adrift Captain William Bligh and eighteen loyal crewmen into the Pacific Ocean.

This event occurred on 28 April 1789, and some twenty years later a naval officer who had been a midshipman with Bligh passed a cloaked figure in the vicinity of Fore Street, Devonport (historically the most important district of Plymouth). Recognising the man as Fletcher Christian, leader of the *Bounty* mutineers, the naval officer called after the furtive figure, and when he received no reply he began to pursue him. The figure was 'enfolded in a boat cloak' and the officer watched him turn into Marlborough Street, whereupon he abruptly seemed to vanish into thin air.

What happened to Fletcher Christian after the mutiny has always been something of a puzzle. He may have died violently in a conflict with natives on tiny Pitcairn Island, in the southern Pacific Ocean. For all intents and purposes he disappeared from the pages of history and it is certain he never returned to Britain.

This puzzling mystery was recalled in the *Western Morning News* in 1949; another question being why Christian's 'ghost' would appear in Plymouth when he was originally from Cumbria – unless it was simply that Plymouth was a naval town that he might have known very well during his lifetime.

The Sampford Ghost

In the autumn of 1814, great argument was courted in the West Country by allegations that the shrill, ghostly voice of a dead little girl, Ann Taylor, the ten-year-old daughter of a Tiverton yeoman, had been heard crying, 'Father, it is not printed!' as her body was being placed in the coffin. This was a reference to revelations she had experienced while in a dreamlike trance on her deathbed, which she had desired to be written down. However, the paranormal sensation of the age concerned the marvellous events that occurred in a little village to the east of Tiverton.

When the story broke of a haunted house in Sampford Peverell in the autumn of 1810, it caused a nationwide controversy. The *Taunton Courier* was the first newspaper to report that this particular house, rented by a huckster named John Chave, was plagued by sinister 'supernatural visits'. A Tiverton clergyman, the Revd C. Colton, next penned a letter under a solemn oath that Mr Chave's premises were most definitely haunted. Colton's testimony, dated 18 August 1810, was printed in the *Courier*, and in part reads:

> And first, I depose solemnly, that after an attendance of six nights (not successive) at Mr. Chave's house in the village of Sampford, and with a mind perfectly unprejudiced, after the most minute investigation, and closest inspection of the premises, I am utterly unable to account for any of the phenomena I have seen and heard, and labour at this moment under no small perplexity arising from a determination not lightly to admit of supernatural interference, and an impossibility of hitherto tracing these effects to any human cause.

So absolute was the reverend's belief that Mr Chave's house was haunted that he offered to freely donate a considerable sum of money to the parish poor should he be presented with undeniable proof that the haunting was anything other than supernatural.

Chave had occupied the 'haunted house' since July 1809, bringing with him his wife and servants (including 'one somewhat stricken in years', and a girl of about eighteen called Sally Case), as well as a man named Taylor who was Mrs Chave's brother. The haunting had first manifested itself early the following year, in April. It would frequently begin around midday, the phenomenon announcing its presence by way of furious knocking in different parts of the house. These noises often followed the occupants as they walked about the premises. Worse, according to the Revd Colton, the frightening supernatural force that had invaded the Chave's home could be singularly violent. Women in the household, including visitors who slept there to support the troubled family, were struck violent blows during the night by an invisible hand, and occupants were also frightened 'by an unaccountable and rapid drawing and withdrawing of the curtains; by a suffocating and almost inexpressible weight, and by a repetition of sounds, so loud, as at

times to shake the whole room'. Colton professed himself bemused, having laid traps for the spectre: slivers of paper were delicately and strategically placed across door frames in secret to see if they were being opened, to ascertain whether someone was gaining entry to the premises. But these remained untouched while the phenomena continued unabatedly. On one occasion, Colton himself heard some 200 blows emanate from an unknown force, and sometimes the servants bore visible injures from the assaults they suffered. One Ann Mills, for instance, was struck so forcefully that her cheek swelled up like an egg; she averred that she had most definitely been alone in the bedroom when she was attacked. Apart from all this, stamping one's foot on the floorboards produced a likewise thumping reply beneath one's feet; steps were heard 'like a man's foot in a slipper'; and a candlestick was thrown by an invisible force at Chave's head, although it did not strike him.

Revd Colton expressed the opinion that if the whole thing were a plot, then some fifty people had to be involved, given the amount of people who had seen something strange, and yet no one had anything to gain from it. In fact, the reverse was the case: the value of the house was diminishing, Chave was losing business, and no one was getting any sleep. The reverend's testimony was witnessed by other dignitaries who had seen weird occurrences at the premises, including a 'Master in Chancery', two surgeons, a merchant and an innkeeper.

But right from the start, the *Courier* was suspicious: 'We anticipate in a short time from him (Colton) a very different statement, confirming our opinion, that the whole is founded in an infamous conspiracy.' As the story developed, the *Courier* reported that the whole phenomenon seemed to coincide with a fallout over money between the two part-owners, Mr Talley and Mr Jennings, following some decorating and repair work, the result of which threatened Chave – the tenant – with eviction. The media reported:

> After this the violence and frequency of the ghostly visits became considerably aggravated. The servants were night after night slapped, pinched and buffeted; the bed more than once became stock full of pins; loud and repeated knockings were heard in all the upper rooms; the house shook; the windows rattled in their casements...

Rumours of witchcraft and demonic intervention were sweeping Sampford Peverell.

When the ghost manifested itself, it could be disturbing; the *Morning Chronicle* (1 September 1810), in a clearly sceptical report, describes a monster 'resembling a black rabbit, only wonderfully larger, and which, when pursued, escapes through the close palings of (Chave's) garden in a moment.' Sally Case, the servant, told interrogators that she had caught hold of the 'thing' twice, and that it was very heavy and felt like a dog or big rabbit – but it was so powerful she could not hold on to it. This phantasm usually manifested itself in the house during the hours of darkness, departing upon daylight breaking. Sally also confirmed she had been repeatedly slapped by some invisible means, 'and that she lately saw through the sheet, while her head was under the bedclothes, a man's hand and arm, perfectly white'.

A hoax was, indeed, suggested not long after. It emerged later in September that a cooper named Dodge had, at some point, been found hiding on the premises behind a curtain, having somehow furtively gained access to the premises by way of one of three entrances that, it was later suggested, Mr Chave allegedly hid from the numberless

visitors. Dodge protested that he had come to sleep on the premises after hearing that the occupants had recently been frightened by stories of an old woman who descended through the ceiling. He further explained he was protective of the occupants, and this seems to have been viewed, rightly, with great suspicion; for he could not explain why he had tried to hide a mop stick whose end was battered and paint-encrusted.

Dodge was allowed to stay the night (there seems to have been no shortage of people coming and going, so his discovery in the house is not quite as intrusive as it might seem); but to be on the safe side he was locked in his room, and during the night the premises suffered no outbreaks. From this is was surmised that the cooper was using the mop stick to create the thunderous sounds against the floorboards and walls during secretive night-time excursions, and when this became widely known considerable sympathy was lost for Mr Chave ... for people were now beginning to believe he was faking the entire haunting in order to purchase the property cheaply.

The cooper, Dodge, had allegedly been found hiding by Talley, one of the owners. There is a comical moment of farce reported in the *Morning Chronicle* (22 September 1810), which explains that, upon these developments emerging, Mr Talley took it upon himself to see if the imposture would work in the way he surmised. Using the mop stick, he thumped the floorboards beneath the so-called 'haunted bedroom', which at that very moment was being displayed by Chave to a curious sergeant-at-arms. Chave, unaware of what was transpiring below his feet, shouted that the ghost had come again, and Sergeant Karslake exclaimed, 'By God, I'll show thee!' With military bravery he grabbed a sword kept in the room (this enchanted weapon, we learn, had allegedly once flown with 'tyger-like' ferocity at the Reverend Colton's head) and plunged it into the floorboards. It was only when Talley rushed upstairs that the sergeant realised the thumps were not due to a ghost but the suspicious owner. The sergeant reportedly grabbed the mop stick, which was covered with plaster and whitewash, and snapped it under his feet, exclaiming that no more knavery should be practised with that instrument.

Although the matter seemed to have been explained, a letter (dated 10 October) by the Revd Colton piled mystery upon mystery when he wrote that the phenomena nonetheless continued unabated. A few nights earlier, the reverend had dashed to the house, as the whole Chave family were reported to be suffering the most noisome poltergeist activity. A recent servant called Jane Harvey had become the newest household member to suffer the violent knocking and phantom assaults while attempting to sleep in the bedroom apartment deemed to be principally haunted. Jane stated that she had slept in the room with Sally Case and a little girl (who was not a resident), but their sleep was disturbed by the 'most violent blows upon the bed, and by still louder knocks upon the wooden head of the bed adjoining, in which no one slept.'

Colton, mindful of the current scepticism, had taken with him a witness from Tiverton. In actual fact, the witness – Mr Quick, the landlord of the White Horse – heard the ferocious noises himself, and Colton concurred that, previously, he had heard these noises reach such a crescendo that they must have been audible 50 yards from the house.

Colton's role in all this remains something of an enigma. He pointedly remarks that Dodge was proven nowhere near the premises that night, and himself professed to retain a healthy degree of scepticism: '[There are] two suspicious circumstances that still appertain to this affair. The agent, be it what it may, certainly dislikes the light, and

has not yet attacked men.' Colton had a pamphlet published, grandly titled *Sampford Ghost: Stubborn Facts Against Vague Assertions, being an appendix to a plain and authentic narrative of those extraordinary circumstances hitherto unaccounted for, and still going on in the house of Mr Chave*. In this he fully outlined the extent of the ongoing phenomena at the property, and he later claimed that it was still going on, long after the public had lost interest. Ingenious, talented and eccentric, Charles Caleb Colton persisted in his declaration that the Sampford Peverell incident was a true and continuing supernatural event, until his death on 28 April 1832, when he clapped a pistol to his head and pulled the trigger.

The haunting had unfortunate repercussions. In April 1811, Chave was followed to his home by a huge crowd of drunken workmen employed in excavating the bed of the Grand Western Canal, some of whom had recognised him at the annual cattle fair in Sampford Peverell. His house was pelted with missiles, and Chave was forced to open fire with a pistol, killing one man. A second person was critically wounded by pistol fire from another part of the house, and the mob severely beat a carter employed by Chave during the violence.

It is an oft-repeated fact that no human agency was ever conclusively proven to be behind the outbreaks, and there is a weird question mark hanging over the whole affair to this day. If it were a plot, then to what end? Why were so many local notables willing to risk ridicule and testify as witnesses? Colton seems not to have been inventing the phenomena, but was he involved or was he a dupe? Or was he simply recording what he saw?

Over time, the place became known as Ghost House. It stood in Higher Town, a cob and thatched dwelling with eight rooms – one of which became known simply as the 'ghost room'. The place is thought to have been built in the early sixteenth century, and on some of the windows sentences were reputedly scratched by a former owner, a man named Bellamy. This person was allegedly a smuggler, and many believed it was the tricks he used to avoid detection – such as digging a hole under the sitting room floorboards – that years later allowed the unknown perpetrator to get away with his fraudulent haunting. The place also supposedly had double walls, with thin passages allowing someone to move about furtively undetected.

But this is conjecture. At about 10 a.m. on 11 September 1929 it was observed that the thatch of Ghost House was ablaze, and the fire eventually gutted and destroyed the building. Several onlookers had a dramatically narrow escape when an end wall collapsed near them.

What caused the blaze was not immediately clear, but there was a bizarre postscript to these events. When Mr G. W. Copeland of Plymouth visited the site of Ghost House in 1937, he was amazed to find it still standing. This astonished him; he had read that it had been destroyed. However, he identified it without question from sketches he had with him; there were no signs of fire and he happily took a photograph of the house for posterity.

But in 1945, when Mr Copeland took his wife to view the house, it no longer stood, and in answer to his bemused enquiries he was told it had burned down long ago. When he showed his lantern slides at Plymouth Athenaeum the following year, he wondered if he had managed – somehow – to glimpse (and photograph) a phantom echo of the house as it had stood before its destruction in 1929. His eerie tale was reported in the *Western Morning News* of 9 March 1946.

Depiction of Ghost House near the site. The remains of the place are part of a garage now.

Birds in Devonian Ghost Stories

Out of all the creatures of the animal kingdom that inhabit our shared environment, the humble bird seems to feature most frequently in the strange lore of Devon. In many cases, stories of birds concern paranormal themes – either as spectral omens of misfortune or supernatural good luck charms. The most famous of these is the so-called White Bird of the Oxenham family. Their ancient mansion near the restored Oxenham Cross east of South Tawton will be looked for in vain; the present building is an erection of the nineteenth century, and is now used as a farmhouse.

It is historically said that a white bird, or one with a white breast, appeared as a forewarning prior to the death of a member of the family. This portentous bird was bound to appear before the death of the head of the family, but might also be witnessed prior to the death of any family member. There is an account of its appearance in 1635, printed in a tract of twenty pages, in which an allusion is made to the sinister bird also having been seen in 1618. According to the pamphlet, the bird hovered over the deathbeds of the children of 'Mr James Oxenham, of Sale (Zeal) Monachorum' during a sickness that swept their home. This illness took Oxenham's eldest son on 5 September, then his second son's wife, his granddaughter and another related child. Other family members affected by the plague who suffered no visitation from the 'bird with a white breast' survived. Its appearance in 1618 had apparently heralded the death of Mr Oxenham's mother.

An incident in 1743 is recorded in the manuscripts of one Mr Chapple as having come direct from the mouth of the Oxenham family physician. Mr William Oxenham was ill, and a white bird entered his room through an open window. At the time, the patient felt not too unwell, and so treated the incident lightly, although he knew the legend. He joked he would beat the ill-omened bird this time – but he died within two days. In fact, an interesting letter to the *Exeter & Plymouth Gazette* in 1882 implies that the ghostly white bird was destined to flutter near the deathbed of the Oxenhams, no matter where

they lay. At one time, an old mansion occupied a high site at Sidmouth. Prior to its being pulled down in 1826 it belonged to the Oxenham line. When the last Oxenham to inhabit the place died, the new owners were told in 1820 that when old Oxenham passed away the dairyman's wife and granddaughter were at his bedside. Both saw a bird, which they took to be a white pigeon, fly over the bed and then fly across the room. It disappeared near a closet, and a search for the bird, both within and without, revealed no-where it could have gone. When the dairyman (a man called Barret) was questioned by old Oxenham's family, he assured them that 'Mr O went off quiet', but his granddaughter interrupted the sombre mood by reminding her 'Gramfer' of the strange avian visitor.

Devon Notes And Queries, Volume 2 (1903) observes of this portent, 'several instances have since been recorded, the latest in 1873.' This was in Kensington, when the portentous bird took up residence in a tree opposite the bedroom of an Oxenham who lay dying in Cromwell Road. It would not move, even when some masons threw their caps at it.

Interestingly, St Andrew's church, South Tawton, contains a marble effigy of an armour-clad man, whose feet appear to rest on a white bird. Sadly, this is not a representation of an Oxenham, but that of John Weekes, of North Wyke, and his feet rest on a barnacle goose. However, he did, in life, serve in the County Militia in 1572, beside John Oxenham and Sir Francis Drake at Nombre Dios. Actual memorials to the Oxenham line can be seen on the wall nearby, and their name is also remembered in the nearby restored cross.

The white bird is said in a local ballad to have originated in a tragic occurrence. On the bridal eve of Margaret, heiress of Sir James Oxenham, a silver-breasted bird flew over the wedding guests just as Sir James stood up to thank them for their good wishes. The next day Margaret was slain by a discarded lover. However birds feature quite frequently in Devon lore. Dunsford, in his *Memories Of Tiverton* (1790), tells us a white owl spoke to two fellows ensconced in the chapel at Chettiscombe, telling them where to dig for treasure. Fuller records that 'divine providence' provided the people of Exeter with plentiful larks to catch and cook, while the city was besieged during the Civil War and starvation threatened. A single magpie, on the other hand, was reckoned to be a sure portent of imminent death. Elliott O' Donnell even mentions in *Animal Ghosts* (1913) that, 'Ghosts of magpies are far from uncommon; on Dartmoor and Exmoor, for example, I have seen several of them, generally in the immediate vicinity of bogs or deep holes.'

Of phantom birds, I might also mention Richard Polwhele's observation in 1793: 'I have been told by a gentleman of Tavistock, that, shooting on Dartmoor, he hath several times seen the black eagle there, though he could never discover its nest.'

Plymtree's 'Troublesome' Ghost

An example of how an increasingly sophisticated media could bring local ghost stories to the attention of the populace can be found in the *Exeter & Plymouth Gazette* (3 April 1841). Under the attention-grabbing headline 'A Ghost! A Ghost!' it told its readership of the current scare at Hayne House, a former manor house built in the early eighteenth century on the eastern fringe of Plymtree, near Cullompton. The newspaper

declared the house was deemed 'troublesome' (a gentle euphemism frequently used to describe haunted houses), plagued by a resident ghost who had appeared once more after several years absence. The spectre's description is uncommonly vague, but it had been witnessed by a shoemaker passing Hayne's iron gates, and also by a 'certain maiden' who was frightened by its 'pale and ireful glance'. Fear and rumour were sweeping the village; a basket maker spotted a frightful visage that appeared to have three fiery heads and others reported a 'fiery hand' being seen also. People came from distant parishes to hang around outside Hayne and see for themselves, much to the annoyance of the owner: 'Truly the gentleman who inhabits Hayne wished the ghost would be pleased to depart upon his voyage across the Styx.'

From Devon's premier folklorist Theo Brown (*d.* 1993), writing in 1982, we learn that in the early twentieth century a daughter of the house reported seeing a phantom child standing at the foot of her bed, although this would appear to be something distinct from the entity that scared the villagers over half a century earlier.

Capturing the Phantom Rabbit of Dartmouth

On the morning of Tuesday 30 January 1849, Head Constable Hearn opened the doors to Dartmouth's council chamber and made his way inside to begin the day's work. Very quickly, his ear was drawn to strange noises from a distant corner of the building, and so, armed with a police stave, he hunted the suspicious racket down. The culprit turned out to be a very large white rabbit, ancient-looking and lean, which did not put up much resistance and allowed itself to be captured by the constable from its vantage point on a table. Later that morning members of the town council visited the captured animal in the Guildhall themselves.

The reason for such an inordinate amount of excitement is this. Since at least the late eighteenth-century it was well known that Dartmouth was, on occasion, mysteriously visited by an 'unearthly being' that took the form of a gigantic white rabbit. Most of the eldest residents could remember a time, half a century earlier, when the white rabbit's ghost would appear as soon as the sun went down. The animal would make its way from the churchyard and through one or two of the principal streets in the town back then, scattering people in every direction who feared it to be some kind of unnatural phantasm. It was frequently chased, and even shot at, and whenever hats were placed over it in an attempt to capture it, the strange animal had utterly vanished when the hat was scooped up and looked into. In fact, it always vanished unmolested, only to reappear the next time. Hundreds knew of the patrols that formed when the phantom rabbit was abroad, and this is why such a singular-looking creature's capture in the town after over fifty years of gambolling caused such a superstitious buzz in Dartmouth. The *Sherborne Mercury* (3 February 1849) reported, with strangely little mockery, 'The general opinion is that it must have purposely gone to the Guildhall, with the intention of delivering itself up, to satisfy the ends of justice.' Members of the council were intending to have it preserved.

Oddly, this type of superstition is found elsewhere in Devon. In Moretonhampstead, for example, it used to be stated that the sight of a hare in the streets was a sure sign a fire would soon occur in the town.

One view of Dartmouth.

The Choir's Terror

As Christmas 1876 approached, the village choir of Kingston, in the remote coastal land adjoining Bigbury Bay, were robustly practising for the seasonal service within St James' church. As they sang, all observed a distant door open and watched a mysterious figure draped in white drift through the dimly lit church to the pulpit. No one challenged this strange figure, and as the joyful singing slowly faded into silence the choristers watched the white figure slowly retrace its steps, where it vanished at the same door.

The terrified choir fled the church in disarray, and the story was later reported in the *Edinburgh Evening News* three days before Christmas. One member was so shocked they required medical aid, but what was truly odd was that some of the witnesses thought they had actually recognised the white figure – and it had borne the features of none other than a deceased popular minister...

Horror Stories of Roborough Down

Roborough Down is an expanse of undulating moorland west of Yelverton, which not so very long ago had a very sinister reputation. Devon folklorist Sarah Hewett, writing in 1899, tells the story of a man pursued down the hill by an immense phantom

dog that was something like a Newfoundland, with great glassy eyes and sulphurous breath. When he reached a crossroads, the dog combusted in a flash of fire. Ms Hewett wrote, 'Tradition says, that a foul murder was many years ago committed at this spot, and the victim's dog is doomed to traverse this road and kill every man he encounters, until the perpetrator of this deed has perished by his instrumentality.' Dashing to the crossroads had saved this victim's life, for such places, like streams, were lethal to phantasms in the West Country.

But an even weirder tradition was recorded by compilers of the *Western Antiquary, Volume 1* (1882). Not far from Maristow Lodge, there was an old ruined building situated on the down. Generations before, an old woman had lived there, and it was said locally that on one occasion a man with two children turned up at her door asking for shelter during a fierce snowstorm. Later, the man journeyed to Plymouth by himself and returned to collect his children on Roborough the following day; however, he found them missing, and a search quickly revealed the old woman had murdered and eaten them. It emerged she had long been in the process of killing and cannibalising travellers, and the *Antiquary* records: 'What her end was I know not, but the house was eventually said to be haunted and was deserted and became a ruin...'

'Something' With Flowers

Devon is a land where paranormal themes take weird forms – consider the 'Hairy Hands' – but a story collected by the Devonshire Association in 1935 surely takes the cake.

One Mrs M. Eckett Fielden told the group that she knew a Manaton woman, Mrs K., whose father had experienced the strangest of mysteries. Mrs K.'s father often walked the road between Crediton and Colebrooke in the company of other young men, and one Sunday evening the group were startled by 'something which jumped from a hedge at them'. One of the group lashed at it with a whip, but this weird apparition followed them until the village lights were reached, whereupon it disappeared.

The following Sunday the thing again leapt from the hedge at the same point, and Mrs K.'s father beat it off with a stick. On the same road on another evening, it became apparent that this 'thing' was trying to present the group with a bunch of flowers, which they refused to accept. After much persuasion it thrust the bouquet into the hands of one of the group; it only remains to be said that the unfortunate young man was dead within a week.

The strange apparition appears to have been of flesh and blood, if it could be struck. Therefore, did 'it' know the young man was about to die? Or was the bouquet of flowers itself the deadly portent? Perhaps the oddest thing about this is that there is no suggestion the apparition was human – Mrs Eckett Fielden's story makes it clear that it was always referred to as 'something', or 'the thing.'

As our tour of paranormal Devon moves into the twentieth and twenty-first centuries, we can see that ghostly manifestations are often, even these days, no less outlandish.

PART TWO

Ghosts for a Less Superstitious Time

Old Parson Parker of Luffincott

Luffincott Rectory could be found in a beautiful hollow near the banks of the Tamar, between Launceston and Holsworthy. Surrounded by charming wooded country, this idyllic place received a degree of notoriety in 1907 when stories of its being haunted emerged.

The rectory was at one time a delightful residence, and in 1907 there were still those who, in living memory, recalled its well-tended grounds and hospitable table, with numerous hooks descending from the kitchen ceiling for flitches of bacon and hams. In the last few years, however, it had become a dilapidated ruin, and this was ascribed by many to the fact that it was badly haunted by the ghost of 'Old Parson Parker' – in life the Revd Franke Parker, who had been rector of the parish for forty-five years and had died twenty-four years earlier.

Apparently, Parker had avowed before death that he would return again in spirit form, declaring that he would appear after his interment at frequent intervals in the form of an animal – a dog, rat or white rabbit. When he died on 3 April 1883, aged eighty, it was said he was buried 17 feet deep to thwart these intentions ... but in the years that passed three more rectors succeeded him, and Parker did not put in his promised appearance – not even when the Revd Haines overhauled the church, noisily renovating the place generally.

However, when the Revd Thomas Ward Brown moved into the rectory in the late 1890s it was observed that he slept but two nights there before upping and leaving, locking the place up and moving to Clawton, never to return to the building.

It was soon common talk locally that Brown's departure had come about because in the middle of the night he had awoken and found the spectre of his predecessor leaning over him. Just before he left, Brown had spotted a picture of Revd Parker in a parishioner's home and stammered, 'That is the man who appeared to me!'

With Brown's departure, local people took to avoiding the place, and youths smashed the windows of the 'haunted house' as it fell into ruination. Ultimately a contingent of military men from Plymouth took up a challenge to spend the night in the rectory and flush the ghost out. These pencilled on the walls the labours of their investigation, such as, 'Arrived here at 9.30 and explored the house. Stayed in this – the Revd Brown's bedroom – until 3.30 a.m. At 12.10 a sound was heard from the cellars. W. J. investigated but found nothing. Rats!' For the most part, however, the

Parson Parker's grave, before the church.

ghost stayed away: this was explained by the fact that no self-respecting ghost would grace the vigils with its presence, as some of them were quite riotous.

On 20 June 1907 a reporter for the *Western Times* stayed at the rectory, and found an old diary on top of a cupboard, with a curious entry for 4 September 1891: 'Skeleton leaves.' It is worth pointing out that the newspaper came in for some strong criticism after reporting this story, as many of Parker's relatives were still living; yet the story is nonetheless an intriguing insight into the rumour mill in out-of-the-way twentieth-century Devon.

Ghosts Around Ilfracombe

Apart from those at Chambercombe Manor, Ilfracombe – the largest seaside resort in North Devon – has reported numerous ghosts down the years. Differing from most big resorts in being built round its old harbour, there are many good bathing beaches, some of them reached by tunnels through the rocks. Although Ilfracombe is a lively place, with many amenities, the tiny chapel of St Nicholas on Lantern Hill reminds us of a bygone time. Since the Middle Ages, a light has shone from this chapel, dedicated to the patron saint of sailors, to guide boats into Ilfracombe harbour.

On the southern edge of the town can be found rugged Cairn Top, a hill looking down on the district of Slade, and they used to say that here the spectre of a murdered Jewish pedlar wandered nightly at Christmas time. It was also claimed that a white rabbit haunted the yard of Holy Trinity church, which was supposed to be the earthbound soul of a person interred therein; there are curious echoes of the 'White Rabbit of Dartmouth' here. F. J. Snell's *North Devon* (1906) links these two spirits, explaining that the pedlar 'wandered nightly in the form of a white rabbit' until a woman called Betsy Gammon discovered the victim's skull and had it buried in the church: 'and there, I believe, it afterwards haunted the churchyard.' Betsy, an old farming woman,

was already a legend in Ilfracombe on account of her raising an army of women, donned in scarlet cloaks, to frighten away four French vessels on 29 February 1797. The Napoleonic forces thought the women – who they saw lining the cliffs – to be the North Devon volunteers in scarlet tunics. At nearby Mullacott, an old man claimed to have opened Mullacott Gates many times to allow a headless apparition past him; perhaps this was how the pedlar's ghost now roamed *sans* skull.

At Ilfracombe's vicarage, a young girl visiting the premises around 1856 chanced to glance into a bedroom and espied 'two beautiful children richly dressed standing in the sunlight'. These had vanished in the time it took to summon the maids, but it was recalled that the vicarage bore a sinister tradition that 'the vicarage children' had been slain by an uncle in a bedroom above the kitchen over a matter of inheritance.

In May 1909, an Ilfracombe spiritualist named R. J. Lees told a conference on the supernatural at Market Hall, Exeter, that he had personally heard of a boarding house in the seaside town that everyone knew to be haunted. *The Western Times* (18 May 1909) reported, 'the story was that in one of the rooms a doctor committed suicide. It was the best bedroom in the house, and the lady who kept it last said it was not a bit of good. It did not matter who she put there, they would never sleep there a second night. It ruined her business; she left the house and the town.'

Hillersdon's Bleeding Hawk

Among the collection of relics at Hillersdon House, a mid-nineteenth-century house in parkland, near Cullompton, there was a mummified, bone-dry hawk, thought to be 2,000 years old and recovered from an Egyptian tomb. The *Exeter & Plymouth Gazette* interviewed Hillersdon's owner, the widely travelled W. J. A. Grant, in January 1924, and he told an amazing story of this bird.

'Just before the Boer War', said Mr Grant, 'I looked in here and found the hawk was bleeding. Spots of blood came up in the form of bubbles on it. All through the Boer War it continued to bleed. The war finished, and, before the treaty was signed, the old hawk was as dry as dust again. It remained dry until about ten days before the outbreak of the last war when bubbles of blood began to appear again. The blood continued to ooze from the mummy until the signing of the Armistice, when it quickly dried up. Only a coincidence of course; but a general who was staying here some time ago said we were on the verge of another bother in the Near East. I went to the case and found the old hawk was dry, and I bet him a hundred to one there would be no war.' There had been no war, and the reporter who examined the hawk's case observed that dried blood spotted the inside lining, evidencing that the hawk must have indeed bled at some point.

Mr Grant died in 1935, and one wonders if the hawk bled then. The last we hear of this remarkable relic is from Theo Brown, who in 1982 noted it was 'back in the house, coffined in a casket made from wood believed to have been taken from Cullompton church, probably at the period of the Reformation.'

As an aside, there is another story of a portentous Egyptian artefact – the gilt mask of an Egyptian princess, purchased by author William Le Queux (*d.* 13 October 1927) in Thebes. This antiquity was some 3,500 years old, and Le Queux brought it home

to Hawson Court, Buckfastleigh. Here he placed it in a glass case, but felt compelled to present it (along with his entire Egyptian collection) to Peterborough Museum following a spate of deaths around him. But now we move forward to consider a home-grown antiquity that has a reputation as the most famous portent in Devon.

Ghostly Legends of Drake

Although Devon has produced many luminaries whose names will forever grace the pages of history books, one person stands out immediately: Sir Francis Drake, Queen Elizabeth I's Vice Admiral, and England's famous navigator and politician. Numerous places here boast connections with Drake: Tavistock, where he was born, and Buckland Abbey, where he lived for fifteen years, being foremost among them. Above all, however, Plymouth is the city of Drake, for it is here he played his famous game of bowls on the Hoe before setting out to destroy the Spanish Armada in 1588. The legend that he finished his game before turning his attention to the Spaniards is possibly true; but if so then Drake's nonchalance must have been at least partly due to a shrewd assessment of the state of the wind and the tide, which would anyway have prevented him from sailing straight away.

Although a hero to the British, Drake remained a pirate and a demon in the eyes of the Spanish until his death at sea off Panama in 1596; at home, the scale of his achievements astonished even the English, and it is no surprise that there are so many supernatural legends attached to Drake in his home county of Devon, where a combination of pride, awe and possibly even a little fear of him produced a fertile mix conducive to home-grown superstitions.

Thus was our hero converted by popular opinion into a wizard, and Anna Eliza Bray records that in her time (early 1800s) many tales of 'the old warrior' were current. One concerned his game of 'kales' (a provincial name for skittles, or, in other words, his famous bowling match) on the Hoe, as the Armada approached. Drake finished the game, then supposedly chopped a block of wood up and hurled the pieces into the Sound. Upon his command, every block morphed into a fire-ship ready to rain 'flame amazement' upon the Armada. On another occasion Drake is said to have determined to bring water to Plymouth, as the citizens had to send their clothes to Plympton to be washed in fresh water. He rode out onto Dartmoor, located a spring, and then whispered a magical incantation into his horse's ear. The beast thundered back to Plymouth, with the stream following its heels all the way to the town: '…the most cheap and expeditious mode of forming a canal ever known or recorded by tradition.' (In fact, this was a drainage project that took nine years, and was completed in 1590, although until the eighteenth century the mayor would ride annually on 31 July to Head-weir in commemoration of the myth.)

A number of traditions associate Drake with the Devil, it being thought he could only have gotten where he had by some satanic pact. Once, they said, while sailing in foreign parts, he had actually had a cabin boy thrown overboard because he suspected the lad had also sold his soul, and therefore might one day challenge Drake's own position of power. Mrs Bray also wrote, 'there is likewise another legend concerning Drake, of which I have heard a confused account: it is something about the Devil helping him to move a great stone, whilst he was repairing certain parts of Buckland Abbey.'

Also at Buckland Abbey, a servant curious to know how 'an extensive building attached to the abbey' was being built so quickly, hid one night in the forks of a nearby tree. He saw, according to Robert Hunt's *Romances Of The West Of England* (1881), the Devil driving teams of oxen during the night. When his satanic majesty tore up the very tree the servant was hiding in, to goad the oxen, the 'poor butler lost his senses and never recovered them.' Another version of this tells how the person in the tree was actually Drake himself, not a servant, who was determined to find out why building materials were disappearing during the night. He observed that a small horde of demons were mindlessly vandalising the renovations, and so, from the tree, Drake emitted a shrill 'cock-a-doodle-do' and then sparked up his pipe. The demons, thinking the glow of the burning tobacco was the sun, scurried away, lest daylight prove fatal to them.

Buckland Abbey is tucked away between Buckland Monachorum and Milton Combe, and was Drake's home for fifteen years from 1580 until his final voyage. It had formerly been the site of a Cistercian monastery, but the place's associations with Drake have ensured that most supernatural events here are firmly linked to him.

There is one stand-alone ghost story, however. T. F. Thiselton-Dyer's *Strange Pages From Family Papers* (1900) notes that 'a few years ago' a small box containing secret family correspondence was found in a closet that been long closed. It was arranged that the box should be taken from the abbey 'to the residence of the interior of the property', but when it was placed in a carriage at the abbey door the coachman could not persuade the horses to move. It was as if they were frozen. More horses were brought, then the heavy farm horses, and eventually all the oxen. This formidable menagerie proved powerless to start the carriage. At length a mysterious voice was heard declaring that the box would never be moved from the abbey. Accordingly it was retrieved from the carriage (easily, by just one man), upon which it was found that the horses were able to once more pull the carriage.

Buckland Abbey's prize relic for those fascinated with the supernatural is Drake's Drum, which is meant to have accompanied him on his journey of circumnavigation. A Victorian balladeer, Henry Newbolt, drew upon legends of the drum, and also the legend that Drake will return when Britain needs him:

> Take my drum to England, hang it by the shore;
> Strike it when your powder's running low;
> If the Dons (Spanish) sight Devon, I'll quit the port o' Heaven;
> And drum 'em up the Channel as we drummed 'em long ago.

In times of national calamity it is said this very drum will be heard rolling, but without anyone near who is actually beating it. The drum is decorated with beads and Drake's coat of arms, and Robert Hunt recorded the first reference to this wonderful superstition in the mid-nineteenth century. He wrote, 'Even now – as old Betty Donithorne, formerly the housekeeper at Buckland Abbey, told me – if the warrior hears the drum which hangs in the hall of the abbey, and which accompanied him round the world, he rises and has a revel.'

A Women's Institute meeting in Exeter in May 1919 was told that Drake's Drum was supposedly heard on many nights before the fateful date of 4 August 1914. The

Buckland Abbey.

ominous noise – announcing Britain's engagement in the Great War – appeared to come from within Buckland Abbey. And a remarkable report in the *Cornishman* (29 June 1916) declares: 'Plymouth folk aver that Drake's Drum has sounded – sailor men have heard it out at sea. It hangs on the walls of Buckland Abbey, situated in a wild spot on the edge of Dartmoor, and has not been heard since the death of Nelson, when it spoke, tradition says.'

Perhaps the most familiar anecdote is the one that the drum was heard aboard the *Royal Oak*, a British naval vessel, on 21 November 1918, when the German High Seas Fleet surrendered. The *Royal Oak* was crewed mainly by men from Devon, and carried a magnificent ensign created by the ladies of the county. Officers watching the surrendering German fleet sail out of the mist first heard a small drum being beaten 'in rolls', and when it became apparent the Germans were not going to offer resistance, attention turned to locating the source of the drum roll. Messengers scoured the *Oak*, but the drumming rolled for hours, emanating from no-where, while the British navy encircled the German fleet about 15 miles off the Firth of Forth. When the surrender was complete, the mysterious noise stopped entirely. Those aboard the *Oak* knew they had heard Drake's Drum, and this story caused a local sensation following its reporting in the *Exeter & Plymouth Gazette* (28 April 1919). Later folklore tells us the drum was heard when the German air raids targeted Plymouth during the Second World War, and on 6 January 1938 this remarkable antiquity came narrowly close to being destroyed itself when a fire broke out at Buckland.

Sir Francis himself is often said to have sold his soul to Satan (some say it was a coven of witches, though) at Devil's Point. Whatever may have been the nature of Drake's dealings with the Devil, we are told that he ended up paying dearly for any earthly advantages he may have received from them in his lifetime. For it is believed that, after death, he was forced to drive a black hearse at night along the road from Tavistock to Plymouth, drawn by headless horses and urged on by running devils and yelping headless dogs. Any household pet dogs that heard this yelping would find it so dismal they would lay down and expire, and here the myth connects with the strange story of the Whisht Hounds, which we shall come to.

Apart from this, Drake's spirit was held by some to drift towards Ashe House, a manor house with fifteenth-century origins and a detached chapel north of Musbury. This was the residence of the ancient family of Drake, although any connection with Sir Francis is questionable. Nonetheless the peasants would tell of 'the wicked Drake' who returned in ghostly form to his beloved Ashe after dying in banishment. When he reached the house, and began to circle it, an exorcism was performed and the spirit was driven away – only to have to start his endless journey back once more. It is possible that the original 'ghost' here referred to an earlier exiled Drake, not Sir Francis himself, but confusion arose because of Sir Francis' death far away from his home. At any rate, as A. H. Norway's *Highways & Byways In Devon* remarks in 1904, 'the slightest sign of incredulity upon hearing stories such as this will instantly dry up the flow of rustic confidence'.

Drake's ghostly presence is also supposed to haunt the Ship Inn, in the claustrophobically narrow Martins Lane, just off Cathedral Yard, Exeter. This, I suppose, is on account of the allegation that he loved this sixteenth-century tavern so much he actually presented the place with a written affidavit confirming as much. At the time of writing, this can be found within the Ship, although it is possible it is a later forgery aimed at promoting Exeter's links with Drake on the same scale as Plymouth. Notwithstanding, what is fascinating about the myths surrounding Drake is that, in the case of Drake's Drum, Theo Brown learned (third-hand) of a gardener who had actually heard the drum rolling by itself around 1915. Even more impressively, ghost expert Peter Underwood's *This Haunted Isle* (1984) makes it clear he had talked to people in Devon who swore they had not only heard but actually seen Drake's fearsome spectral coach.

Unearthly Screams at Hillersdon

There had always been a tradition of a brutal murder told by the inhabitants of Hillersdon House, the mid-nineteenth-century house near Cullompton referred to earlier. Sometime in the late 1700s a woman had been slain in the part of the park where the keeper's cottages once stood, and the murderer, in his insanity and dressed in his night attire, had dragged the body to the giant Fish Pond in Alder Grove, dumping it in the water. Horrific shrieking was said to have been heard for decades afterwards, caught on the wind in the park, but by the turn of the twentieth century these ghostly echoes of bloody murder were but a distant memory.

However, sometime around 1927, the phenomenon resurrected itself and terrified Lady Scott, widow of Admiral Sir Percy Scott, who would ever after recount a bizarre brush

with the paranormal. Lady Scott had been invited to a party at Hillersdon by her cousin, and, arriving late, had to sleep in the only available bedroom – the Green Room. Sinister rumours were connected to this room, and it had not been occupied for thirty years.

In telling the story, Lady Scott would explain how she had found herself fully awake in the middle of the night, with an overwhelming sensation that something horrible had happened. After peeking through the bedroom's curtains, she satisfied herself that nothing was amiss, and was on the point of drifting off again when a shrill scream rent the air. The screaming continued, and Lady Scott later described it to the *Western Gazette* as 'the most terrible sound I have ever heard – a ghastly combination of utter desperation and agony, piercing and long drawn out'. The sound froze her blood, and she once again went to the window and out on to the veranda to look into the park, which was illuminated by the moon. She stood in utter fright and watched 'a tall white figure' out in the park to her left moving steadily to the right, from which point the shrieks emanated. The screams became louder and more appalling, until Lady Scott collapsed in a dead faint at the spectacle.

Here her adventure ended, leaving her with a mystifying and thrilling story that she would often recount years later.

The Hands of Dartymoor

The massive tract of country called Dartmoor (or, as the local colloquialism termed it, 'Dartymoor') has always had a certain atmospheric romance about it. In places, the hills can be so high that some of them are like mountains, bejewelled by a number of picturesque streams and sparkling waterfalls, and also by a great many rocks, some standing alone and others piled on the top of the heights in such an odd way that they look like the ruins of castles or towers built by giants in a time lost to memory. These are called 'tors', and they are sometimes so lofty that the clouds hang upon them and obscure their heads. And what with it being so large and lonely, and its having less trees than one would think, Dartmoor is altogether a grand and wild place. The Tavistock writer Mrs Anna Elizabeth Bray observed,

> It is nothing wonderful that such an extensive waste of the moor, so full of rocks, caverns, tors, and intricate recesses, should have been, in all ages, the chosen haunt of banditti (criminals); and in former days they did not fail to avail themselves of its facilities for conveying away plunder, or for personal security against detection; whilst the gentry of those times, unless in a numerous and armed company, feared to cross the moor, so dangerous as it was known to be from lawless men, and so reputed to be haunted by the spirits and pixies…

The moor can evoke these same sensations to this day, in the right conditions, and one wonders what Mrs Bray would have made of the most famous supernatural entity here, emerging as it did thirty-eight years after her passing on 21 January 1883. For this concerns the aforementioned 'Hands of Dartmoor', a tale that has never really faded from public consciousness in the area and one that in many ways seems to encapsulate

all that is mysterious about this part of the world. The phenomenon first attracted public notice over ninety years ago, when the *Western Daily Press* (9 October 1921) reported:

> In June, a medical officer at Dartmoor Prison was riding his motorcycle across a wild moorland road from Two Bridges to Postbridge. He had two children in the sidecar and as he drove down towards the bridge crossing the East Dart he suddenly shouted to the children to jump clear. They managed to scramble clear as the motorcycle swerved off the road and was smashed to pieces. The doctor was killed instantly. Last week, another motorcyclist was riding home on the same road. He arrived in a dazed condition and his motorcycle badly damaged. Requesting that his name was not published but insisting his story was true, the man told our reporter, "As I drove down the hill I felt a pair of rough, hairy hands close over my own on the handlebars. They dragged me off the road. I remember nothing after that until I regained consciousness and found I was lying very close to the spot where the doctor had died."

This deadly supernatural entity also seems to stray from the road. The folklorist Theo Brown's mother recalled how, in 1924 during a caravan break by Cherry Brook, she witnessed the fingers and palm of 'a very large hand with many hairs on the joints and back of it' outside the caravan. It crawled up the window, towards an opening, but at the terrified utterance of a prayer it slowly sank back out of sight. It has been theorised that this weird apparition might have been the spirit of some Stone Age inhabitant who resented the intrusion of motorists upon his happy hunting ground. Intriguingly, a correspondent to the *Western Times* (21 September 1928) wrote: 'On Tuesday morning last a party of us who were motoring across Dartmoor were interested in some notices on each side of the road not many miles from Moretonhampstead with these words in large print: Beware of death by the hairy hands.'

I can personally testify just how dangerous the driving conditions can become along this stretch, when the mist clings to the road surface and rain is pelting your windscreen in the gloom of a Dartmoor dusk; but the story of the 'Hairy Hands' is one that might actually have a precedent even earlier than the advent of the automobile, for if one continues along the B3212 and through Princetown one traverses the Devil's Bridge, at the spot where the Plymouth milestone stands. Although some say that the bridge earned its moniker through a Victorian workman's nickname, a 1933 record of Dartmoor Prison refers to the bridge as being 'of evil fame' but without explaining further. It is here that three soldiers were overtaken by a blizzard on the evening of 12 February 1853, two perishing at the bridge itself and a third expiring near the former Duchy Hotel in Princetown. Of this area, there is a singularly suggestive report in the *Royal Cornwall Gazette* (21 June 1888) of a pony – 'usually a very quiet one' – being 'frightened in some way in the middle of a hill' near Princetown. It bolted, dragging the carriage it led, forcing the occupants to leap for their lives. One, twenty-five-year-old Miss Downing, of Penzance, Cornwall, landed on her head and was fatally injured. Her mother was also seriously hurt in her endeavour. Could this accident have been due to an early appearance by the 'Hands'?

This stretch of road appears to have had an eerie reputation historically; whatever the case, the 'Hands' is a legend that the local media occasionally revisits. The suggestion is

The haunted route at Cherry Brook along (what is now) the B3212.

always raised in the advent of a single-vehicle traffic accident, and a trio of such accidents along another stretch of Dartmoor road has lately (2011) prompted the observation in a local periodical that the Hairy Hands phenomenon might have relocated entirely. I have also been told by a friend, who hails from Buckland Monachorum, and is very familiar with Dartmoor, that he heard the origin of the Hands was different to the supposition they belonged to a Stone Age inhabitant. He understood the phenomenon started following a disastrous explosion at Powder Mills, a gunpowder-making factory, the remains of which are visible from the B3212 at Cherry Brook. In the blast, one of the fatalities concerned a man who was almost vaporised, apart from both his hands, which remained largely intact. These subsequently materialised on Dartmoor, and (for unknown, supernatural reasons) targeted those very drivers who, as reported, lost their lives in lonely, unexplained accidents.

A Church Vision

Turning north to Combe Martin, there is a story collected by the Devonshire Association in 1932, which indicates that if ghosts are real then perhaps they have to be seen by someone 'sensitive', while others not imbued with this ability remain oblivious.

A member, Miss Close, reported that an artist friend of hers had been visiting St Peter's church in August or September 1921. This lady had attended evensong and was enjoying an organ recital afterwards, when to her utter amazement she beheld a door in the screen open and a procession of people enter the church.

That these were not ordinary people was very clear. They were dressed in medieval clothes, and a bishop wearing a mitre and wielding a crosier headed the procession.

He wore a long straight gown of cream and gold. Several priests in the same colours followed, and next came six sturdy-looking men carrying a 4-foot-wide tray. This bore an image of a walled city that looked to be made of fawn-coloured wax. Courtiers, ladies and, lastly, peasants, followed, and when it was all over the witness realised that no-one else in the church appeared to have seen this ghostly vision – begging the question as to whether these phantom replays are all around us, but it takes a very special person to physically see them.

The House that Killed Itself

Lovehayne, a farm situated in a hollow 1½ miles from the Honiton–Seaton road in the parish of Southleigh, and nestled west of prehistoric Blackbury Camp hill fort, was long believed by the owners to be haunted.

In 1932 the place was occupied by a family named Dare, although the parents had moved to Dalwood and left their sons as sole inhabitants there. Both men firmly thought the place had a paranormal presence: upon retiring to bed they would hear in the stillness sounds of another era, such as the rhythmic ticking of an old clock (which they did not possess) or muffled footsteps moving about the corridors. This sensation became so unnerving that when one brother was away, the other refused to sleep there by himself, and so it happened that – because of this circumstance – Lovehayne found itself unoccupied on the night of Tuesday 5 January 1932.

At about 8 p.m. the remaining Dare, who had opted to stay with a neighbouring farmer in his brother's absence, spotted smoke rising from the direction of Lovehayne, and rushed to the place to find it ablaze. Seaton Fire Brigade responded very promptly but were unable to save the house, which was very old and of thatch. However, they did manage to save the outhouses and ricks nearby. Reporting on the incident, the *Western Times* observed that the origins of the fire were a total mystery. The blaze had evidently started in a beam, and may have been smouldering for some time, but it was almost as if the house had spontaneously combusted in an attempt to destroy itself – if it had been occupied then the accident would (quite naturally) have been blamed on one of the Dare brothers, but because Lovehayne was demonstrably empty at the time, we can only guess why and how this 'haunted' old farm suddenly burst into flames…

Historic Haunted Buildings

Like Lovehayne, certain old buildings lend themselves quite naturally to ghostly legends, often by the very nature of their antiquity, prestige or remoteness. At Honiton Barton, a seventeenth-century farmhouse west of South Molton, people whispered for generations that a mysterious cowled figure could be glimpsed in the coppice beyond Pond Meadow, where there was formerly a small fish pond. The spectre was believed to be that of a monk connected to a nearby medieval chapel, who guarded a hidden chest of money and precious stones.

Sixteenth-century Court Hall, Sidbury, incorporates the remains of an Elizabethan mansion and reputedly has a 'haunted chamber', in which a human skull was at one point discovered beneath the floorboards. This grim relic was found a few years prior to rebuilding work in 1856, immured under the flooring of an upper room. The Sidmouth historian P. O. Hutchinson was privy to this discovery, and noted that the skull bore a hole over the right ear that appeared to be the death injury, and also that the remains were considered that of a woman. Generations of inhabitants at Court Hall knew of vague stories that 'apparitions of a supernatural nature' haunted that specific room – although Hutchinson suggested that perhaps these rumours originated with the murderer himself so as to keep the inquisitive from potentially discovering the skull of his victim. No other remains were uncovered during the building work.

In 1890 a sensational story did the rounds concerning allegations that Eveline, Countess of Portsmouth, had been awoken by a clammy hand in the middle of the night while staying at Eggesford House, near Wembworthy. By candlelight, she had allegedly conducted an interview with a ghost that had awoken her with its cold touch, and the story (when reported in the periodical *Whirlwind*) was, for a while, the talk of Devon. So much so that the countess was forced to deny it: 'But alas! Eggesford House has never been visited by so interesting a guest as a ghost!' Castellated and grand, the house – which had stood since around 1820 – was an abandoned ruin by 1911. Now partly restored, it is a private dwelling.

Old Forde House, a beautiful sixteenth-century residence near the Torquay Road in Newton Abbot, now functions as the most elegant of wedding and conference venues; however, in the days when it was a genteel residence owned by the Reynell family, a dastardly crime is meant to have occurred here. A Stuart-era ward named Cecilia Drew, convent educated, was supposedly murdered by a member of the Reynell family for refusing an offer of marriage and immured in a standing posture in the wall of the house. This was the explanation for allegations that a ghostly figure like a nun haunted the house. However, according to Lady Amy Bertie, a resident whose story was told in the *Western Times* in 1932, she had herself never spotted anything remotely ghost-like in twelve years there; yet nonetheless she felt inclined to test the truth of the story by opening the walls up in the hunt for Cecilia's skeleton. This, she asserted, she would have done if she personally owned the place!

South-west of Barnstaple, Brynsworthy House was said for generations to be haunted by the ghost of a former Squire of Brynsworthy. At midnight, he materialised in the drive leading to the house riding a white horse and holding a glass of wine in one hand. In 1933 it was reported that a disastrous fire had overtaken the house, although curiously the only room that was not entirely gutted was the drawing room. In this room, at one end, the phantom squire had a reputation for appearing frequently before guests and owners alike.

Maybe any owner of a historic Devon home has a long way to go before they can beat the experience of the Revd W. R. Dunstan, incumbent vicar in the ancient little village of Spreyton, on the northern border of Dartmoor. He lived at the seventeenth-century vicarage (now privately owned), adjacent to the Norman church of St Michael. By 1932 both the vicar and his wife had heard heavy footsteps and thunderous crashes within the property, although Revd Dunstan remained pragmatic; perhaps he was forced

to think twice when he took photos of the vicarage that showed, when developed, 'in the foreground distinctly defined shadows forming the outline of a cowled monk'. This strange figure appeared on two negatives, and in each case the 'person' appeared to be in a kneeling position some five or six feet from Mr Dunstan, and clad in a flowing robe. The figure's cowled head was quite distinct. The reverend knew, without question, that it was not his own shadow that had been cast, due to the position of the sun, and experts who examined the photos (and the box camera he had used) found no possible explanation.

The vicar's story, reported in the *Western Morning News* (15 July 1933) and elsewhere, remains a mystery.

Aveton Gifford's Phantom Ferryman

Hidden in the archives is the story of an almost forgotten haunted building, in the shape of the Old Ferry House, near Aveton Gifford Bridge over the River Avon at Aveton Gifford. This is yet another haunted spot closely associated with water, for there is a tidal road beside the Avon Estuary Walk.

By December 1934, the Dobell family had lived here thirty-three years, conducting a hand-weaving business. Their home was originally the ferry house, tenanted by a ferryman until sometime around 1800, when the land was reclaimed and the position became obsolete. Prior to this, there was no bridge and people used to ferry across at high tides or ford the river using stepping stones at low tide.

The Dobells had heard a story that, long ago, the landlord of Old Ferry House had blocked up a door to a flight of steps that led to the ferry. In addition he also constructed another door elsewhere and facilitated the walk to the ferry with a mere slope. This so incensed the tenant ferryman that, after his death, villagers swore that his ghost periodically visited the house armed with a crowbar, to check whether later tenants had placed any obstruction up against the wall where his beloved door and steps had been. In showing a reporter from the *Western Morning News* round the oldest part of the house, Mr G. Dobell explained that one Saturday the family found an immensely heavy cupboard, full of crockery and so tall it almost touched the ceiling, had somehow moved by itself towards a window, and shifted itself 18 inches from the wall. This cupboard had no floor compartment, merely crockery and old tins resting on several layers of newspaper at its bottommost extremity, and amazingly this had all moved along with the rest of the huge piece of furniture, the whole remaining intact and undisturbed. The cupboard weighed nearly half a ton, and had moved sometime between 1 p.m. and 2.30 p.m. This poltergeist-like entity was also blamed for meddling with the looms, mysteriously attaching spools to them.

The old house was thought to have other ghosts: a servant who hanged himself over the kitchen stairs, and a dying man who expired across his windowsill while shouting curses at his neighbours from the window. The Dobells confirmed that 'at various times the villagers have declared they had actually seen the ghosts'.

Here it might be considered that if the Dobells were 'inventing' paranormal phenomena for some unknown reason, they might have invented something a bit more impressive than a moving cupboard. They gained nothing by their disclosure to the

newspaper, and were genuinely mystified by the incident, going so far as to check the cellar for cracks and subsidence for an explanation. In some cases, it is the random pointlessness of it all that impresses the most: for the paranormal inhabits a strange realm, where sometimes the more mundane an incident is, then the more believable it can appear as a genuinely unnerving psychic phenomenon.

Phantom Domiciles

If people can return as 'ghosts', and by association animals, is it just possible that buildings of bricks and mortar can also, from time to time, display themselves in phantom form? As we have seen at Sampford Peverell, there is a suggestion that Ghost House might have reappeared after its destruction. And this phenomenon, if it be 'real', seems to favour Devon more than other British locales.

There are old stories with this theme. One ancient legend speaks of a wicked priest and his clerk visiting Dawlish to enquire after the ailing Bishop of Exeter, who was convalescing there. Somewhere in the vicinity of Great Haldon (where there now can be found Exeter Racecourse) the priest and his clerk lost their way, and so he summoned a demon familiar to help. There immediately appeared a simple peasant, who led the pair 'down the steep to the manor house' where a retinue of serving men waited to serve the priest hand and foot. During his stay the wicked priest received the news that the bishop had finally expired after being poisoned, and he made plans to get to Exeter as soon as possible – for he wanted the bishop's job. He was only too glad to leave his mysterious hosts, too, for the seas out in Babbacombe Bay were whipping up tremendous storms that were on the brink of flooding the manor. When the priest and his clerk left, 'the demon house vanished amidst screams and wild laughter as of fiends mocking'; their temporary abode had not been of this earth. It only remains to be said that, somehow, their stay at the phantom manor house had doomed the priest and his chaplain, for they vanished off the face of the earth after setting out, and their two horses were found wandering on the shore by themselves. However, the souls of the priest and his clerk resided ever after in the weathered rocks and stack on the coast of Holcombe at Hole Head, called the Parson and Clerk. The historian and traveller Mackenzie Walcott wrote in 1859, '...when the storm wind blows, the cry of the imprisoned spirits is heard quivering on the gale'.

What might have been a ghost cottage – complete with spiritual occupants – was discovered by three girls who had become separated from their father during a shooting expedition on Buckfastleigh Moor. In the gloom of dusk, they found a roadside cottage from which the inviting warmth of firelight danced within. Looking through an un-curtained window the three girls saw an old man and woman sitting crouched over the fire; and then in full view the entire scene simply evaporated and the girls found themselves stood alone in the darkness of night. This weird story is told in John L. W. Page's *The Rivers Of Devon* (1893), Page adding that after they returned home the girls made enquires about the house and were told locally it was well known and called the Phantom Cottage of the Moor. It had a nasty, evil reputation, and Page made efforts to find any evidence of it himself but without success. He had received the story first-hand from one of the girls concerned, and comments: 'Whatever sceptics

may think, there can be no doubt from the language employed that she really saw, or was under the impression that she saw, a very ghostly sight indeed.'

Despite its fairy-tale-like element this is a bizarre type of ghost story that has been repeated in other parts of Devon. Ruth St Leger-Gordon's *Witchcraft And Folklore Of Dartmoor* (1972) explains that there were numerous alleged sightings of a phantom cottage in a wood near Haytor Vale, possibly Yarner Wood. Haytor Down is a mystic landscape, peppered with prehistoric hut circles, settlements, cairns and wind-blasted tors like Haytor Rocks, as well as lonely – but spectacular – Hound Tor. The cottage was denominated 'phantom' because it simply could not be found when looked for a second time; a number of unconnected witnesses had experienced this mystery for themselves. In at least one instance it was glimpsed in the trees from the lane that skirted the tree line. Most remarkably, a surveyor working on the OS layout spotted the cottage from a high vantage point, and even reported smoke drifting from the chimney and clothes hung up on a washing line. This bemused him utterly, because he could not understand how the cottage had been so thoroughly missed in previous surveys of the wood. He walked down to the place where he had seen the cottage, only to find that it could not be located, and in asking a woman out walking her dog for help he was told that she also had seen the mysterious building, but had been unable to find it again. The wood's owner was actually forced to deny a cottage existed there. Ruth St Leger-Gordon herself scoured Haytor for the cottage, but found nothing – not even foundations that might have indicated a cottage once stood in the vicinity.

The Edwardian spiritualist and ghost hunter Elliott O'Donnell mentions in *Haunted Britain* (1948) that he knew of two ladies who had found a most charming cottage within walking distance of Chagford; when they enquired after accommodation there they were told the place was presently full and so asked to reserve rooms there the following summer. When the time came around, the cottage had disappeared entirely, and in response to the enquiries local people told them that it was, in all probability, a phantom cottage.

It was well known that these phantom cottages displayed themselves only once every ten or twelve years. Nor did these phantom buildings need to be in Devon's remote countryside. Elliott O'Donnell himself believed he might have stayed in a phantom hotel in bustling Plymouth. He chanced to stay in the city, and found one in the vicinity of Millbay; when he entered there was a surreal atmosphere and 'in the vestibule I encountered an official whose face I seemed to know, and although I had never been inside the building before, it struck me as strangely familiar'. Later, he wrote:

> I hoped to stay there again. But now comes the strangest part of all. When next I visited Plymouth, a year or so later, that hotel was nowhere to be found. There was no building in the least degree like it in the street in which it had stood, and although I made endless enquiries of endless people, for I remembered every detail concerning it, no one to whom I described it had ever heard of such a place…

Theo Brown was aware of other locations where ghost cottages materialised: a large old manor house and garden displayed itself at Doccombe near Moretonhampstead for the benefit of a witness who knew there to be no such building, and another was

rumoured to appear three times a year near Cadeleigh. Most impressively, in 1965 she received correspondence from a former resident at Start House, west of Slapton, who had seen a great manor house with big, arched doors while walking near Battle Ford with her sister in November 1939. The encounter happened on a misty and damp afternoon. The witness knew, beyond doubt, there was no such building hereabouts, and in her letter to Ms Brown she explained:

> You ask how I know it was not real? Well of course I knew the country so well, having walked there dozens of times, and I knew there was no house there. Also it did not look real. It is difficult to explain, for although the house was perfect, yet it had no substance. That is the best description that I can give. We saw no people, although we longed for the great doors to open and for people to ride out.

Needless to say that she walked the route with her husband when he returned from the war, and found there to be no building there whatsoever.

Leaving aside the obvious answer to the riddle of Devon's phantom buildings (that in each case the visitor could not find the dwelling because they were simply looking in the wrong place), if such things really can exist then we have a mystery that is multi-layered. Does this mean that the phantom-replay type ghost also extends to places and buildings, as well as people? If so, why is there a suggestion that, in some cases, visitors actually interact with the occupants of these dwellings? Why are no foundations ever found in the vicinity of the sighting? Could it be, as some researchers have suggested, that these are future echoes of buildings that do not yet exist? If so, and the phantom cottage really does appear every ten years, then keep your eyes peeled – it would seem to be due an appearance at any time. Maybe it is even being built as you read this book!

Uneasy Presence At Powderham Castle

Powderham Castle is a beautiful Devon landmark, picturesquely situated in Deer Park by the Exe and remarkable for having stayed in the same hands since its inception in the late 1300s. In July 1938 the *Western Morning News* ruefully observed that the castle possessed no spectres, although Lady Gabrielle Courtenay, daughter of the Count and Countess of Devonshire, could tell a curious story. She explained for the benefit of visitors an occasion when her mother, newly arrived at the castle, felt uneasy in the room that she was allotted. She tried to ignore it but in the end the sensation became so great and so unnerving that she was forced to move to another room. Not long after, the ceiling beam that hung over the bed was found to be dangerously unsafe. From this, Lady Gabrielle would observe, 'If there is a ghost, then we are sure he or she is kindly disposed.'

However, the weird story of a Mr G. L. Godbeer would indicate there very definitely are ghosts hereabouts. Around 1919, as he told the same newspaper, he had been walking in the castle grounds with the church rector. Godbeer saw two figures very clearly in the evening gloom, although he couldn't identify them and thought them possibly his wife and daughter, come to meet him on his sojourn. This was not the case (his family were at home), and the strange figures, also seen by the rector, vanished

Road past Powderham's church.

in the blink of an eye. Three weeks later, Godbeer's daughter died and was buried in Powderham's cemetery.

St Clement's church can be found nearby, within spitting distance of Powderham Sand. On 6 February 1939 the *Western Morning News* reported that an Exeter man had stopped his car a few evenings earlier because he had seen the shrouded figure of a woman standing in the middle of the roadway, draped in a black cape. Thinking her in distress, the man watched aghast as she simply disappeared in front of him, and in a state of utter mystification he searched in vain for her. He never found any sign of anyone, although he thought he might have briefly glimpsed a figure slipping through the churchyard gate as he got back in his car and drove off again.

Post-War Mysteries in Plymouth

Wartime has, in the past, proved fertile ground for allegations of paranormal occurrences. This was even so during the Second World War, when Britain was a much less superstitious nation than it had been. For instance, the *Daily Mirror* (22 November 1940) reported a mysterious story, of which the date is unclear:

> There have been a number of accounts of "Phantom Armies", notably the report by a retired Lieutenant-Colonel in Devon who, while out walking with his dog, saw a

misty group of figures marching in the direction of Dartmouth who he was convinced were a troop of soldiers kitted out for embarkation.

Three years after the end of the Second World War, three men engaged in dismantling a derelict tank landing craft at Queen Anne's Battery, Cattedown, Plymouth, were alarmed by strange noises as they worked through the night. Unnerving footsteps could be heard echoing from the steel superstructure, and knocking sounds emanated from the cabin bulkheads. In late October 1948 one worker, upon hearing the footsteps, threw open the door of his cabin and saw, 'Nothing wearing something float by', which aptly described the semi-visible form passing him.

Just across the Cattewater, there was another wartime ghost that haunted the Royal Air Force station at Mount Batten. This place later became home to Mount Batten Sailing & Watersports Centre, which opened on the site of the former sergeant's mess, but in 1948 it was a Maintenance Unit and former air station for seaplanes. The sick bay was reportedly haunted by the ghost of an airman dressed in full flying kit, who had been both seen and heard in the post-war years; he was said to be a member of an air crew that had been shot down, and whose bodies had been placed in the mortuary at the air base. The interesting thing about these ghosts, reported in the *Western Morning News* of 2 November 1948, is their immediacy. For these were ghosts whose appearances allegedly came no more than a few years after their earthly deaths, which is markedly different from most haunting episodes. Perhaps again it says something about the fertile atmosphere of war being conducive to the quick appearance of such spectres.

The Man in the Overcoat

Prior to the opening of the M5, the A38 (also called the Devon Expressway) formed the main 'holiday route' for tourists from the midlands heading to the southwest. Following accounts in the *Western Morning News* in 1970 that a strange figure in a long grey coat was being spotted along the A38 near Taunton – its reckless behaviour was causing near-accidents – it came to be speculated that this figure might be a ghost, since he appeared to have always vanished utterly when road-users stopped to remonstrate with him.

The rumours prompted a long-distance lorry driver called Harry Unsworth to come forward with his own tale of ghostly terror, which has now become one of Devon's classic urban legends. Twelve years earlier, in 1958, Unsworth claimed that he was driving back to his depot in Cullompton at about 3 a.m. when he glimpsed a man stood by the side of the A38 in the vicinity of the Blackbird Inn, east of Wellington in Somerset. It was raining heavily and the stranger was drenched, so Unsworth took pity on him and pulled over to give the man a lift. He noted that his new companion held a torch, and was dressed in a cream or grey mackintosh. The man was middle-aged, and asked Unsworth in a well-educated manner if he could be dropped off at Beam Bridge, near White Ball on the Devon/Somerset border. While travelling, Unsworth's new companion regaled him with ghoulish stories of the accident rate along this stretch of the A38, and when he dropped him off Unsworth was not sorry to see him go.

One view of the Cattewater, Plymouth.

Former Air Force Station, Mount Batten, Plymouth.

Despite his misgivings about his passenger, this situation repeated itself a few days later, again in driving rain and at around the same time in the morning. About a month later, Unsworth saw yet again the familiar man by the roadside, waving a torch in the pouring rain, and once more stopped to pick him up.

This time, the mysterious passenger asked that Unsworth wait at Beam Bridge while he collected some cases, and Unsworth complied; however, after twenty minutes sitting waiting for the man to reappear, he gave up and started along the A38 once more. However, some 3 miles further up the road he once more saw the familiar figure waving his torch by the roadside near a transport café, and now the hairs on his neck began to stand up. Unsworth knew full well that no-one could have walked that distance in such a short time, and also that no other vehicles had passed that way which could have collected the man. He opted to drive past him, but the hitcher, in a suicidal manoeuvre, flung himself in front of the lorry. Collision was inevitable, and Unsworth slewed his vehicle to a halt a few dozen yards further on. He jumped from the cab expecting to find a corpse in the road but there in the middle of the A38 stood the sinister hitcher, fully alive, gesticulating, shaking his fist and swearing at Unsworth. This figure then turned his back on the terrified lorry driver – and utterly vanished.

Unsworth got back in his cab and drove away as fast as he could. Periodically, this story resurfaces with rumours and allegations of fresh sightings of the torch-wielding man in the overcoat, but Mr Unsworth's encounter remains the definitive one, and was originally reported in the *Exeter Express & Echo* (12 August 1970).

The Phantom Perambulation

Hunter's Tor is another gargantuan Dartmoor pile, surmounted in a lofty position near an ancient fort, and offering impressive, blustery views over North and East Dartmoor National Park. In 1958 Miss Lois Deacon collected a curious story from a friend, Mrs Brackenbury, of the Ring of Bells Inn, North Bovey, for the Devonshire Association. The account (which appeared in Volumes 91–92 in 1959) explained that Mrs Brackenbury and a friend had been riding via Hunter's Tor at the entrance to Lustleigh Cleave when both saw very clearly 'a string of richly caparisoned riders ahead of them on the bridle path; and some men on foot, greyhounds etc'.

All wore clothing of a type not recognisable, and both women had no idea who the mysterious group could be. Imagine their surprise when 'the riders and horses advanced to the edge of the wood, and there they just disappeared.' Stuck for an explanation, Miss Deacon intelligently suggested they may have witnessed ghosts engaged in a phantom '1240 perambulation' – this being the medieval survey aimed at recording the exact boundary of the Forest of Dartmoor.

Sea Yarns

Devon has its share of sea yarns, quite naturally because of its two coastlines – the northern, which looks out over the Bristol Channel and towards the Atlantic, and

the southern, which abuts the English Channel. Stories of shipwrecks are legion, even of deliberate wrecking by communities of ruthless villagers; but some stories are downright eerie.

Revd George Tugwell, in his *North Devon Handbook* (1857), makes a fleeting reference to a ship that sailed into Lee Bay, west of Ilfracombe, devoid of crew or any other signs of life on board. Another strange story is noted in *Chambers' Journal* (1890):

> Only some fifty years ago [i.e. *c.* 1840) the captain of a revenue cutter reported that he had passed at sea, off the Devonshire coast, a spectral boat rowed by what appeared to be the ghost of a notorious wizard of the region. The question is, how did the revenue skipper know that the boat was a spectre? He does not seem to have boarded her.

Strange rumours were abroad in Dartmouth in February 1849. For two months, 'dock-yard lighters' had been unsuccessful in their attempts to raise the wreck of the schooner *Marian* off Dartmouth. On one occasion they lifted her and she was moved 50 yards from her original position when the chain cable 'of one ½ inch bolt' broke – the fourth time such an accident had happened. Many blamed the lack of success on the ghost of a certain 'Old Jeffries', who had killed himself at Slapton a year or so earlier, for his ghost was said to reside at the bottom of Start Bay. This spirit filed the links in the chain beneath the water, causing them to snap, all the while crying beneath the waves, 'Ten a penny and two over!' The *Western Times* (3 February 1849) reported that lately a diver had come from Plymouth, 'with his dress and machinery' to enable him to stay beneath the water long enough to see why the chain kept failing. In the gloom beneath the surface, however, a strange noise frightened him back to the surface after four minutes, whence 'he declared he would not again venture in such company.'

It is a strange fact that a ghost was blamed for scuttling a sloop, the *Dispatch*, near what was called locally the Shallow Path off Ilfracombe in 1851. As reported in the *North Devon Journal* (27 March 1851): 'The master who bought the vessel, and the pilot who lost the vessel, both protest their belief in the presence on board of its late owner, whose mortal remains were long since committed to mother earth.' At sea, nothing worked right aboard the vessel, with chains and ropes somehow holding fast as though frozen; even the very anchor refused to obey the laws of gravity and drop to the bottom of the ocean. This ghostly visage was seen 'bestriding a horse' on the bows before supernaturally taking control of the ship and dragging her onto the rocks.

Sea communities, understandably, have always been prone to superstition, and an example of this was illustrated in September 1946, when the *Western Morning News* reported on the recent gales that had thrashed Brixham. On 20 September, the cutter *Bamba* had broken adrift; but despite the tempestuous seas she somehow managed to avoid smashing into any of the other yachts in the harbour, and was even lifted miraculously over the jagged remains of the fishing smack *Silver Lining*, which had been sunk during the war. Despite some damage to the hull, no water had (somehow) gotten in, and the *Bamba* remained largely intact, when it should have been utterly destroyed. This deliverance the Brixham fishermen ascribed to a 'phantom skipper on board.'

There is latterly a story, told along the southern coastline, of two boats attempting to rescue a vessel in distress off the Devon coast in crashing, booming seas in 1959. The vessel was observed to be a Second World War landing craft, flying the Cross of Lorraine, symbol of the Free French forces. However, a gigantic wave obscured the mysterious ship from the rescue boats, and they could not catch sight of it again: the implication being it was a phantom echo of a wartime casualty.

The Phantom Ladies Who Wander the Landscape

At Lew House, the seat of the Gould family at Lewtrenchard, there was once rumoured to be a famous earthbound spirit. This ghost was known as the White Lady, or the Old Madam, and thought by some to have been in life Margaret Gould. Margaret came into the estates in the eighteenth century as a widow, and eventually died sitting upright in her favourite high-backed chair. Her heels were heard tapping in the great gallery, and her figure (in white with drops of water glistening in her hair) allegedly haunted the family, their servants and the neighbours.

There are many other reports of phantom ladies, often identified by a colour scheme as Mrs Gould's ghost was. For example, a certain Paignton Cottage in Crediton was believed to be haunted by a Blue Lady in the early nineteenth century. The spectral woman was tentatively identified as the loving sister of Robert Emmett, a leader of the United Irishmen who staged a rebellion in the late 1700s. The ghost's bluish appearance was explained thusly: following her brother's execution, Emmett's sister became subject to epilepsy and a doctor prescribed a dangerous medicine that altered

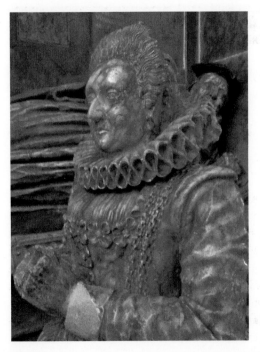

This glassy-eyed 'White Lady' in Tavistock's church is, in fact, Alice Skirret, wife of Judge Glanvill.

her complexion. She took to wearing a blue veil to disguise this, but it was not clear when or how she came to be in Crediton; although this was the story told by the later occupiers of Paignton Cottage, William and Grace Hazlitt, in the early 1800s.

Elsewhere, there can be found a sixteenth-century farmhouse called Bush House – claimed to be the largest house in the village of Spreyton. Some idea of its antiquity can be gleaned from the suggestion that it existed in the days before any tavern here, a 'bush' being hung outside to indicate that liquor could be found within. In the 1930s the place was notorious for having a ghost called the 'Lady in the Black Silk Dress', who (according to a report in the *Western Times* of 7 July 1933) terrified two girls staying there in 1930. According to tradition, she would emerge from a very old cupboard in one of the bedrooms, her silken dress rustling loudly, and if anyone had the nerve to follow her she would lead them to a vast sum of money stowed away somewhere in one of Bush House's nooks and crannies. Unfortunately for the owner, Miss Hopkins, the only cash ever found was an Exeter half-penny dated 1792 that had been unearthed in a rubbish heap.

A story collected by the Devonshire Association in 1935 alleges that Bow Bridge, west of Hartland and crossing Abbey River, was haunted by two white lights, which, when approached, turned out to be the wraiths of two headless women. (I wonder if this story is at all connected to nearby Ladies Walk Wood.) And according to the *North Devon Journal* of 24 December 1957, locals were hoping for a glimpse of a phantom White Lady who was said to be haunting Abbey Lodge, a building in Pilton, Barnstaple.

Curiously, one of Devon's most famously haunted places also concerns one of its most vaguely substantiated ghosts. Betsy Grimbal's Tower, still standing in Tavistock despite nearly all the rest of the town's abbey being destroyed, is supposedly haunted by Betsy herself. Who she was is not known, but some suppose she was killed here, having set her affections on a monk who thus requited them. Others claim the ghost is that of a woman fatally shot on the spiral stairs while fleeing a soldier; her bloodstains could still be seen here at least as late as 1859, according to a contemporary writer, M. E. C. Walcott.

During a talk with a youth group from Tavistock, the folklorist Theo Brown was told that 'Betsy' was held to gaze sadly from one of the upper tower windows, and it was claimed she had been witnessed a day or so before the Aberfan tragedy in 1966 – lending this ghost a dismal reputation as a portent of a national calamity.

The Most Haunted Place in Devon?

Berry Pomeroy Castle, a late fifteenth-century Grade I listed building, stands in Castle Wood, northeast of Berry Pomeroy village and west of Paignton. The castle is seated on a high ridge, but is largely a ruin: the ivy-mantled walls, the great gateway, the round tower of St Margaret, the south Tudor front, and part of a Jacobean court are full of rents, unroofed and open. This is all that survives of a once vast and sumptuous structure originally begun by a Norman knight, Ralph de Pomeroy, and held by his descendents until 1547 when it passed to the protector, Somerset, and thence to King Edward VI.

Legends abound here. It is said that during the Western Rebellion in 1549, the two sons of Henry Pomeroy, under siege at the castle, blindfolded their horses and rode

them to a catastrophic death over the lip of the glen into what is now called Pomeroy's Leap. This would appear to be historically inaccurate, however, and Victorian writer W. H. K. White's *Picturesque South Devonshire* recorded a variant version of this legend: 'Among old tales of other days is one relating to a certain intrepid Pomeroy, who, towards the end of a lengthy siege, found that his castle must fall to the enemy. Putting on all his armour, he mounted his favourite horse and, blowing his bugle, crashed down the precipice and was crushed to death upon the rocks below.' The castle was last inhabited in the reign of James II, and tradition says it was struck by lightning shortly afterwards. Some now describe the castle as the finest ruin in the West Country.

A fantastical legend is attached to the fortunes of the de Pomeroy line. M. E. C. Walcott's *A Guide To The Coast Of Devon* (1859) tells us that their success or doom depended on the safe keeping of a mysterious berry originally presented to de Pomeroy by his mother the night before he sailed from Normandy with Duke William, the Conqueror. This berry was passed through successive generations until Lady Constance was forced to hand the heirloom to King Henry VIII and thence to his son, Edward VI. When the boy king died, 'an ancient form appeared before the duchess in this castle, and pronouncing its doom accomplished, buried the kernel in the ground, from which sprang a noble beech tree, still pointed out.' This tree can still be found, and is called the Wishing Tree. If you should choose to walk round it backwards three times and make a wish, this will come true in time – but only if you keep your desire a secret.

Stories of ghosts here are legion. The castle is supposedly haunted by the daughter of a former baron, who bore a child to her own father and afterwards strangled the fruit of their incestuous liaison. After her death, this wretched woman could not rest and whenever death was about to visit the castle she was generally seen sadly wending her way to the scene of her earthly crime.

This ghost's most famous appearance was in the late eighteenth century. Dr Walter Farquhar (who was created a baronet in 1796) had been summoned to the castle to attend the seriously ill wife of the steward, who at that time lived at and maintained the building. While waiting to see his patient in an outer apartment (as a narrative attributed to the doctor explains), the door opened and 'a female somewhat richly dressed' swept into the room, wringing her hands and apparently in great distress. She hurried to a flight of stairs, and quickly ascended them, appearing oblivious to the presence of the doctor. When she reached the highest stair, the light outside illuminated a youthful, attractive face, but nonetheless a face which showed naught but despair, anguish and guilt. Dr Farquhar, assuming the mysterious woman to be of the family, was called into the chamber of his patient.

His treatment of her illness appeared successful, and the following day Farquhar felt he had saved her. However, when he casually asked the steward who the distressed woman on the stair might have been, the man grew ashen-faced, and in a terrified voice declared, 'The day my son was drowned she was observed; and now my poor wife! I have lived in and near the castle thirty years, and never knew the omen fail!' Despite Farquhar's insistence that the patient was getting well, he and the steward parted in mutual disagreement as to her fate, the steward convinced his wife would not see the day out. He was proved right – she died that afternoon. Dr Farquhar's later correspondence, after he became a professional apothecary in the capital and a friend of the Prince Regent, makes it clear

he was aware of other instances when this phantom woman was seen at Berry Pomeroy – including on the day of the steward's own death, when she was seen by a visitor.

One tradition, recorded by A. H. Norway in 1904, speaks of a brutal incident, 'in those days when there was none to question any action that the Pomeroy thought proper to commit.' A son of the Pomeroys was thought to have killed his own sister and an enemy of the family after catching the two in a clandestine relationship. In Norway's time it was said that two ghosts, a man and a woman, attempted to reach each other, arms outstretched, 'in a winding passage just within the castle entrance' – but were held back from each other by some supernatural force.

According to another old story, the spirit of the Ladye Margaret, a young daughter of the house of Pomeroy, appears in ghostly form clad in white on the broken steps that lead into a dismal vault at the tower that bears her name. She beckons to visitors and passers-by in an attempt to lure them to destruction in this dungeon ruin. Margaret, in life, is said to have been the tragic victim of a crime, for during the medieval era (some say during King John's reign) she and her sister Eleanor both fell in love with the same man. Eleanor was insanely jealous of Margaret's beauty, and so imprisoned her in the tower and let her gradually starve to death. However, this legend has a tendency to be muddled, for some say Eleanor was the victim and Margaret her captor, with the poor victim being imprisoned from the outside world for a curiously specific time of nineteen years. John Prince's *Worthies Of Devon* described the tower in 1702 as being named 'St Margaret's Tower' which implies Margaret was thought the victim; although, all said, it seems unclear if there is any factual element to this tale.

Regarding this ghost, Elliott O Donnell's *The Screaming Skulls* (1969) recalls an old story collected in 1913 by the International Club for Psychical Research. This spoke of an army officer attempting to rescue a beautiful young woman, who beckoned to him from the top of St Margaret's Tower. In scrambling up its façade to try and help her, a portion of the masonry collapsed and he was nearly killed. Perhaps these rumours were abroad when a fourteen-year-old boy, Maurice Williams, was almost fatally injured when he fell 30 feet while clambering over the ruins by himself. The *Exeter & Plymouth Gazette* (8 September 1933) reported that his 'faint cries for help' led to his discovery; it was ascertained he had suffered broken bones and multiple bruising. The reason for the boy's dangerous adventure was not reported.

It might appear at this point that we are in the realms of ancient legend regarding Berry Pomeroy's ghosts, rather than any modern evidence constituting 'fact' – but for a couple of things. A great many people comment on the loneliness and desolation at this place, which is not all that surprising; yet for the atmosphere to affect pets might be considered curious. An old friend told Theo Brown how his red cocker spaniel had been tormented by paroxysms of fear whenever near Margaret's Tower.

Then we have an enigmatic photograph of the ruin that was presented to the poet Robert Graves (*d.* 1985), whose *The Crane Bag* (1969) explains that he was shown the eerie image by Mr Beer, husband of a local typist. Beer pointed at the image and said, 'I don't know how this woman came into the picture. I didn't see anyone around at the time. It looks like she's leading a dog on a string. I was there (at the castle) last Sunday morning with the wife.' Graves wrote that the photograph showed '...a tall thin woman in fourteenth-century costume, walking past the gate ... and leading a

Some see a 'White Lady' beckoning in this pattern high up a wall at the castle.

small ape on a chain.' Beer presented Graves with the picture, but the poet quickly burned it after his guest had gone: 'It was too horrible.'

As Lady Rosalind Northcote observed of Berry Pomeroy Castle in an interview with the *Exeter & Plymouth Gazette* in 1908: 'I do not know if Berry Pomeroy is said to be haunted, but it awakens an uneasy sensation that it is itself a ghost – the ghost of an unsatisfied ambition, the creation of many minds who planned and toiled, soared and fell...' The same would aptly describe the castle, even now.

The Ghosts of the 'Old Spanish Barn' and Abbey

Like Berry Pomeroy, Torre Abbey in Torquay has many a weird legend. This historic building was founded in 1196 as a monastery for canons and remained so until the Dissolution in 1539. It now presents what is generally considered one of the finest examples of a medieval monastery in the south-west of England.

The best known story here concerns the tithe barn, which was built at the same time as the abbey. For two weeks in 1588 it was home to 397 Spanish prisoners of war, following the failed Armada so successfully thwarted by Drake. Tradition avers that many of the prisoners were starved to death, and according to legend a sympathetic farmer surreptitiously delivered food to the dying captives. When the people discovered this, they hanged the Good Samaritan from a tree branch. J. T. White's *The History Of Torquay* (1878) explains:

The village gossips affirm that the spirits of the slaughtered Spaniards visit the spot at those times when it is supposed such visitants walk the earth; and they add that a Spanish lady, whose devoted attachment to an officer of the expedition induced her to don male attire in order to join the Armada, shrouded in a gracefully flowing manner, may also at times be seen gliding along the lane. The spectre, however, very discreetly retires on the approach of a wayfarer.

In 1925 the Devonshire Association collected more details on this:

One of the avenues near Tor Abbey, known as the Spanish-lane, was supposed to be haunted by a Spanish nun. It was stated that once when some Spanish prisoners were being taken through Torquay, a rescue was attempted, and much blood shed during the fight. Afterwards it was discovered that one of the prisoners was a Spanish lady who had followed her husband to the war disguised as a man. This story most likely gave rise to the story of the nun, as the lady may have worn a mantle.

The unfortunate woman was one of the first to die in the awful conditions in the tithe barn, and her spirit still drifts hopelessly near the abbey. For, as ghost expert Peter Underwood's authoritative *A–Z Of British Ghosts* (1971) tells us, 'motorists driving along the King's Drive late on moonlit nights have reported seeing such a figure in recent years'.

There are other ghosts here, however. The Devonshire Association recorded in 1879 that a certain Lady Cary had lived at the abbey around a hundred years earlier, and it seemed she enjoyed the masquerades and balls that occurred here when the fleet landed. Lady Cary was sometimes seen after death in glittering attire, reclining in a phantom carriage steered by a coachman and a footman, which swept swiftly and noiselessly through the lanes:

Some few years ago, the attention of two young women, walking through these avenues, was arrested by a brilliant light. They looked in the direction from whence it came, and seeing a carriage and pair advancing, stepped aside to avoid being run over. They observed the men in the box, and the lady seated inside; but when the equipage was nearly abreast of them, the whole suddenly vanished!

A great scandal occurred during the abbacy of William Norton, who was confirmed abbot on 27 July 1382. A rumour spread that Norton had seen to it a canon, Simon Hastings, was decapitated, and although an inquiry in 1390 exonerated him, by the late 1800s it was still said that Hastings' headless ghost haunted the lanes near the abbey. He appeared in November, atop a galloping horse; or, if not seen, the clatter of horse's hooves could be distinctly detected.

A Ghostly Guide

One of Dartmoor's most famous stories tells how John Childe of Plymstock lost both his way and his company while hunting during the reign of Edward III. Near Fox Tor,

There was controversy in Torquay in 1956, when Revd Anthony Rouse removed an eighty-year-old organ from the church of St John here. Since 1883, people claimed they had heard music coming from it when there was no one playing it, according to a church periodical, *The Living Church*, in August 1956.

Childe's Tomb is near dangerous land called Foxtor Mires.

and in blizzard conditions, he slew his horse and sought shelter in its disembowelled carcass. Unfortunately, he died, and when his body was found by a party of monks, his will written in the blood of his horse bequeathed his manors to those who should bury him.

It is in this dreary, inhospitable environment, a region of old druidical avenues and cromlechs, that a twentieth-century hunter avoided a like fate due to supernatural intervention. The story is told by the *Telegraph*'s country correspondent, R. W. F. Poole, and seems to have occurred around the middle of the century. Poole was master of the Dartmoor Foxhounds, and on Christmas Eve he became separated from the hunt in freezing fog; worse, it was beginning to snow. As he reached Green Hill (southwards of the battered cross denominated Childe's Tomb), the baying of the hounds had been lost to his ears and Poole feared he was doomed.

In the mist there appeared a 'wiry little man on an iron-grey horse with a ratty tail.' This personage silently beckoned Poole to follow him, and he dutifully followed his rescuer, who seemed to know the undulating pathways and tracks of the moor like the back of his hand, even in these conditions. He even navigated their way along the treacherous Black Lane and through the wet green mosses that had swallowed many a Moor pony. After some time they came to the slightly better ground of Swincombe, near Hexworthy, and Poole's guide held up his hand to halt. Poole now recognised where he was, and, reassuringly, saw the hounds and his fellow huntsmen by the moor gate in the Swincombe Valley. As he turned to thank his saviour, Poole observed him to wave a hand before the mist swallowed him up and he disappeared.

Two hours later Poole sat by the fireside of a local farmer, relating his strange preservation. His host listened, and then in amazement unhooked a picture from the wall and presented it to Poole, who saw it bore an uncanny likeness to his mysterious rescuer. The farmer commented, 'That's Limpety, the gypsy huntsman. He died in a blizzard at Swincombe Heads fifty years ago on Christmas Eve.' Mr Poole's curious story was told in the *Weekend Telegraph* of 19 December 1998.

A Roman Encounter in Okehampton

Around forty-five years ago, in the late 1960s or early 1970s, a woman who has lived in Okehampton many a year now experienced a very vivid ghostly encounter. It was as she was walking (in daylight) via the woodland near Okehampton Station – nicknamed the Tramlines – that this lady experienced a peculiar, spine-tingling sensation of being looked at. Glancing at the tree-line she observed – to her utter surprise – a man looking at her who appeared to be kitted out in the garb of a Roman soldier: shoulder plates, body armour, and red tunic and skirt. The most striking thing about this figure was that he appeared to be looking right back at the witness, seeing her, and equally nonplussed. This lady tells me that she looked away, and then looked back, and in the blink of an eye the figure had disappeared. She is adamant to this day that there is literally no-where he could have hidden or ducked from sight during this split-second distraction.

Not long afterwards, in relating her adventure over some tea, this lady was informed by a friend that her son had lately found a Roman coin in those very same woods,

and presented it to the Museum of Dartmoor Life. It had, in fact long been speculated that Okehampton might have been the site of a Roman outpost. In 1898, hard by the roadside at Okehampton, a hoard of the smallest Roman coins was found, all dating to the reign of Constantine the Great. However, evidence of a Roman Auxiliary Fort further up the East Okement River near Chichacott Road was not confirmed by aerial photographs until *after* the witness concerned had her ghostly experience, and she is adamant that at the time she had no knowledge of any reason why a Roman soldier might be wandering the outskirts of Okehampton. It took the subsequent discovery of the fort to make her understand why she might have seen him.

The Chambercombe Manor Farm

At the end of a leafy road called Chambercombe Lane, on the southern fringes of Ilfracombe, can be found the whitewashed façade of Chambercombe Manor, in a beautifully wooded valley through which saunters a little streamlet, which empties itself into the sea not far off at Hele Sand. The manor of Ilfracombe has belonged to many noble families and distinguished individuals – the Champernownes, Sir Philip Sydney, the Martyns, Audleys and Bourchiers, Earls of Bath; but at some point this twelfth-century building fell from its high estate, for the Reverend George Tugwell observed it to be a 'retired farm house' in 1857, by which time it had evidently been so for some time.

Tugwell noted that, in his time, 'the inhabitants still show the "haunted room" to the curious in such matters, a long low chamber in the roof of the house, from which the flooring has been removed, and which is now used only for the purposes of storing away useless lumber'. Tugwell heard that 'many years ago' an observant yeoman farmer had noted, while making repairs, that there were one too many windows without for the rooms within at a certain part of the house, and he quickly enlisted help to knock down one of the interior walls. They found a small chamber; moth-eaten tapestries hung on the walls, cobwebs were everywhere and dust was thick on the carved oak furniture. Drawing back the embroidered hangings that obscured a bed, they saw ghastly skeletal remains laid out, with this discovery so alarming the farmer's wife that she had him wall the secret room back up 'for a future generation.'

Tugwell admitted that there were numerous versions of this story in circulation in his time, and in 1862 intrigued investigators from the periodical *Once A Week* arrived at the farm to look into this. Here, 'the old dame who at present inhabits this place will tell [the inquisitive], as she told our party, that "The Ghost Room is where the ghost is … it isn't open now, and it never will be" (for it is a fearsome thing to raise a ghost, even in this nineteenth century, in a Devonshire house).'

It is interesting to note that at the time no backstory was evident for this ghoulish discovery: 'No conjectures can be formed respecting the dead lady; each one may fill up for himself the particulars of her death or murder, and deem her riches or her beauty the cause of her untimely end.'

Nonetheless, by 1922 the *North Devon Journal* (24 August) was reporting there were most definitely ghosts here at Chambercombe linked to the discovery. According to the

Chambercombe Manor.

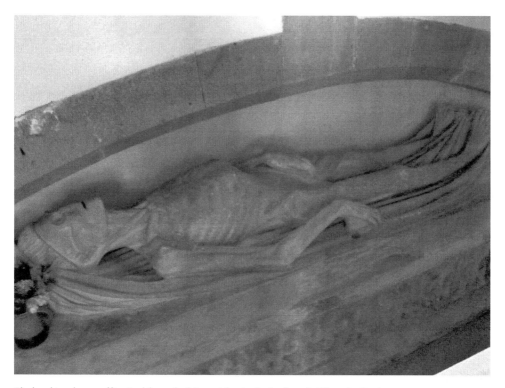

Skeletal 'cadaver effigy', although this resides in St Andrew's Church, Feniton.

newspaper, the skeleton on the bed had been discovered (presumably rediscovered, for this is after Tugwell wrote of the mystery in 1857) during structural alterations in 1865. The skeleton's origins are explained thus:

> Hele – quite a holiday haunt now – was then the home of bold bad man whose least crime was smuggling. One night a ship was driven or lured ashore. The crew were drowned or murdered, and a beautiful Spanish woman of distinction on board was made a prisoner.

Conveyed through a subterranean passage that at one time connected Hele beach to the manor, this woman was held captive until she was finally allowed to starve to death in the secret chamber.

The newspaper noted some evidence to back up the yarn:

> The haunted room stands as it did when the skeleton and furniture were removed in 1865. The roof of the manor farm forms the ceiling; a small hatchway in a wooden wall affords a view of the interior. In the courtyard of the farm there are traces of the old subterranean passage. Some little distance has been cleared, and at the foot of the cliffs at Hele is a small cave, said to have been the entry to this tunnel.

It was impossible to force a way through, however, as the roof and side had collapsed.

Other versions of this story flesh it out much further nowadays – adding the detail that the Spanish captive survived and married William Oatway, son of the wrecker who nearly killed her. William and his Spanish wife bore a daughter, Kate, who moved to Ireland to be the bride of an Irish captain called Wallace. When Kate journeyed home to Ilfracombe to see her parents twenty years later, her ship capsized, and she was found washed up on the beach, battered and disfigured. The now-elderly William Oatway, not realising who she was, furtively robbed her and hid the corpse at Chambercombe Manor. He only realised it was his own daughter when a messenger called, making enquiries about Mrs Katherine Wallace. Distraught and ashamed, William bricked his dead daughter's body into the secret chamber, and vacated the house with his Spanish wife. This is the story that is generally told these days, although it owes a great deal to a romantic, story-like elaboration in the *Leisure Hour* (1865) of the same legend earlier told by Tugwell, whose original yarn seems to be the template for all the versions that followed it.

As with many old, old ghost stories, the mists of rumour that cloud the origin of the ghost ought not to detract from the fact that ghosts are nonetheless reported. The *North Devon News* reported in 1922 that a phantom female woman had been seen here at least twice – by a guest occupying a room once used by Lady Jane Grey, and by another guest who had spotted 'her' standing on the stairs. This apparition was generally considered benign, even back then, and has since come to be denominated the Grey Lady, with some saying that she mingles with tourists at Chambercombe, smiling gently. I understand she was spotted quite clearly around 1976, although more recently some also have reported a male presence in the place at night; this is supposed to be Kate's errant father, William, walking the rooms because of his guilt.

Chambercombe's haunted reputation is evidenced by an article in the Halloween 2009 copy of the *Guardian*, which reports: 'It's not surprising that ghost-hunters here get pelted with stones, pushed into corners by freezing blasts of air and are run out of the house by moaning voices…'

Pub Spectres

Many of Devon's most famously haunted places are public houses and hostelries, it perhaps being no surprise that often the combination of an isolated location and the consumption of vast quantities of cider bred so many stories. Some pubs have earned 'ghosts' thanks to their sheer antiquity, and have had them for decades. For instance, the Braunton Inn, southeast of Braunton and on the banks of the River Taw, was originally an old manor house called Heanton Court. As early as 1907, it was written of this castellated pile:

> There is a special interest attached to the house by North Devon people as a result of stories told of its being haunted. People who profess to know say mysterious sounds are sometimes heard in the house… [however] the ghost has never been seen at Heanton, nor had the source of the sounds been traced.

'Pub ghosts' is a phenomenon that has refused to die a death, as it were, and two made national headlines in the 1970s. In 1976 it was reported that manager Don Mudge was suffering an outbreak of paranormal phenomena at the Prince Regent Hotel on Esplanade Road, Paignton. According to the *Mirror* of 12 May, he was plagued by the mysterious switching on of lights and radios, while beer in the cellar was 'tampered with'. More disturbingly, Mudge's six-year-old son was reporting that a shadowy figure came into his bedroom in the night and sat on his bed. Strangely, this didn't frighten the child – he apparently felt some sympathy towards the spectre, for he was trying to find out its birthday so he could send it a card!

Two years later it was reported (also in the *Mirror*) that the historic fifteenth-century Blagdon Inn, west of Paignton near Collaton St Mary, was haunted by a ghost – believed in life to have been a certain John Henry who lived at the pub a century earlier and who had taken his own life. Henry's restless spirit was blamed for any poltergeist-like activity, such as noises in the night and bottles being found mysteriously smashed. At a New Year's Eve party in 1978 a comic hired by the landlord, Ian Emslie, voiced a piece on humorous phantoms, and it appears this turn annoyed John Henry – for a blaze that very night, after the guests had gone, caused £30,000 worth of damage. The landlord blamed John Henry's ghost for the fire.

Village of the Dead

It is fairly common knowledge that the Old Inn at Widecombe in the Moor is haunted by two resident spooks: a figure denominated 'Old Harry', and the distinct sound of an

A friend in nearby Bridestowe informs me that the White Hart in Okehampton is haunted by a little boy called Peter, who wanders the upstairs part of the hotel crying for his lost mother. Apparently, sometimes his frustration leads him to throw things around, poltergeist-like, although no damage is ever caused.

infant or child bawling in a room upstairs during the night. But this picturesque little Dartmoor village was the setting for a dramatic and disturbing supernatural encounter – experienced by a famous American actor, of all people.

The famous face in question was Daniel Stern, perhaps best known to British audiences as the dim-witted sidekick to Joe Pesci's equally incompetent housebreaker in *Home Alone*. In an episode of Bio Channel's *Celebrity Ghost Stories* (screened 11 December 2010), viewers heard the actor talk about his bizarre experience, which happened at Widecombe in the Moor during his English honeymoon with Laure Mattos in 1980. The couple were driving to Tavistock, and, seeing the spire of St Pancras' church, stopped off to have a look. They found the atmosphere in the village surreal, and in Stern's own words:

> There were thirty or forty people milling about. They were all walking at a particular pace. The most noticeable thing was no talking, and their lack of eye contact. They looked like extras in a movie [like] *Night of the Living Dead*. And then as we started to become a little bit more aware of our surroundings we saw that everybody was dressed in black. There was absolutely no colour on the street of anybody walking around, no talking. The town was silent. We could see their faces but everybody was

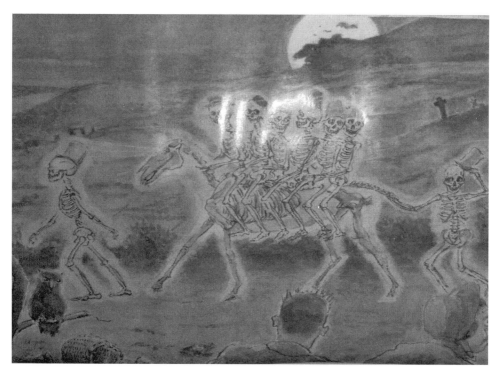

Depiction in Widecombe church of another ghost: Tom Pearce's grey mare, which wanders the surrounding lanes, according to an old and familiar song.

sort of staring straight ahead, with a kind of blank expression … and at this point my wife and I decided to get out of there. How do we get back on that road to Tavistock? So, we're in front of the Widecombe church. We approached a woman who was standing by herself, and so figured maybe we wouldn't be interrupting her. She's all in black, from behind, with a kind of a veil thing over her head, and we say, "Ma'am, do you know the way to Tavistock?" And then it was like a movie moment. [Her] white eyes are the creepiest, scariest part – there's no colour, she's lost the colour of her eyes. It's just a milky wash. And that's the point where she started speaking in tongues: I've heard of speaking in tongues, and I think that that's what this woman started doing. She either looked possessed, or sounded possessed, or it felt that way to us … We really lost it at that point. We made a beeline for the car.

Stern and his wife were so disturbed by this that they drove to Tavistock, even despite having a flat tyre, where their host at the bed & breakfast explained that Widecombe was a ghost town, deserted and avoided since the Great Thunderstorm of 1638. Of course, this is not true, although there can sometimes be a depressing sense of unreality that visitors can experience upon arriving in such isolated places as Widecombe, particularly when it is winter, raining heavily and there is not a soul about anywhere.

Maybe in Daniel Stern's case there were literally only 'souls' about on this occasion; the wraiths of the long dead – perhaps those of the shocked and stunned villagers following the so-called 'event of 1638'. This concerns a disaster on Sunday 21 October

1638, outlined in a pamphlet at the time telling how 'the parish church of Withycombe in Devonshire neare Dartmoores' was rent by thunder and lightning. The sky turned black and some observed in the midst of this a great ball of fire enter through the window, which bounced and blasted around the church interior, filling it with smoke, sulphur and flame. At least four people were fatally injured by this phenomenon, and such was the shock in the area that many immediately believed it could only have occurred through Satan's wrath. In 1869 a periodical called *All Year Round* retold one such legend, which generations had grown up with. This concerned stories that an old woman who kept a little inn on the edge of the moor served a stoup of cider to a strange figure on the day of the disaster. This personage was tall, lame and dressed in black, and he reined in a powerful black horse before enquiring the way to Widecombe church. He asked the woman to show him the way, as he was concerned he would get lost on the moor, but she refused, becoming frightened when she heard the cider hiss in his throat and saw smoke issue from his mouth. When the figure climbed atop his horse, she saw he had a cloven hoof protruding from his boot; half an hour later the church was rent by the disastrous event that overtook it.

Perhaps Stern and his wife drove out of the Dartmoor mist and experienced a vision of the aftermath of the catastrophe ... Whatever happened, it left an impression deep enough to still unnerve them thirty years later, when their strange experience was recounted on television.

This chapbook in Widecombe's church illustrates the disaster.

Plympton's Shimmering Figure

Plympton was at one time an ancient stannary town with its own motte-and-bailey castle, although today it is a populous suburb of northeast Plymouth, having been absorbed by the city in 1967. South of Plympton, the road called Drunken Bridge Hill takes one out of the town, past Dorsmouth Rock topped with its Triangulation Pillar, and thence via Hardwick Wood, a thick and sinister patch of woodland stretching west of the hill.

According to J___, a Plympton local, the first rumours that something weird inhabited this ancient woodland came in August 1985, and from him I learned this strange story. When he was about sixteen, J___ and some friends were idling the evening away on small 50cc motorbikes, when one of their number turned up in a truly distressed state. This youngster had, earlier in the evening, ridden off alone and taken himself into Hardwick Wood. As it had grown dark, the lad claimed, he had glimpsed a 'shimmering white figure' standing in front of him. In J___'s own words:

> He knew what it wasn't, it wasn't anything that he'd seen before, and it definitely wasn't someone dressed up. He could see partially through the figure, and the shimmering glow was totally un-natural. He immediately turned around and fled the woods, back to us where he relayed the story.

The youth's story was met with some derision, but J___ recalls that he could not be persuaded to join the group, who were anxious to go into Hardwick Wood to look for the 'thing' themselves. In fact, he never ventured near the woodland again.

Ten years later J___ had all but forgotten the odd incident, when, during the course of a few drinks with an old acquaintance in 1995, he was told a chilling story that brought the events of his childhood flooding back to his memory. His friend claimed that a few weeks earlier in summer, his parents had been driving up Drunken Bridge Hill: 'In the trees high up, they saw a shimmering white figure which was definitely not human, and un-natural. It just stood up high on a bank looking down on them.' Oddly, the friend's grandparents – who lived locally – steadfastly refused to discuss the matter with the family. J___ is adamant that the two people who told these stories to him could have had no way of knowing each other.

Upon making enquiries later, J___ learned that the wood had a surreal and spooky reputation, and dogs occasionally appeared frightened of entering it. He also learned that a mysterious person was supposed to walk along nearby Back Lane, past the houses there, only to vanish into a wall between two windows. This entity, however, seemed distinct from the white figure glimpsed between the trees in the wood...

Mysterious Chagford

Chagford, west of Moretonhampstead, was another important stannary town until the late sixteenth century. Today it is a popular and attractive base for those touring northern Dartmoor, with Tudor and Georgian houses surrounding its square

and thatched bank, and a sixteenth-century bridge crossing the Teign northwest of the town. One of Chagford's most famous stories, as recounted by folklorist Ruth E. St Leger-Gordon, tells how Chagford's 'faithless wives and fickle maidens' were compelled to expiate their misdeeds on the wilds of Dartmoor, trudging out of the village and up Hangingstone Hill to wash themselves in Cranmere Pool in penance before marching up the summit of Sittaford Tor to the two stone circles known as the Grey Wethers. Here, the erring women would fall on their knees and pray for forgiveness before 'one of the standing stones'. It was believed the stone was imbued with a sensible power, and should the woman's sin be too great for forgiveness it would topple forward and crush her to death; should she be absolved, nothing would happen.

There are many curious stories here. Westcote's *A View Of Devonshire* (1630) reports that at Chegford on 1 August 1616 a chamber where the 'tin-court' was held collapsed because of decaying pillars, its falling stonework killing some ten people in a disastrous accident. But among the dead and seriously injured, a 'little child was taken up from among the slain' in the rubble. It was believed the child might have had an angel looking over it, thus miraculously delivering it from harm.

One of the area's most famous ghosts concerns the wraith of Mary Whiddon, or Whyddon, whose smiling spectre is supposed to appear before new brides at the three-storey Whiddon Park House, which stands to the east of Chagford on the western edge of the Whiddon Deer Park. Mary lived here over 350 years ago, and a memorial stone to her memory can be found in St Michael's church. The inscription etched onto this tablet hints at Mary's tragedy:

> Reader wouldst know who here is laid;
> Behold a matron, yet a maid;
> A modest looke, a pious heart;
> A Mary for the better part;
> But drie thine eies, why wilt thou weep?
> Such damsells do not die, but sleepe.

On 25 January 2012, upon paying a visit to this church, an administrator here – a person with a great interest in Mary's story – explained that Mary was without doubt a real person, probably aged about twenty-one. She was fatally wounded on her wedding day when a jealous ex-suitor shot her as she left the church on 11 October 1641 (or, alternatively, as she stood at the altar, it not being clear if she had actually been married when she was slain). Although nothing existed in print to account for this, my informant believed the story implicitly, stating that many records county-wide disappeared during the confusion of the Civil War, and that the story must have existed in R. D. Blackmore's time since he appeared to have used the incident as a plot device in *Lorna Doone* (1869), thus eliminating the possibility of the shooting being a modern invention. My informant was somewhat sceptical of Mary's ghost appearing at Whiddon Park House, however, stating that it could not be true, as she personally knew a bride who had stayed at the house in 2011 and seen nothing strange. Nonetheless, she confirmed that it was common practice for new brides to lay bouquets of flowers on Mary's memorial stone in the church as a ritual aimed at bringing good

luck in their forthcoming marriages. The allegation that Mary's ghost appears at the house stems from an incident recounted in *Reader's Digest's* 'Folklore, Myths And Legends Of Britain' (1973), which observes that early on the morning of 10 July 1971 a guest attending a wedding reception 'woke to find a young woman, dressed in black, standing in the doorway. She smiled and then vanished. The phantom has been seen in that room on other occasions...'

I have lately been told that what is supposed to be Mary's ghost has also been witnessed at the Three Crowns inn on Chagford's High Street, where she stands on the threshold of a particular room gazing at new brides.

Further to this, my informant also told me of another, distinct ghostly entity at the Three Crowns. Murray's *A Handbook For Travellers In Devon And Cornwall* (1856) tells us that Chagford was the setting for another violent incident, the slaying of Sidney Godolphin, the poet, courtier and politician:

> During the Rebellion the royalists made an attack on this village, when, says Clarendon, "they lost Sidney Godolphin, a young gentleman of incomparable parts".

Mary Whiddon's inscribed gravestone. She may not be buried here, however: the slab might have been brought inside from the church grounds.

He received a mortal shot by a musket, a little above the knee, of which he died on the instant, leaving the misfortune of his death upon a place which could never otherwise have had a mention in the world.

Opposite St Michael's can be found the aforementioned inn, from which it is rumoured a subterranean passage extends to Whiddon Park House. Godolphin – so I was told – was shot in its porch, although he actually died after being carried to Okehampton for treatment. His death came in 1643, at the age of about thirty-three. Although some people lay claim to know that Sidney Godolphin wanders the Three Crowns in full military regalia, my informant declared that she was only aware of the place being haunted by a 'presence' whose favourite trick was to obligingly open doors for people quite unexpectedly. This, she knew, had happened quite recently for the benefit of a man on crutches; so Godolphin's spirit appears to be a gentlemanly spectre, to say the least.

The Vanishing Passengers of Barnstaple

Barnstaple, for long the third-largest town in Devon, is one of the oldest towns in Britain, an established borough minting its own coins as early as the tenth century. It prospered greatly in the eighteenth century, and continued to spread over the surrounding countryside in the process of becoming a sizeable industrial district. It is little surprise that this historic and important marketing centre, looking out in the direction of Barnstaple Bay, has had numerous ghosts.

Something akin to panic swept the Derby area of Barnstaple in February 1898, when a rumour started that a ghost was scaring people in Union Street. Apparently, this entity had appeared to numerous people in the blink of an eye, usually in doorways and at night, where he was observed to smoke a pipe containing 'fragrant weed'. He would vanish equally abruptly, and spoke only once to a startled passer-by, saying, 'Follow me'! Others claimed he moved grotesquely, and waved his arms in a frightening way. Vigilante groups began to form: but the 'ghost' stopped appearing, with the *North Devon Journal* noting, 'Inquiry points to some person having been masquerading with a view to creating a sensation.'

The *Manchester Courier* (17 May 1909) reported this vague story:

Great excitement has been occasioned at Barnstaple by the alleged appearance of a ghost in an old disused burial mound, and large numbers of people have visited the place for the purposes of catching a glimpse of the mysterious apparition. An enterprising photographer has succeeded – though nobody knows how or when – in photographing the "ghost", and is exhibiting it in his window as a picture postcard.

This ghost had caused great concern after nightly appearances at Garden Court, but seemed to disappear after a crowd saw it and pelted it with stones. The lucky photographer lived in Bear Street, and his image had captured 'a white apparition, but no form can be seen, whether of a man or a woman' beside a tombstone.

More recently, the *North Devon Journal* (19 June 1980) reported that a ghost had been seen by a number of people at the Classic Cinema, lately by an usherette. But Barnstaple's latest ghostly mystery is also one of its weirdest, and a variation on the phantom hitchhiker – the phantom bus passenger. In February 2011 it was widely reported how a forty-two-year-old bus driver, driving a First bus with a single passenger, stopped at the Green Lanes shopping centre. Here, he admitted two more passengers – an elderly woman and a much younger man wearing a dark leather jacket carrying a bunch of red and white carnations. The driver enquired of the woman if she was going to the hospital, but she merely smiled and he issued a concessionary ticket. The young man produced a ticket of his own, and both boarded and sat next to each other. When the bus reached the hospital, only the original passenger departed; the elderly woman and young man had somehow vanished en route, despite the bus not stopping at all during the rest of the journey. In his surprise, the driver made numerous enquiries, but all passers-by declared they had seen only the original passenger get off; and, stranger, the concessionary ticket he had printed off was still in the machine ... The *North Devon Journal* (24 February 2011) notes that other urban legends were to be found among Barnstaple's bus drivers, such as lingering cigar smoke being detected on an empty bus, or an out-of-service bus echoing to the ringing of the 'stop' bell. At the time of writing, this mystery – for a short spell the talking point of Barnstaple – remains unexplained.

Jay's Grave

By following the B3387 out of Widecombe in the Moor, then taking a left along the unclassified road to Hound Tor, following the road past Swine Down, you will come to an ancient bridle path that crosses the road. Here can be found, in the middle of nowhere, a low mound, grassed over and bearing a stone marker, which is bedecked with offerings made by people who have passed this way. Flowers, coins, and even twigs bound together to form the shape of a cross litter the mound's surface – for this spot is Jay's Grave, and her story is a famous one indeed. Mary Jay is said to have been born around 1790 and brought up at the Newton Abbot Workhouse before entering servitude at Barracott Farm, Manaton. At some point she hanged herself in an outhouse at Ford Farm. It was commonly believed she was pregnant by either the farmer or the squire, and because of this she was denied a church burial. Over four decades later, around 1860, a road mender dug into a crude burial near Swallerton Gate, overlooked by Hound Tor, and unearthed Mary's remains quite near the surface. After initially believing them to be the remains of a Moor pony or a sheep, a doctor declared them human. The then squire had Mary interred where she now lies, after the road mender's wife recalled being told by her mother that the girl was originally interred far from a church because she had committed suicide.

Much of this is based on the writings of Mary Whitcombe, in her *Bygone Days In Devon And Cornwall* (1874), and Beatrice Chase (*d.* 1955). There is an article in the *Western Morning News* (3 March 1934) in which Beatrice Chase laments the errors connected with the grave. The woman who was interred there was often named as

Kitty Jay and the grave was Jane's Grave, for instance. Beatrice claimed to have been told the story personally 'by the old man who found the bones', and by one 'Granny' Caunter' who recalled being told the story when she was a child of about twelve. Mary Jay's name appeared in the poorhouse records, and Beatrice spoke to the current owner of Ford Farm, Robert Nosworthy, whose father had been born at Ford in 1834 and had always referred to the dead girl as Mary Jay. To this end, Beatrice campaigned to have the grave officially denominated 'Jay's Grave' on OS maps.

She makes an interesting observation: 'I have known that grave now for over twenty-five years, and never, even in winter, have I seen it without some rough decoration.' This seems to be the basis for an enduring legend that it is Mary Jay herself whose cloaked ghost sometimes sadly places flowers on the grave, so that she is never forgotten and because she was denied a Christian burial. I have heard that travellers, in the past, did not like passing this spot because it was rumoured a young girl was sometimes seen, alone and bending down over the grave. Theo Brown recorded in 1982, 'Gipsies were said to avoid camping on the down above the road and during petrol rationing when lorries were sent by the quickest route I heard of an Ideford driver who flatly refused to pass the grave at night...'

It is unclear how the custom of placing offerings on the grave started, with some believing it a ritual aimed at appeasing Mary Jay's ghost, and others thinking it will bring them good fortune. Some believe it is passing gipsies who keep placing offerings

Jay's Grave, in dreadful weather.

at the site, while some even think it is pixies, whose hearts are kinder than mortal man's. Beatrice Chase wrote in 1934: 'One day last summer a char-a-banc was seen to stop beside the grave, while a lady alighted and placed a beautiful bouquet on the grave. Another bouquet last summer was that of a bride or bridesmaid.' Whatever the truth is behind the ritual at this melancholic landmark, I'm pleased I paid it a visit and would not automatically dismiss the tradition of placing a small token on its wet, grassy surface. Following a visit in January 2012, in dire weather during a thunderstorm, I placed an offering of coinage here, watched by a curious bullock that had somehow gotten out of its field and into the road. Suffice to say, on the journey home I narrowly avoided a disastrous car accident near Okehampton, by complete fluke with neither damage to the car or myself, other than utter shock – so perhaps there is something to it, after all…

Modern Haunted Hostelries

These days many pubs actively promote themselves as having a resident ghost, and 'pub ghosts' are more likely nowadays to crop up in the local media than, say, resident spooks at churches.

At the Tors Hotel, at Belstone on the northern edge of Dartmoor, a singular experience was recently recounted in the prestigious *Dartmoor News* magazine. On Sunday 7 July 1996 the then landlord saw – in the clear daylight of mid-morning – a strange woman about five metres away from him. She was around sixty to seventy years old, had yellowy-grey hair and wore a red dress. At this precise moment, lights flickered throughout the pub, and customers in the bar looked up from their drinks, wondering what was happening. It was long believed that the spirit of a woman who had died in a fire about a century earlier haunted the pub, but normally she restricted her appearances to minor poltergeist activity. This included inexplicable draughts, beer taps turning on and off, and beer barrels somehow rolling themselves. My contact at *Dartmoor News*, to whom I am indebted for this weird anecdote, personally knew the landlord at the time.

Stories like this are legion in pubs across Devon. In Combe Martin, the High Street's most famous landmark is undoubtedly the Pack O' Cards pub, and here I was told:

> The Pack O' Cards was built by the village squire when he won a lot of money in a card game. Built as a tribute to lady luck, the building measures 52 feet by 52 feet, which is the number of cards in a pack. It has four floors (suits in a pack), fifty-two stairs, fifty-two windows and thirteen fireplaces. The building is haunted allegedly – but not by the original squire. According to some paranormalists we have four ghosts including Marie Corelli (the author who lived here), a world war one airman who visits his fiancé, a little girl who plays in the main hallway and a spirit in the garden – not to mention the numerous "spirits in the cellar".

The squire concerned was George Lay, and I was also told that 'mediums checked out the property when the previous owners were here over fifteen years ago'. Despite this,

Interior of the Tors, Belstone.

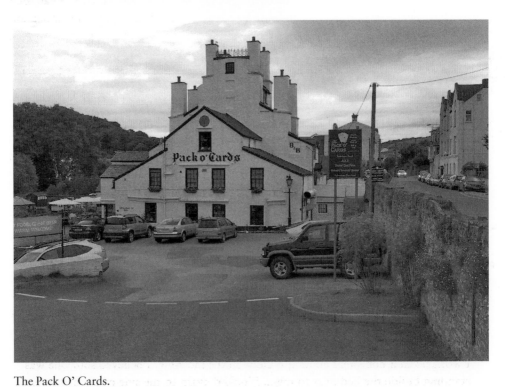

The Pack O' Cards.

the current owners are firmly non-believers in matters supernatural, and so ghost-hunts are not encouraged. (A traditional story from this picturesque valley village explains that a certain Squire Usticke returned in ghostly form to the manor house near the church, to berate a lazy servant girl during his own funeral. He angrily told her to get out and go about the preparation of his funeral breakfast. When the mourners returned from the funeral they are said to have been astonished to find the squire's spectre standing beside the sumptuous feast. Nowadays, he is said to 'walk' on Christmas Eve – although he does not, apparently, put in an appearance at the Pack O' Cards.)

The Highwayman Inn at Sourton, near Okehampton, is another remarkable watering hole. It is sometimes quoted as the most unusual pub in Britain, and is believed to have been a tavern of some description since the thirteenth century. The place is something of a charming hotchpotch of styles and tastes: gothic architecture, music from different eras and dimly-lit bars full of curiosities evoke the sensation of something extraordinary, and the ghost here appears an old one indeed. I have been informed that many people believe they can detect a presence, and the ghost – when 'he' appears – takes the form of a man dressed in green with a feather in his hat. It is said he has been glimpsed disappearing through a wall that used to be a route to an adjoining stable block. The owners have also explained that, during an impromptu séance on a foggy November night, a medium claimed to have made contact with a man called 'Samuel'. Apparently, he had died aged thirty-six and was trapped in limbo at the inn, having been in some kind of battle (this might have been a Civil War clash, but it is difficult to tell as Devon has been involved in many civil conflicts over the centuries). What is truly eerie, however, is that it was remembered how, a few months earlier, an eight-year-old girl claimed to have had long conversations with an oddly dressed man called Sam – who wore a feather in his hat and whom no-one else had noticed at the time. Intriguingly, Sally, one of the current owners, also tells me, 'my mother has seen him. but sadly I have not – yet.'

Elsewhere, west of Torquay, we come to the Old Church House Inn at Torbryan. This is thought to have been built in the mid-thirteenth century at the same time as nearby Holy Trinity church. The inn may in fact have Saxon foundations, and today retains many interesting features; an apt place, then, for a ghost. In response to my enquiries I learned that the owners have received numerous letters from customers claiming to have heard unexplained sounds in the dead of night, but some correspondence pertains to the sight of an actual spectre.

In the owner's own words:

Many years ago, a man sleeping in the bar one night (the inn being full up) woke in the early hours with a feeling of "something odd", looked around the room and saw the seated figure of a monk. As he got up to take a closer look it seemed to dissolve into the wall behind it.

And the following is an extract from a letter received from a rather surprised customer who stayed at the Inn one night:

I woke up in a hot sweat about 4 o'clock in the morning. I believed someone was standing beside the bed next to me ... I looked again to the side of the bed where

my husband was sleeping and saw a bald man walk past the side of the bed and disappear...

It is possible this monkish figure is the shade of one who inhabited a medieval priory at nearby Ipplepen, which is believed to have stood north of St Andrews church. If so, then this ghost has been around centuries; presumably he enjoyed the hospitality at the Old Church House Inn so much that he cannot bring himself to leave!

Next, at the seventeenth-century Waterman's Arms, set in a steep valley next to Bow Creek and bridge near Ashprington, there is the ghost of a woman holding an equally phantom set of keys, who is known to the staff as 'Emily'.

In August 2012, a former member of the bar staff at the pink-washed Castle Inn, Lydford, informed me that one specific bedroom there – bedroom six – was so badly haunted that she had known several instances of people refusing to sleep there again. Apparently, one phenomenon that manifested itself concerned an ancient grandfather clock whose hands would suddenly whizz round the clock face for no reason; my informant actually saw this for herself – she kicked the clock and it started behaving itself again.

Many young staff at public houses in general are told of the resident ghost upon commencing their employment, ensuring that these old legends continue to be talked about among the next generation of bar staff and customers. As an example, almost hidden away in the steeply wooded land south-west of Yelverton can be found the

The Who'd Have Thought It Inn.

Who'd Have Thought It Inn at Milton Combe, situated picturesquely by Milton Brook. This sixteenth-century free house's name is explained on its sign, where the first landlord is depicted declaring these words in amazement at the fact that he was granted a license – for in those days another inn stood directly adjacent, although this is now a private house named the 'Old Post Office'. The license was granted in the late nineteenth century, and the folklorist Ralph Whitlock observed in 1977 that the Who'd Have Thought It was traditionally haunted by Abe Beer, the lucky landlord, 'and an earlier phantom who seems to be a cavalier'. During an incidental visit on 25 January 2012 a young employee explained to me that she had heard the place boasted 'several ghosts', but the one that unnerved her most was the allegation that 'an old woman' supposedly glided along the pub's corridors. This made working by oneself, especially late, somewhat uncomfortable, and this young lady also told me that on occasion she had heard the sound of a woman's heels in the downstairs bar area – these she rationally ascribed to a malfunctioning refrigerating unit. However, I have no doubt that in later years this employee will tell others of the time she spent working in a 'haunted pub'.

Haunted Exeter

Exeter has its origins in a Roman city founded AD 50–55 that later became the capital of the West Saxons, although the place is much, much older even than this. The present High Street was an ancient ridgeway when the Celtic Dumnonii tribe settled here between the second and third centuries BC. These days, despite the severe damage it received during the Second World War, the city retains enough of its past to repay exploration. However, the bustle of a thriving modern city full of restaurants, cinemas, shops and other attractions makes for an interesting contrast with Exeter's ancient cathedral – not to mention Heavitree, a former village east of the city centre whose residents may now be unaware that at one time convicted criminals were strung up there.

In passing by Exeter's historical riddles, the reader's interest cannot help but be piqued by a remarkable circumstance in 1585. This was when Sir John Chichester and several others, including a judge, perished because of an 'infectious smell' that came from the prisoners during the Lent Assizes at Exeter Castle. But this aside, Exeter quite naturally boasts many an ancient ghostly tale of the supernatural.

Around 1721 one William Ridley, who kept the Red Cow public house in the city, vanished after a day's drinking with an acquaintance called John Miles. During the boozing spree Ridley had left to collect some money, and when he returned the pair carried on their drinking at Ridley's home. Sometime during the night Ridley vanished, and Miles was found paralytic in a back room by himself. Ridley's wife alerted the authorities to her husband's disappearance, and Miles – being unable to give a satisfactory account of his friend's movements – was arrested. His incarceration was fuelled by extraordinary rumours that Ridley's house had become haunted. Mysterious knocking was heard during the night, and two lodgers avowed they had seen the missing man's spectre. A third lodger in the building, an old man, stated that the curtains in his room had blown open and the ghost of Ridley had glared

in through the window, covered in blood. With a piteous look and hollow voice the spirit declared Miles had killed him for his money during their private drinking session. Ridley's neighbours formed part of the jury, and Miles was found guilty of murdering the still-missing man. After the trial, Mrs Ridley moved out, and the new occupant thereafter found Ridley's body under the flooring at the end of a long dark passage. The dead man had not been robbed, and doubt was cast on whether he had actually been killed deliberately, as it was recalled the flooring had been renovated on the day of his disappearance ... he might simply have drunkenly tumbled to his death in the dark recess, which was very deep. It made no difference to Miles' fate, for he had already been executed by hanging. The Red Cow stood in Red Cow Village, St David's, until its demolition in 2006.

This was not the first time that something like this had happened in the city, for Joseph Glanvil's *Saducismus Triumphatus* (1681) refers to 'that noted story of the spectre seen so oft at Exeter for the discovering of a murther committed some thirty years ago'. This story was recorded in a popular, sensationalist tract in 1677, and concerned the bizarre events that followed the discovery of a skull, still topped with a linen cap, within an inn. A ghostly apparition subsequently appeared frequently before the new occupant, telling him he must go to the authorities and report the grim discovery; in return he would learn where to find riches, and the ghost would provide witnesses – or else appear in court itself! This gentleman did as the spectre bid, and suspects were rounded up. A servant woman who had worked on the premises three decades earlier denied under oath any role in the affair of the skull, until she was 'suddenly smitten, and dyed'. Upon this, a second servant confessed the killing, and the pamphlet records that the truth of the matter could be attested to by 'many Whole-sale Men who were at the Lent Fair at Exeter, it being the common Discourse of those parts'.

Glanvil also recorded a dire, portentous phantom knocking that plagued an Exeter family around 1674 prior to a death within the household. This formed the distinct sound of a cudgel striking on their chamber table, even as those in the room looked on in fright and amazement. In 1690, another popular pamphlet titillated townsfolk with 'Strange and wonderful news from Exeter, giving an account of the dreadful apparition that was seen by Mr. Jacob Seley of Exeter, on Monday Sept. 22, 1690, who gave the full account to the judges the next day, who were going to the western circuit.'

Two hundred years later, not much had changed, which implies the Stuart-era pamphlets might have been recording popular panics and were not simply journalistic inventions. A report by Sir John Bowring for *Transactions of the Devonshire Association* (1868) explains that decades earlier he was told by an eighty-year-old Exeter woman that a stone in one of the walls in Mount Radford (south of the cathedral) was thought to be a genuine petrified human face. This supposedly housed a 'sperrit' that stopped passers-by and seized children. Nursery maids carrying their wards would scurry past the place in utter fear, and one wonders what dreadful occurrence in the distant past might have evolved this belief.

On occasion, an Exeter ghost meant dire news. The Revd Sabine Baring-Gould recorded in 1908 that he knew of a Mrs Burrow, who had spotted an acquaintance named Jones one night in Fore Street. Jones was a retired silversmith, and as she endeavoured to catch him up Mrs Burrow watched him walk up to the door of his

former place of business – and completely evaporate. The next day a messenger informed her of Jones' death ... which had occurred exactly the time she saw him vanish in Fore Street.

Numerous ghost scares have gripped Exeter through the years. The *Exeter Flying Post* told its readership in July 1897 that there was a haunted house in the vicinity of Sidwell Street, an ordinary terrace with its back in juxtaposition to a church (of which there are numerous here, including the Saxon St Sidwell's church, later destroyed during the war). Initial reports suggested the house was plagued by a repetitious knocking noise, including a hammering on the front door, which, when opened, presented no persons in sight. The occupants becoming frightened, watchers were posted at the windows to spot tricksters, and one witnessed the ghostly silhouette of a woman moving silently across the yard. She appeared to be dressed in black and paced to and fro before stopping in front of a monument 'that stands in the yard.' This seemed to excite the spirit, for 'she' began gesticulating and waving her arms about wildly before disappearing in a spectacular flash of lightning. The following night, the same performance was repeated, with the family's poor cat shrieking at the sight of the woman in black and shooting away, never more to be heard from. On another occasion the phantom woman appeared within a room inside the house, this time robed in white: 'She simply stood a moment or two, then made fireworks of herself.' An eyewitness told the *Post*: 'Suddenly it changed into a bright light, and shone up the room something splendid for five minutes.' Things took a sinister turn two days before the story hit the press, when, at about 1.30 a.m., the family's daughter was found unconscious in a back room after venturing in to close a window. When she came round, she claimed that something invisible had gripped her by the shoulders, whereupon she had fainted away. Following the newspaper reports, huge crowds swelled outside the house for two nights running, having to be kept in order by the police.

A curious feature of this case is that the *Post* didn't actually specify a particular house, yet the mob clearly focussed its attention on a specific domicile, indicating they 'knew' a certain house to have a reputation already. In the end it was decided the 'uncanny visitor' had been frightened away by 'the monument (presumably a religious icon) at the back of the house'. The last rumour to sweep the crowd was that said monument had been found inexplicably shattered into pieces.

During a Christmas visit to St John's Hospital School in 1904, the Dean of Exeter happened to let slip that the trespassing of a ghostly woman sometimes interrupted the privacy of the Deanery. Intrigued, the *Western Times* investigated and confirmed from Chancellor Edmunds that the story was true. This phantom woman had been around quite a while longer than the Deanery itself; for in the time of Athelstan a nunnery had been situated here, and sometime during the reign of Edward the Confessor a nun was supposedly immured in one of the walls for some unknown offence, possibly a clandestine affair. The *Times* (27 December 1904) noted: 'Having paid the penalty of her crime, the lady now "walks" the Deanery ... it is reassuring to know that the Dean's household do not allow their peaceful repose to be disturbed by the knowledge that the lady sometimes takes her walks.'

In November 1919, a Women's Institute meeting in Exeter heard that the Abbot's Lodge in Cathedral Close was 'within recent years' haunted by the distinct sounds of a

scuffle – followed by a thumping noise that sounded like a body being dragged down the stairs. The then-residents declared that they thought the sounds were something to do with a former Abbot of Buckfast, who was around in the Middle Ages. He had been murdered in the ancient Banqueting Hall, they believed. Unfortunately the Abbot's Lodge was totally destroyed during an air raid in 1942, when it received a direct hit and four persons died.

In the twenty-first century, ghostly stories are still popular in Exeter, with many stories centring on the Well House Tavern in Cathedral Close. This historic inn is well known in the city centre as a prestigious restaurant, and for as long as anyone can recall a collection of bones has graced the Well House basement cellar.

These were originally thought to belong to a fourteenth-century plague victim, but more recent examination at St Alfred's College, Winchester, has discovered they belonged to both a man and a woman. There is an old tradition, very well known in the city, concerning the days when there was a Tudor college for monks in Cathedral Close. When one monk embarked on a relationship with a nun and made her pregnant, the church authorities threatened the pair with execution. The pair threw themselves to their deaths down the well in Cathedral Yard; nowadays they are referred to as John the monk and Martha the nun. John is said by some to be the strange figure in a cowl that has allegedly been glimpsed in the courtyard, while a wafting scent of rose water sometimes caught in the air has been linked to Martha.

'Martha', at least, might be connected with the lady who haunts the Deanery mentioned earlier. Upon visiting the Well House recently, and being shown the skeleton(s) I was told they belonged to both 'a boy and a girl', while forming a whole skeleton – so one wonders where the other half of the remains lay interred. For the staff, the biggest mystery is the inscription emblazoned on the wall behind the remains, which is partially decipherable and appears to offer the solution to the salvation of those entombed – and perhaps the salvation of mankind itself.

I have also heard that the thirteenth-century Turk's Head building on High Street earned a very sinister reputation for itself before its closure in January 2005 – because it was claimed an elegant lady in a long, flowing gown appeared and disappeared on one of the balconies. (This ancient building next to the Guildhall is, at the time of writing, Prezzo restaurant.)

Guided ghost tours by red-coated historians are now a popular fixture of Exeter's vibrant social life, and perhaps a fuller study of this great city's ghostly heritage ought to be left to one of the many regional ghost-hunting concerns, or tour leaders. In conclusion, I can do little better than quote the *Exeter Express & Echo* (28 August 2008), which justifiably congratulated itself on the city's haunted heritage following the publication of the Revd Lionel Fanthorpe's *Supernatural Britain Report*:

[Exeter] is rated as the fourth most haunted city, with nine out of every 10,000 residents reporting a ghost sighting since records began, according to the report. Ghost tales in Exeter include that of a nun at the cathedral, which has been seen gliding alongside the south wall of the nave on July evenings [Martha again?]. Another harks back to the English Civil War between the Parliamentarians and Royalists. The heavily pregnant Queen Henrietta Maria took refuge in Exeter in 1644 and, although she

Skeletal remains grace the Well House's cellar.

escaped to Falmouth and then fled to France, her ghost has reportedly been seen in the gardens of Barnfield House.

On 2 October 2010, the *Express & Echo* told its wide readership of more recent paranormal entities in Exeter, again drawing on Revd Fanthope's research. These included a female form in a long black cape glimpsed in the courtyard of the White Hart Hotel on South Street; historically, this place is believed to be haunted by the ghost of the notorious Judge Jeffries. Articles like these in local newspapers are often intriguing, however, for their locally well-known incidental detail. The *Express & Echo* notes, 'students of the strange have welcomed the new reports that go well with existing tales, notably the Giant Bat of Magdalen Road, the heavy breathing Roman of Marks & Spencer and the phantom cyclist who pedals the Underground Passages.' And long may these types of legend continue in Exeter.

Echoes of the Past at Tiverton Castle

Few buildings evoke such a feeling of history as venerable Tiverton Castle, which stands in a commanding position near St Peter's church on the lip of a cliff above the banks of the River Exe. Originally built in 1106 by order of Henry I, and later rebuilt

and much enlarged in the thirteenth and fourteenth centuries, it was once the home of the powerful medieval Courtenay family and also of a princess, Katherine Plantagenet, daughter of Edward IV and wife of William Courtenay, who became Earl of Devon. Unfortunately for the Courtenays, this royal alliance led to their eventual downfall in that turbulent age. During the Civil War, the castle was besieged by Sir Thomas Fairfax and fell to him thanks to a lucky artillery shot fired at the drawbridge from the nearby Iron Age settlement called Cranmore Castle. With later additions and alterations down the centuries, all periods of architecture from medieval to modern can be seen, and beautiful walled gardens grace the romantic ruins. Nowadays the castle is a peaceful private house; it is open the public, allowing them to soak up its historical ambiance.

Ghost stories have been told here down the ages. Sometime in the seventeenth century, when the castle was governed by Sir Hugh Spencer, a bitter duel was fought between the castle's manager, Maurice Fortescue, and Sir Charles Trevor, a wealthy local dignitary and suitor of Sir Hugh's daughter Alice. The quarrel had arisen after Sir Charles Trevor had killed Maurice Fortescue's dog Vulcan with a sword, whereupon Maurice had punched Sir Charles in the face. When the duel was fought in woodland beside the flooded River Exe, Sir Charles defeated his young opponent by fatally stabbing him in the neck before throwing his corpse into the swollen river. Alice, who had watched the battle from a castle window, ran down to the scene and launched

The grounds of Tiverton Castle.

herself into the Exe to drown. She had in truth been in love with Maurice Fortescue, and his death had left her nothing to live for. At the castle, they say, 'ever since that day it is said that whenever the Exe is in flood the ghosts of Maurice, Alice and Vulcan may be seen walking together in the woods at the foot of Tiverton Castle.'

From around 1930 to 1965, the Shield Room here was used as a doctor's waiting room, with the surgery being in the next room. The last practitioner here, Dr Roche, would often sit and gossip with his final patient of the day, and on numerous occasions both he and his patients would hear a loud coughing from the waiting room. Of course, when Dr Roche looked there was no-one there, and so one day the doctor placed a bottle of cough mixture and a spoon in the room. The mysterious phantom coughs were never more heard thereafter.

Upon contacting the castle, I was told, 'Dowsers have found lots of underground passages here which came in useful during the Civil War, but they are now impassable … we are told there are many ghosts at the castle, and there are several ghost stories. We have never seen them but many visitors have, and we understand there are many happy, smiling ghosts to be seen, but sadly we do not know who they are.' All said, Tiverton Castle is a great place to visit, although – like many places in this book – visits from paranormal societies are not encouraged at the time of writing; the owners would rather not disturb any spirits that might be here.

Strange Tourist Experiences in Lydford

Lydford is a secluded village by the River Lyd, dominated by the remains of its castle (although in fact, the building was used as a prison from 1195 to house offenders against forest and stannary laws). Up the Lyd, about half a mile east and near a mine, is a waterfall, upon a smaller scale than the one at Lydford Gorge, called Kitt's Hole or Kitt's Fall. This stems from the circumstance of a woman named Catherine, or Kitty, having been drowned there when returning from market, owing to the rising of the water after heavy rainfall. This accident seems to have happened prior to 1846, when the traveller Rachel Evans noted the event.

According to the prolific writer and ghost hunter Elliott O'Donnell, among others, Kitty's ghost is supposed to have been seen by two visitors to Lydford, who spotted an woman draped in a red shawl at the foot of the fall; she carried a basket, but seemed to slip into the water. These witnesses rushed to find help, but encountered a singularly unconcerned local who merely told them they had seen Kitty's ghost: 'People can't be drowned twice.'

It is at Lydford Castle that a more recent ghost may have been seen. The castle was at one time considered to be 'one of the most heinous, contagious and detestable places in the realm', and today presents a four-sided behemoth on a grassy plateau, scowling at the beautiful countryside about it. I personally know of a person who, early in May 2012, was walking up to the castle when he spotted what he took to be a fellow visitor already on the hill walking beside the wall. The figure evoked no strange sensation: it appeared to be a woman, with dark hair, moving and seen from the back, wearing a modern, multi-coloured, raincoat, carrying a rucksack over her arm. Thinking he had

Lydford Castle.

company, this witness started up the hill, but in quickly walking round the castle exterior he found the person had entirely vanished. From his commanding vantage point the mysterious woman was nowhere to be seen, in any direction – for even if 'she' had left the castle she ought easily to have been spotted walking down the hill or somewhere in the immediate vicinity. The castle is, after all, not too large. The woman was also nowhere in the subterranean dungeon complex: she had completely disappeared. So puzzled was this witness that he even scoured the nearby church, although in the full knowledge the person could not have got there without being spotted.

This witness, though bemused, was unconvinced he had seen an apparition, largely because the person looked 'too modern.' But in discussing this matter with others, the consensus has been that it might easily have been a ghost: after all, if ghosts be 'real', then it is only natural they reflect modernity and are not all phantom Cavaliers or Tudor white ladies. To me, this line of thought leads only to the conclusion that we might – possibly – see ghosts more than we realise, if said ghost is not noticeably out of place...

Ladies of The Night at the Minerva Inn, Plymouth

In a place of such history, the Minerva Inn on Looe Street, Plymouth, has a unique claim: for it is believed to be the city's oldest serving public house, dating from around

1540 and meaning that Drake would have known of it. The pub is timber-framed, and a lot of the timber is from the Armada fleet – including a mast hosted in the spiral staircase leading to the private residence. Stories of plots and rumours of secret tunnels are quite believable in a place like this … and so are the tales that press gang operatives furtively dropped money into pints of beer here in the seventeenth century. When an unsuspecting drinker picked up the tankard, he had 'legally' accepted the king's shilling and so would suddenly and violently be hauled off to a ship against his will to join the navy.

At this historic place, they tell me:

> The Minerva always has a welcoming friendly atmosphere, yet occasionally there has been felt a ghostly presence. First-hand experiences in recent years have included a levitating spoon, numerous instances of the cellar gas being turned off, the jukebox playing after it has been switched off, and a small figure standing at the bar. There are other ghostly tales from past landlords and locals of a couple of prostitutes sitting directly under the dartboard where the original entrance door was, and our pet dogs don't seem keen on that area of the pub, so maybe they sense something too!

It is only natural that in the past a marina inn like the Minerva would attract clientele like prostitutes; but, as I put it to the owner, I would love to know how these two ghostly ladies were identified as such!

Haunted Homes

Allegations of ghosts do not need to be confined to rambling rectories, historic stately homes or centuries-old pubs, they can attach themselves to the type of house you or I may inhabit. Consider the extraordinary rumours sweeping the fishing town of Teignmouth in May 1867. Following the death of a man who lived on Bitton Hill, some people were claiming that the deceased had been seen in his dwelling from the street outside and through an upper window. He wore a white vest, necktie and collar, his eyes appeared sunken, and his appearance patriarchal; on 22 May the windows were painted black to stem these rumours but by this time half of Teignmouth was there, and the usual clashes erupted as the constabulary (fearful of a blocked thoroughfare) tried to move folk away from the 'haunted house'.

In 1925 the Devonshire Association collected another tale of a haunted house, this time in the middle of nowhere north-west of Tiverton, at Creacombe. Events were supposed to have occurred around 1845, when the parish parson was enlisted to combat a strange apparition that appeared on the landing at midnight. As midnight came and went, the parson contemptuously denied the stories of a 'ghost'; at which denouncement the candles were suddenly extinguished and the parson was violently shoved down the stairs, landing flat on his back at the foot of the last step.

On 10 April 1888 the *Western Times* reported the strange ghost plaguing a rented property at 'a very good locality' in Brixham. One tenant had moved out, frightened by a strange figure that waved its arms in front of the fire or manifested on the stairs,

and his departure was swiftly followed by another – prompting the landlord to lower the rent drastically. When the house became tenanted, watchers kept a vigil. Upon strange noises and sights (undefined) being experienced, they chased 'something' that disappeared up the chimney. This proved to be a large cat, and the *Times* (in the rational, superior fashion of late Victorian reporting) considered the matter explained, although it has to be wondered how a cat could wave its 'hands' or frighten grown men out of their house.

In Crediton, it was a residential house where multiple ghosts were seen. According to the *Western Times* (2 March 1934), a female occupant – who wasn't specified – had died two months earlier. Since then, the lady of the house and her children had seen the dead woman's ghost on three occasions. In one instance, the lady deliberately stayed awake to see this spectre, and saw her at around midnight stood at the foot of the bed, silently beckoning. This was around the time of the deceased woman's death, and her appearance was preceded by three knocks on the wall. The witness concerned appears to have been extremely sensitive to paranormal phenomena, for three of her children had died some years prior, and about three weeks after their death all three appeared in front of her as she sat in the kitchen reading. Impulsively, she held out her arms to embrace them, but the ghost of the eldest child shook her head, and said, 'No. We will wait for you here.' The father claimed only to have heard mysterious rapping on the walls, and crockery shaking in a cupboard. The exact address of the house isn't specified.

The Devonshire Association were avid collectors of folklore in the early 1930s, and recorded another haunted house. Mrs M. Eckett Fielden contributed a strange story from Coffinswell, between Newton Abbot and Torquay, where she knew a woman who complained of frequently hearing an unnerving sound upstairs like a heavy wagon drawn by two horses passing overhead. One night, this lady's brother saw the white spectre of their deceased mother standing beside the bed, looking at him and his wife, and when his wife screamed 'the apparition disappeared into an old chest'. The following day a parson was enlisted; he spent an entire night in the haunted bedroom, armed with a Bible, and afterwards the paranormal phenomenon was never more experienced.

A weird poltergeist was reported to be plaguing a family of three living on the premises of a butcher in St Marychurch, Torquay. According to the *Daily Mail* (14 May 1977) the entity – described as 'something evil' – appeared to want to financially ruin the Harding family, emptying a cashbox of £5 notes despite its being locked within the confines of a safe. Money vanished so frequently and inexplicably that the family took to sleeping with the money under their pillows, or clenched in their hands; yet still it disappeared during the night. As their business fell into ruin and their marriage was threatened, the family brought in the Revd Michael Malsom to bless the house, but the phenomenon continued unabatedly – even after the resident husband, Mr Harding, moved out. In the end, the whole family were forced to leave by this weird phantom thief.

Perhaps all houses wherein people have lived have the potential to harbour some ghostly occupant. In August 2012, for instance, I was told by a lady in Tiverton that her husband had once lived in a house in South Devon haunted by a poltergeist. Apparently, he became quite accustomed to this entity: for at one point the din the

thing caused actually prompted him to tell concerned visitors, 'Don't worry – that's not our china he's throwing around!'

Maybe I have even experienced a haunted house myself. Recently, I was told by the occupant of a residence in Bridestowe, southwest of Okehampton, that there might be a ghost there. This beautiful terrace of old houses at one time apparently formed a single building, and there is a vague story that, long ago, a maid was executed by an outraged local dignitary upon finding out she had been having secret liaisons with the servant boy. They apparently used to whisper their romantic intentions through a slender gap in the attic woodwork that divided their apartments (which my informant herself had been forced to close up, due to safety restrictions), and the disgusted, puritanical owner had killed the girl upon discovering their trysts. It was said he hanged her from the staircase beams of (what is now) the middle terrace, and this was the reason for an uneasy sensation, or presence, on the stairs that at the time of writing appears to affect the owner's cat and dog. Having stayed in this very house I have experienced the uncomfortable sensation, at around 9 a.m., of hearing footsteps clumping up the staircase in the full knowledge this place was empty apart from myself.

This occurred during those twilight moments between sleep and being fully awake, so I am inclined to dismiss it as a dreamlike phenomenon. But, then again, who knows…

Like many places in this book, the premises are privately owned, and any incursion on the owner's privacy is considered undesirable.

Brixham's Ghost Who Ignores the Smoking Ban

In 2012 I talked to the curator of Brixham Heritage Museum near Bolton Cross, after hearing long ago that the place allegedly had ghosts. The museum has been housed here since 1976, although prior to this the building, which dates to 1902, was Brixham's police station and sergeant's house. The museum is dedicated to the history and heritage of the town and at the time of writing has been shortlisted for the *Sunday Telegraph* Family Friendly Museum Award.

In its former incarnation it naturally saw drama: for instance, on 20 August 1942 a Canadian soldier named Fowler walked into the station and surrendered a revolver, confessing he had just fatally shot Miss Daisy Kitto with it in Burton Street. But curiously the ghosts here do not seem to be linked to anything criminal. For, as the curator explained to me, one of the most often experienced manifestations concerns the particular smell of cherry tobacco being detected in the nostrils despite a smoking ban having been imposed in all public buildings in England. I was told this smell was 'quite distinctive' and the curator had himself detected the smell when there was nothing anywhere in the building that could account for it. Strangely, it is said that one of the last officers to work the station here in the 1960s smoked such a brand of tobacco. I was also told he was 'now deceased' – so perhaps the old officer loved his beat so much that some phantom evidence of him still lingers. It is an interesting concept that ghostly manifestations need not be 'phantom people', as it were – but can be 'smells' too.

But there is another, distinct ghost here that has also been experienced a number of times. In fact, when I talked to the curator here on 28 May 2102, 'it' had been seen

within the last day by a worker. Numerous volunteers claim to have witnessed this wraith over the years, all of whom are described to me as 'level headed.' The ghost is described as a 'shadowy figure that bears the outline of a woman,' whose identity at the moment is not known. Both these ghostly manifestations have happened so often that the place has recently allowed television's *Most Haunted* team onto the premises to try and explain the riddle.

The Phenomenon of Ghosts

To illustrate the dilemma concerning the 'reality' of ghosts, we have certain stories that, as reported, sound like attempts by the popular press to imply such superstition was a national embarrassment, and ghosts could not and did not exist. This is perhaps most evident in the accounts of the late nineteenth century, where certain ghost stories were even turned into jokes with superior rationalisation. The *Exeter & Plymouth Gazette* (5 February 1884), for example, reports 'a funny story' that the spirit of an old man, John Perriman, who had been murdered the previous September, was rumoured to be visiting the scene of his death in Branscombe. When a man was pursued by a white 'something' to his door that bowled him over, terror swept the village … until it was supposed the ghostly attacker was a white ram that had butted the man and then jumped over a hedge in the gloom. The *Gazette* found these events in Branscombe extraordinarily funny and backward, the ram theory detracting from what, until that point, had apparently been considered a genuine haunting.

Nowadays, the average reader might find it more difficult to believe that a nineteenth-century Devonian could not distinguish the difference between a sheep in a darkened lane and a ghost, as was implied. But, strangely, by the mid-twentieth century allegations of ghosts were being treated with a healthier combination of possibility, open-minded scepticism, intrigue and pride – a spiritualist revival having supplanted in many quarters the automatic ridicule of so many late nineteenth- and early twentieth-century ghost stories. For example, upon the outbreak of war in 1939 the *Western Morning News* reported on the fifteenth-century Bradfield House's offer to be a hospital if needed. In doing so it straightforwardly observed that this historic home of the Walronds near Cullompton had a ghost:

> The ghost of a murdered maiden is said to haunt one room and to be responsible for mysterious rappings on doors. The ghost is said to appear to alternate generations of Walronds, but Mrs Adams [the late honourable Lionel Walrond's wife] assured me [the reporter] that to her knowledge nothing has been seen or heard for three generations. As for the hidden treasure, a relic of the troubles of the Civil War, repeated search has revealed no trace.

Bradfield is now used as a private home.

For all the stories (and there are many in Devon), there are still to this day people who are willing to come forward with credible testimony to the effect that they have seen ghosts, and this does make me loathe to automatically dismiss anything of a

folkloric nature that has gone before. Lately, the *Mail* (18 February 2012) has reported that until recently Heale House (a fifteen-bedroom mansion near Heale Wood, south of Bideford) was subject to the visitations of a pale figure who seemed to be a woman. She appeared frequently at around 1 a.m., and drifted along the corridors and into bedrooms surrounded by a kind of blue haze. She faded away at the legs and was sometimes accompanied by the faint strains of Chopin's music. Some who saw her were terrified, but what is interesting is that the current owner also personally professed to having seen her at the foot of his bed.

This gentleman explained that he had been presented with a portrait during a visit to a local junk shop (the proprietor surmised he might be from Heale House and declared she had a gift for him). The image was that of an Edwardian lady named Mrs Bell, wife of an Argentine beef baron: she had lived at Heale in the early twentieth century, and the portrait depicted her sitting at a piano which still graced the drawing room of the mansion. Apparently Mrs Bell had fallen into bankruptcy and been forced to sell many of her possessions, including her own portrait. Once Heale's owners had rehung it in the drawing room the ghost stopped appearing, and viewers of BBC television's *Antiques Roadshow* (19 February 2012) may recall Heale's current owner having the picture valued and the story being told. The portrait depicts a handsome lady with auburn hair seated elegantly and dreamily at the piano, in satin and silk, and is thought to have been painted by Cyril Roberts.

There is really no ambiguity in cases like this: events either happened as we are told, and as such 'ghosts' exist ... or they did not.

Nowadays, far from the multilayered mystery of ghosts being consigned to a superstitious past, the phenomenon can be taken quite credulously. In May 2004 it was widely reported in the national media that the Royal Navy had called in a nineteen-strong team of mediums, psychics, and historical researchers to investigate claims of spectral activity inside eighteenth-century buildings at the South Yard of Devonport Naval Base, Plymouth. The base's commander made no bones about the fact that since the Second World War many people who worked there had reported ghosts: a little girl in Victorian costume who played with equally-phantom toys, and a bearded eighteenth-century sailor in the master rope-maker's house, for instance, as well as a weird paranormal atmosphere in the nearby hangman's cell in the ropery. The latter contains what is thought to be the only remaining working gallows in Britain, and was the scene of numerous executions of French prisoners of war. The paranormal team employed started a two-night investigation here on 28 May that year. (Nor is this unique: the *Mirror* (17 January 1968) reported a poltergeist at the Royal Marine Barracks at Lympstone, today the Commando Training Centre, that lifted an entire pile of wood shavings 2 feet into the air and fiddled with the boiler in the boiler house, all for the benefit of a witness.)

When an investigation of this kind takes place under controlled conditions and under the auspices of those commanding the largest naval base in western Europe, it ensures that – for now – the mystery of ghosts is one that cannot be straightforwardly dismissed. As for the eternal, unanswerable question of what causes ghosts, there are several antiquated theories in Devon. A curious one concerns Devonport itself, for *Choice Notes From "Notes And Queries"* (1859) states a past commissioner here as

saying, 'When I was young it was thought lucky to have a still-born child put into any open grave, as it was considered to be a sure passport to heaven for the next person buried there.' Although this might appear somewhat tasteless, it is in fact recognition that such an uncorrupted soul was already assured a place in Heaven, and those interred beside them could benefit from the same aura of innocence when their time came to be judged. The spirits of others might take longer to leave this mortal coil. But perhaps one of the oldest and simplest Devonshire traditions is the right one: they say no soul can escape from the house in which its body died unless all the locks and bolts are opened … A curate in Exeter noted this ritual as being actively performed when he submitted correspondence to *Choice Notes* in the nineteenth century.

Whatever the explanations are, they are currently, perhaps tantalisingly, out of our sphere of understanding. It may be that these strange and often unnerving manifestations are fleeting glimpses through the gap in the curtain, evidence of another plane that the living have hardly begun to explore even barely competently. However, one thing is for sure: such is the average Devonian's fascination with ghosts of all types that the phenomenon will be studied, reported and speculated on until it is either explained to the amazement of us all as being true, or is finally dismissed as utter, childish nonsense. Either way, I doubt we will have an explanation in our own lifetime, and in another 200 years, when a similar book of this nature is being written, I suspect these same conclusions will still be the only ones reached!

The most recent (November 2012) ghostly mystery I have been told concerns 'an old cottage in Okehampton'. On at least two occasions, the young son of the family living in the cottage had told his parents about a funny 'man in slippers' who appeared in the corner of his room and danced about like a puppet on a string. This apparently did not alarm him; however, one day the boy encountered this strange figure on the stairs, and this time the man glared at him so madly that it terrified the child, forcing him to run to his mother in a flood of tears. My informant was the aunt of the child concerned, and she explained that while babysitting at the cottage, she had heard frighteningly loud thumps and crashes overhead, which had made her fearful of going upstairs; amazingly, when she did, she found her nephew, and a sibling, fast asleep in their respective beds, and the source of the noise remained unexplained.

Anyone with even a passing interest in the paranormal in Devon will know that, in theory, this chapter could continue indefinitely. There were many stories passed to me that I couldn't even begin to get to the origins of: an actor from *Z Cars* who haunts Brixham's theatre, a ghost that appears in a bombed-out church in Plymouth on a certain night each year, and something called the 'Tavistock badger' – described to me as the 'least frightening ghost you could imagine'! Allegations of ghosts in Devon, both folkloric and eerily sincere, seem to hugely outstrip many other counties, which I suppose says much; but here we must leave the realm of clanking chains, ghosts and poltergeists to explore other dimensions of the paranormal in Devon: the world of creatures that are not supposed to exist, strange phenomena, and mysterious beings linked to other worlds and dimensions.

CHAPTER TWO

Footsteps into the Unknown

Introduction

Perhaps little needs to be said about Devon's most enduring mystery – the night they say the Devil walked across the snowy landscape of the county. All over southern England, the winter of 1854/55 was the coldest in living memory, and the people of Devon awoke on the morning of 8 February 1855 to observe that 2 inches of snow had fallen while they slept – and that the accompanying severe frost had frozen a trail of mysterious footprints that zigzagged across about 100 miles of the county. An account of the mystery in a monthly periodical called the *London Investigator* (Volume 1) was typical of the reports that featured in the contemporary Victorian media, in which the phenomenon was discussed nationally:

Considerable sensation has been caused in the towns of Topsham, Lympstone, Exmouth, Teignmouth, and Dawlish, in the South of Devon, in consequence of the discovery of a vast number of foot-tracks of a most strange and mysterious description. The superstitious go so far as to believe that they are the marks of Satan himself; and that great excitement has been produced among all classes may be judged of from the fact that the subject has been descanted on from the pulpit. It appears that, on Thursday night last, there was a very heavy fall of snow in the neighbourhood of Exeter and the South of Devon. On the following morning the inhabitants of the above towns were surprised at discovering the foot-marks of some strange and mysterious animal, endowed with the power of ubiquity, as the footprints were to be seen in all kinds of unaccountable places – on the tops of houses and narrow walls, in gardens and court yards, enclosed by high walls and palings, as well as in open fields. There was hardly a garden in Lympstone where these footprints were not observable. The track appeared more like that of a biped than a quadruped, and the steps were generally eight inches in advance of each other. The impression of the foot closely resembled that of a donkey's shoe, and measured from an inch and a half to (in some instances) two and a half inches across. Here and there it appeared as if cloven, but in the generality of the steps the shoe was continuous, and, from the snow in the centre remaining entire, merely showing the outer crest of the foot, it must have been concave. The creature seems to have approached the doors of several houses, and then to have retreated, but no one has been able to discover the standing or resting point of this mysterious visitor. On Sunday last the Rev. Mr. Musgrave alluded to the subject in his sermon, and suggested the possibility of the footprints being those of a kangaroo;

but this could scarcely have been the case, as they were found on both sides of the estuary of the Exe. At present it remains a mystery, and many superstitious people in the above towns are actually afraid to go outside their doors after night.

Hundreds saw these tracks, and scores of letters poured in to newspapers in which people debated what on earth might have caused them. According to one story, dogs following the trail into dense bracken near the village of Dawlish could not be coerced into entering the undergrowth and backed away, howling dismally. Another contemporary discussion on the matter in *Punch* noted, 'It seems to have had but one leg, and, after proceeding up to a door, to have disappeared, as there are no backward traces.' Natural explanations were put forward for these sinister tracks – a badger, a rat, a toad, or some type of bird etc – but the last word on the mystery has yet to be written; suffice to say that at the time many people refused to leave their houses after sunset, and children took to hiding beneath their bed sheets, terrified by the fireside speculation of their parents that suggested the Devil himself had walked in Devon that freezing winter night.

As if to illustrate how such mysteries resurrect themselves, there was some mild controversy in Woolsery when strange, cloven hoof-shaped marks were discovered in a residential back garden in March 2009. As in the 1855 incident, the tracks followed a straight line in the snow and abruptly disappeared. The *Mail* reported: 'A 150-year-old mystery has reared its head after a woman woke to find "Satan's hoofprints" dotted across freshly fallen snow in her back garden.' Examination of the tracks suggested a natural explanation, such as a hare, but this does well to show how the most antiquated of paranormal superstitions still raise their mysterious head in the Devon of today.

Our second chapter is concerned in no small part with the overall weirdness of some of these superstitions. But this chapter also leads us ever further away from the natural world, into the domain of demons, witches and creatures that ought not to exist, and yet have still been reported, into the twilight world of pixies and the panther-like beasts they say prowl the countryside, and finally into the realm of everything paranormal outside of human explanation.

PART ONE

Cryptic Creatures of
Every Shape and Form

When the Devil Visited Devon

One of the stories told of Kent's Cavern, a system of caves and passages created some two million years ago about a mile inland from Anstey's Cove, Torquay, is that it was – or is – the very entrance to Hell itself. According to an article on Devon in *Harper's New Monthly Magazine* (Volume 38, 1839):

> It is a by-way to a very warm and unmentionable place. The legend as to its name is that a traveller went in there with his dog; the traveller was never again heard of, but the dog was found in a weak condition in the county of Kent, about 170 miles distant.

Curiously there is a nearby limestone promontory, jutting from the coast south of Redgate Beach, named Devil's Point.

Worryingly, the Devil seems to have periodically emerged from Hell and taken an entirely unholy interest in the county of Devon. A typical legend is retold in *Black's Guide To Devonshire* (1864) of Buckfastleigh:

> You ascend to its elevated church, which is perched up on high as if to make religion difficult, by a flight of 130 or 140 steps. Of course, the legend runs that it was placed here out of the reach of the Devil, who had a troublesome habit of undoing every night the work accomplished by the building during the day...

In the nineteenth century, a large block bearing the mark of the 'enemy's' finger and thumb was pointed out on a farm about a mile in the distance, as proof of the event.

A similar story is told of Brent Tor, which – with its little church perched high on the summit – forms a striking landmark north of Tavistock. It is thought the church's original function was as a beacon, on which wood, turf and other fuel was burnt by way of a signal, although tradition ascribes its elevated position to interference by the Devil. The church, they said, was originally built at the foot of the tor but Satan continually moved the building materials to the summit with no other purpose than frustrating the project. In this he was disappointed; the labourers simply opted to build on the summit, where the blocks were being displaced. Here they completed the church

Brent Tor.

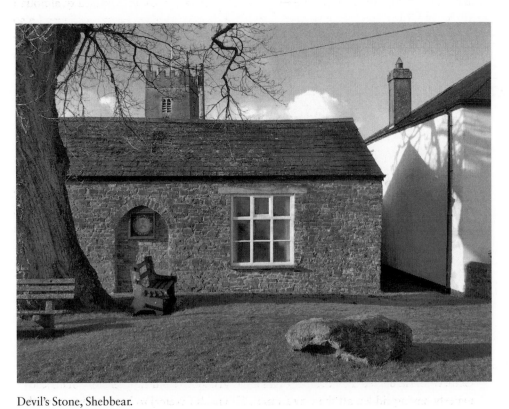

Devil's Stone, Shebbear.

despite being harassed by furious winds and visits from 'the arch enemy'. Upon the church's completion, immediately after its dedication to St Michael, the patron saint miraculously appeared and hurled such a tremendous mass of rock at the Devil that he retreated and never returned to Brent Tor. *Murray's Handbook for Devon* explains that the rock 'may be seen to this day at the base of the tor'.

A grim story, retold in *Choice Notes From "Notes & Queries"* (1859), explains that the Devil came to the grave of a recently deceased Devonshire squire, who had sold his soul. He disinterred the squire's corpse and flayed the skin from it, remarking ruefully 'Well! 'Twas not worth coming after all, for it is all full of holes.' He then directed his attention to a witness, a friend of the squire's who had been employed to watch out for the Devil and was sat petrified on the parson's pew holding a live cockerel. Satan belched fire as he roared, 'If it had not been for the bird you have got there under your arm, I would have your skin too!' From this we learn that the Devil was fearful of cockerels, but the tolling of church bells also affrighted him: according to H. A. Hill's *East Worlington Kalendar* (1910) Satan dropped the Long Stone by the roadside when he heard East Worlington's church bells. This stone can still be seen where the road divides at Stone Farm, leaning heavily to one side; perhaps this is on account of the numerous attempts made to shift it using teams of horses – all of which proved fruitless, of course.

It is a curious fact that in Shebbear a ritual is still carried out every 5 November, whereby the large boulder standing before a 700-year-old oak in St Michael's church is ritualistically turned over. The origins of this ancient custom are lost to antiquity, although some believe it is linked to the ancient Britons and sun worship. However, legend also links it to the Devil, the earliest stories, as reported, saying that Satan dropped the stone there when he was descending from Heaven to the nether regions, making people afraid to remove it. Turning the rock over was considered the only way to avert disaster, with one elderly inhabitant telling a reporter from the *Exeter & Plymouth Gazette* in 1937, 'If we didn't do this we should lose all we have and should be dead in a fortnight.'

The Devil as a Real Threat

That some stories of the Devil are pure folklore is clear: for instance the one about him playing a match of quoits with King Arthur atop a haunted Dartmoor tor sounds rather implausible. But some were touted as real incidents. A Tudor monograph mentions briefly that 'certain players at Exeter acting upon the stage the tragic story of Dr Faustus the conjurer' were frightened out the theatre when they observed there to be an extra figure among the actors portraying Faust's demons. Convinced the Devil himself had joined them on stage, the players fought to be the first one out the door, and are said to have left Exeter the following morning after spending the night in fervent prayer. In 1868, Sir John Bowring noted other strange stories like this:

> There was a story of Satan having knocked down with a Bible the keeper of the Exeter Gaol, who had denied the existence of his infernal majesty; and another story of his said majesty having ridden all the way from St Thomas's [Exeter] to Moretonhampstead behind a farmer, who fainted with fright when he reached his door.

When England went to war with itself in the 1640s, the civil conflict was seen by many as a wider struggle between good and evil. Rival journalists fought a propaganda war, in which they depicted the Devil as taking an active part in the conflict: one Royalist pamphlet reported in 1645

> ...a true and strange relation of a boy, who was entertained by the Devill to be servant to him with the consent of his father, about Crediton in the west, and how the Devill carried him up in the aire, and showed him the torments of Hell, and some of the Cavaliers there, and what preparations were made for Goring and Greenvile against they came. Also, how the Cavaliers went to robbe a carrier, and how the carrier and his horses turned themselves into flames of fire. With a coppie of a letter from Major General Massie, concerning these strange and wonderfull things...

Although this may seem fanciful, consider the event noted by the reliable Anna Eliza Bray in 1833 as happening a few years earlier near imposing Roborough Rock, on the haunted Down west of Yelverton. She wrote:

> Three men were at work late on the Saturday night at the South Devon Wharf, when suddenly they saw issue from the rock a large ball of fire, which, with a rumbling noise, rolled on towards them, and in its approach assumed a variety of forms; sometimes that of a human figure, then of a church with arched windows, pillars etc. The men were dreadfully terrified, and calling to their recollection that the Sunday had commenced, they fully believed they saw, and were pursued by the Devil; and this continues to be their firm conviction.

Roborough Rock: the Down has a sinister history.

As this implies, churchgoers were frequently warned of the dismal Hellish fate that awaited them if they were tempted by the Evil One into Sabbath-breaking. South of Belstone, on the hillside of Belstone Common stands a cairn circle of seventeen stones, which is called, singularly enough, the Nine Stones, or Nine Maidens. Of course, they nourish a fantastic legend concerning a party of Sabbath-breaking revellers who were smitten into stone as a punishment for their sins. Some claimed these petrified revellers were allowed to become animated every so often and dance at noon once more. This ghostly visage has been explained by the sun-heated moor giving off currents of air, which rose about the peaks, and lent the stones a kind of tremulous appearance. Mrs Bray, in correspondence dated 8 January 1833, explains there was also a contemporary story told by Tavistock mothers to their children. Not so long before, a 'youth of this neighbourhood' went nut picking in woods on a Sunday. He was joined by the Devil, who was pleased to help the youth, who should have been in church. When he spotted his new assistant's cloven foot, the lad fled the woods in terror, but it was too late, for he soon after perished.

We are presented with some intriguing descriptions of the Devil, from times when his influence was felt everywhere. Mrs Bray states that he was the patron saint of fiddlers, and:

Whenever he appeared before any one of these, he generally came in the shape of a gentleman, dressed in black, with white ruffles round his wrists; and he usually made so liberal a bargain that the sons of harmony were very much pleased with him; till they now and then happened to spy the cloven foot, a thing which he … had no power to hide.

This was a widespread belief in Tavistock. The Devil also targeted gamblers, and a story current in Dartmouth told how there was a certain Madame H. who lived in Lower Street. She was addicted to card playing, and when no other partner was available she chose to play with a certain 'dummy'. It seemed her vice had claimed her life, because one Sunday morning, her body was found reduced to ashes beside the card table in the parlour – this 'dummy' had been none other than the embodiment Satan himself.

There is a singular suggestion that the Devil played awful tricks in his boredom. The *Westminster Magazine* reported on 11 April 1752 that John Davy had been convicted lately at Exeter Assizes of murder. Davy, an adulterer, had been convicted of killing his estranged wife upon 'Ingolsby-Common' near Hatherleigh, after luring her there upon the pretence of reconciliation. He confessed that he previously bore his wife no ill will, but 'happening to be at the place before his wife, he never was so uneasy…while he was thus waiting he saw a tall gentleman, dressed in black, pass by him, who spoke to him, and told him he must kill his wife, and then disappeared'. Davy described 'much pleasure in his mind' when he subsequently saw his wife approach, yet after they had 'reconciled' (in a carnal sense) he throttled her to death while knelt upon her chest. Davy was executed at 'Heavy Tree Gallows' alongside four other convicted criminals on 3 April, his body afterwards being hung in chains at the site as a warning to others. Perhaps the only demons were the ones in his mind, but the implication in Davy's confession is that he was 'led' by an agent of evil to commit his wicked deed.

Of the Devil's quoits match with King Arthur, it is said that they both fell into flinging rocks at each other from their respective vantage points on Heltor and Blackingstone, and these settled down into rocks of granite that today surmount the tors. The Devil lost, and in his defeat he is said by some to have wandered in the direction of Northlew before eventually succumbing to cold and perishing. But this story notwithstanding, could any of the stories of the Devil have any basis in fact? As they say, the greatest trick the Devil has pulled lately is convincing the world he doesn't exist. Who knows, perhaps at one time he really did sit atop the set of rocks in the upper Cowsic valley denominated Devil's Tor, looking out over Dartmoor and wondering how he could bring Devon's people to ruination.

The Whisht Hounds

Dartmoor is the land of one of Britain's oldest and most famous supernatural phenomena. On stormy winter nights the peasants of times past would listen in terror for the 'Whisht Hounds' sweeping through the rocky valley at Shaugh Prior – the bloodcurdling cry of terrible dogs, the winding of horns and thunderous hoof beats. This was the demonic hunt itself, pursuing another luckless mortal into insanity or to their death over the tip of the rocky promontory known as Dewerstone Rock. According to *Murray's Handbook for Devon* (1851), 'Superstition has connected a fantastic legend with the Dewerstone. In deep snow, it is said, the traces of a cloven hoof and a human foot were found ascending to the highest summit.' The implication is clear: this was one unfortunate pursued here by his Satanic Majesty and the Whisht Hounds, whose unearthly master was sometimes spotted leading the hunt, 'a tall swart figure with a hunting pole'. Walcott's near-contemporary *Guide To The Coasts Of Devon* remarks of this frightening belief:

> ...echoing to the impatient stream of the Cad, is the cliff called the Dewerstone ... where the old folks say the snow is printed with the marks of unearthly feet, and the tracks of a black headless dog; and in the night when the storm winds are loosed on Dartmoor, (there) sweeps down a ghastly chase – the wild huntsman on his coal-black steed, with his goblin train, the baying of the hound and the blast of the horn.

Elsewhere, the Revd Sabine Baring-Gould (*d.* 1924), who lived at Lewtrenchard Manor near Okehampton, recorded the well-known belief that, 'on Heathfield, near Tavistock, the wild huntsman rides by full moon with his "wush hounds".'

This awesome visitation went by many names across the county: the Whisht, Wisht, Whist, Wush or Wish Hounds on Dartmoor, while further north they were referred to as the Yeth (Heath), S'Death, or Yell Hounds. Wistman's Wood, a remote copse of stunted oaks beside the West Dart River, is thought to owe its name to these phantom, yelping hounds, with Robert Hunt writing in 1865 that the wood '...is the very home of the Wish Hounds, which hunt so fiercely over the Moor; and this Wistman appears to have been some sort of demon creature, whose name alone remains.' He also noted that their favourite coursing ground was along the Abbot's Way, an ancient Dartmoor road that extended into Cornwall.

The hounds were heard much more often than their satanic master was sighted, however. While some firmly believed these canine creatures to be the incarnation of the souls of unbaptised children, most ascribed them a demonic origin – the very Hounds of Hell, chasing sinners and the godless. Some claimed to know that these creatures were in fact hunting down the spirits of unbaptised infants, so that they could find no resting place in their graves, and there is one ghastly tale of a man on horseback crossing Hamel Down, north of Widecombe, who encountered these creatures, as well as their otherworldly leader. The demon huntsman, for sport, threw the traveller a bag, which, when unwrapped, contained the corpse of his own deceased child. Depictions of the Whisht Hounds illustrate them as having coal-like red eyes and fire belching from their jaws, their sweating jet-black coats flecked with spots of blood.

The most famous story with these associations concerns Squire Richard Cabell, or Capel, whose bizarre looking altar tomb can be found next to the remains of the burnt chapel on the commanding ground overlooking the panoramic of Buckfastleigh. Cabell, when he died, was buried very deep in the ground, a square chamber with a great triangular roof built over his place of interment. Through the massive iron grille on the side that faces the church can be seen a plain card that reads, impressively: 'The Cabel Tomb. *c.* 1656. The source of local legends, and of inspiration to the author Sir Arthur Conan Doyle.'

The Capel tomb, next to the burned church.

In truth, very little is known of Cabell, except that he lived at Brook Manor, nestled away west of Buckfastleigh, was married (to Elizabeth Fowell at Ugborough on 7 January 1654/55, who bore him a daughter), and carried a position of authority locally. Where fact was lacking, rumour apparently filled the gap, for the Revd Sabine Baring-Gould wrote of the squire:

> Outside the south porch is the enclosed tomb of Richard Cabell of Brooke, who died in 1677. He was the last male of his race, and died with such an evil reputation that he was placed under a heavy stone, and a sort of pent-house was built over that with iron gratings to it to prevent his coming up and haunting the neighbourhood. When he died (the story goes) fiends and black dogs breathing fire raced over Dartmoor and surrounded Brooke, howling...

It hardly needs repeating that Cabell is generally considered the template for the wicked Sir Hugo Baskerville in Sir Arthur Conan Doyle's *The Hound of the Baskervilles*, who, 'in the time of the Great Rebellion', thundered into the Dartmoor night pursuing a maiden who had escaped his vile clutches. Baskerville was himself pursued, however: 'There ran mute behind him such a hound of hell as God forbid should ever be at my heels.' This monstrous creature tore Sir Hugo's throat out, and the old legend plays a pivotal role in Holmes and Watson's subsequent terrifying adventure. The story was suggested to Conan Doyle when his friend Fletcher Robinson recounted an old West Country legend to him: it can be no coincidence that Robinson lived at nearby Ipplepen, and most believe Robinson told Conan Doyle the story of Richard Cabell.

This type of story is found in many places across Europe and is often connected to the importation of Scandinavian mythology concerning Odin – and the corruption of his name, Wunsch. In 1866 the folklorist William Henderson, however, recorded of the Whisht Hounds: 'There are people now living who have witnessed it.' And a contributor to *Choice Notes From "Notes And Queries"* (1859) submitted this anecdote, which does make one scrutinize the 'Heath Hounds' with perhaps less scepticism than we might ordinarily: 'They were heard in the parish of St Mary Tavy several years ago by an old man called Roger Burn: he was working in the fields, when suddenly he heard the baying of the hounds, the shouts and horn of the huntsman, and the smacking of his whip. This last point the old man quoted as at once settling the question. "How could I be mistaken? Why I heard the very smacking of his whip."' The Devonshire poet Edward Capern also recorded that dread of the 'moor-fiend' still lingered in North Devon, his poem 'The 'Yeth' Hound' (published in 1870) being based, in part, on his recollections of an old matron who believed in the phenomenon without question.

Instances of lonely fatalities on the moor were sometimes ascribed to the Whisht Hounds, for according to local writer Ruth E. St Leger-Gordon, 'it is on record that when a man's body was found on the banks of the River Yealm in the 1870s, the coroner's jury, unable to establish any cause of death, decided that he must have been "struck down by the phantom hunt"'. As late as 1904, A. H. Norway's *Highways & Byways of Devon* notes that the yeth hounds hunted among the tors, spitting blue flames from their mouths, 'and there are many people still who have heard their baying'.

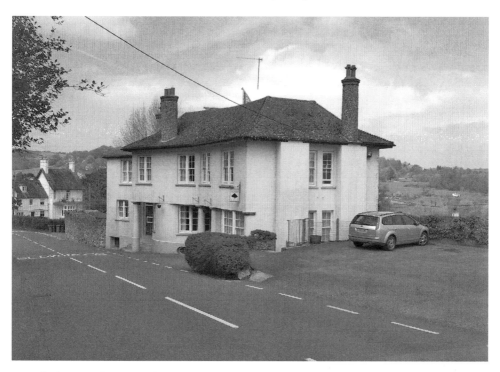

Not all phantom dogs were demonic. The Black Dog, Uplyme, owes its name to a spectral canine that divulged the presence of a hoard of coins in the attic, centuries ago.

Of Witches and Witchcraft

The following article appeared in the *Exeter Gazette* (4 May 1900):

> MONKLEIGH – A relic of the "dark ages" came to light in the shape of a "witch's bottle" on the reopening of a grave. There was a much-encrusted bottle containing an inky fluid, and in the cork as many pins as could be stuck. The legend runs that this was a charm to avenge one who had been bewitched, and would cause the death of the offending witch.

Finds like this occasionally occur today. In April 2009, for example, a scary looking mummified cat, judged to be some 400 years old, was found lodged in the wall of a house at Ugborough, during renovations to an upstairs bathroom. As the *Daily Telegraph* reported, the find raised a dilemma, even in these less than superstitious times: whether or not to replace it whence it came, as a previous occupant had apparently done two decades earlier upon its discovery. The lady of the house was worried that to replace the relic would give her 'bad dreams', and this observation is intriguing – given that the assumption is that this dead animal was entombed as a charm against the dark spells of witches all those years ago.

Discoveries such as these reflect the fact that at one time there was a very real terror of witches and witchcraft in Devon, and although the true age of witches now belongs

to another era, the phenomenon was a surprisingly long time dying out. But to begin at the beginning, the Tudor and Stuart eras in Britain were strange times, of which it is almost impossible to understand society without some knowledge of the part played by witchcraft in the lives of everyday people.

For example, in an affidavit dated 6 September 1681, an apothecary named Anthony Smith testified on oath that in around 1671 he had been called to assist a Honiton serving girl called Elizabeth Brooker, who had been brought to Exeter in agony, complaining of pains in her leg. Brooker claimed a woman of 'ill report' had threatened her in Honiton after an argument over the sale of some pins. When an incision was made in the affected area, to the astonishment of all present a large pin was found embedded beneath Elizabeth's skin.

It is not clear if the 'witch' in this case suffered any consequence of her threats. For accusations of witchcraft between antagonistic neighbours and relatives could spiral out of control terrifyingly quickly, and many a countryside beauty spot came to be spoiled by the carcass of an old woman dangling from a gallows erected outside the town. This usually followed a pantomime trial at which the most outrageous, shocking, disturbing and ludicrous allegations were heard. Most counties have their sensational witch trial of the age, and in Devon it occurred in 1682, the events neatly summed up in a contemporary pamphlet grandly entitled:

> A true and impartial relation of the information against three witches, viz. Temperance Lloyd, Mary Trembles and Susannah Edwards, who were indicted, arraigned and convicted at the Assizes holden for the county of Devon, at the Castle of Exon, Aug. 14, 1682, with their several confessions taken before Thomas Gist, Mayor, and John Davie, Alderman of Biddiford in the said county, where they were inhabitants: as also their speeches, confessions, and behaviour, at the time and place of execution, on the 25th of the said month.

Of particular interest are the depictions of the Devil we are presented with. Temperance confessed that she had met Satan in the form of a small dark figure, who appeared in a lane and was about the length of her arm. Afterwards, he took the form of a magpie or a grey cat. Susannah Edwards confessed to having encountered the Devil in Parsonage Lane, dressed very respectably and gravely in a dark suit, and she stated that afterwards he had shrunk to the size of a small boy. In both cases, the women admitted that they had carnal relations with the Devil, for he had 'sucked the teat' of both of them. Mary Trembles confessed the Devil came to her in 'the shape of a lyon' and sucked her so hard she screamed in pain. These women confessed to the most amazing of abilities: Temperance averred she could assume the form of a cat and Mary that she could travel invisibly. Their crimes were heinous, for they admitted causing many shipwrecks and murdering several people by witchcraft, including one Hannah Thomas, who they had squeezed to death. They could only say the Lord's Prayer backwards. However, when the three women stood on the scaffold minutes from execution, they denied everything they had previously been cajoled or frightened into admitting.

In 1696 one Elizabeth Horner was brought before the Lord Chief Justice in Exeter, charged with bewitching three of William Bovet's children, one of them fatally. Another

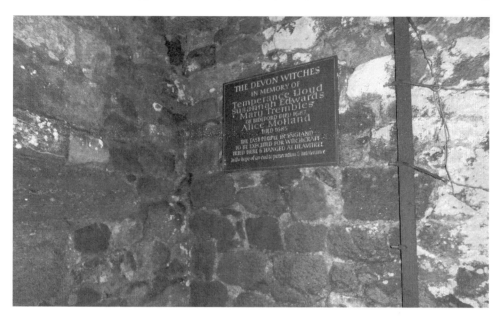

Memorial to the Bideford witches at Rougemont Castle, Exeter.

'had her legs twisted, and yet from her hands and knees she would spring five feet high'. The children vomited crooked pins and stones, and were bitten, punched, pricked and bruised by invisible hands; they also swore that Bess Horner's head would lift off her shoulders and 'walk quietly into their stomachs'. The children's mother deposed that one child had walked 9 feet up a smooth plastered wall five or six times, declaring that Bess Horner was holding her up there. Old Bess also had a wart on her shoulder that Bovet's children claimed was her witch mark, where her imp – in the form of a toad – suckled her. At her trial the old woman was forced to prove she could say the Lord's Prayer forward, and bare her shoulder to prove she did not have a nipple there, and in the end she was acquitted by Sir John Holt. What is perhaps most disturbing however is the number of neighbours willing to claim Elizabeth Horner possessed supernatural powers; Margaret Armiger, for instance, swore she had met Elizabeth in a country lane, despite her being incarcerated in Exeter at the time. John Fursey claimed he saw her three times at night on a large down, as if rising up out of the ground.

Elizabeth's acquittal is symptomatic of the blurry rationalisation which was beginning to overtake the 'true' Puritan era of witches. The modern reader might find a huge contradiction in the fact that Holt found the claims that the child walked horizontally up a wall unbelievable – yet the allegations of supernatural dealings with Satan still carried enough weight to force a trial in the first place.

Legends of County Witches Shape-Shifting

Stories like this were the Devil's involvement in human affairs made real. Perhaps because of the lasting shock of such real events, legends of witches in Devon are

legion, and allegations of witchcraft persisted until well into the nineteenth century. Anna Eliza Bray recorded a traditional story that spoke of a Tavistock witch able to transform herself into a hare. This she would do, and then send her grandson to a local huntsman to alert them there was a hare to be had – for he received sixpence every time he imparted this information. Naturally, the 'hare' (being, in fact, a witch) always evaded the hunting party, and this happened so often that the authorities and the church became suspicious. The next time the grandson came to impart that he had seen a hare, the hunting party were better prepared, and the 'hare' received a savage mauling from a hound before once more escaping. During the event, the boy yelled, 'Run, Granny, run! Run for your life!', and from this the authorities guessed who their true quarry was. At her cottage, the old hag was found bleeding, and covered with bite marks, and thus she ended up on trial as a witch, ultimately finishing her days at the stake. The grandson was sentenced to a whipping.

A story collected by the Devonshire Association in 1935 tells an interesting variation on this. One member's old schoolmaster would often recount how an old man (thought by Hartland villagers to be a witch) was capable of turning himself into a snake, and he would slither into the vicarage in this guise. One day the vicar horsewhipped the intrusive reptile – and later learned that his enemy was seriously ill at home in bed.

Notes and Queries (1907) recorded another allegation of this ability, in which the Revd F. E. W. Langdon related what he had been told by old people of witches in Membury. One anecdote concerned old Hannah Henley, who had lived over sixty years earlier, and of whom it was said could transform herself into a hare – although at the risk of being chased by the Cotleigh Harriers.

The allegations against Hannah were serious, it being said that she killed the livestock of a farmer whom she harboured a grudge against. As the man returned from ploughing with his team of horses, she had allegedly drawn a circle in the road with two sticks. The horses stepped into the circle – and died. On another occasion, according to testimony preserved in the reports of the Devonshire Association Committee, she cursed her enemies' cattle, blinding them, and also gazed into a field of newborn lambs, which 'turned head over tail until they died'.

It was widely averred that Hannah met her end by being carried away by the Devil, for her body was found on a Good Friday morning on a branch overhanging the stream close to Boobhill, where she lived; her three cats were found with her. Revd Langdon explained that when Hannah was found, there was a kettle by her side, and she was terribly scratched. She had been ill the night before, and she had ordered some people away because, she said, she knew she was going to die. It appeared 'she had been dragged through one of the lights of the window and over a great high thorn rattle, on the top of which was some part of her clothing'. Nonetheless, an inquest returned a verdict of 'water on the brain'.

The Reality of Witchcraft

Hannah's death was, in all likelihood, a combination of accident and illness. But outside of folklore, it is clear from poring through the last 150 years worth of county

newspapers that the 'reality' of witchcraft and spells persisted much later than one might suppose, it's threat still being seen in certain districts until quite recently. This certainly casts a darker shadow over stories of the folklore type observed above – which we can assume might actually have been based on sincere beliefs.

Perhaps to distance themselves from the infamy of their forebears, some witches in the nineteenth century christened themselves 'white witches', being distinguishable from their evil counterparts by their availability to overturn spells on those 'overlooked'. These people were often the first resort in a supernatural crisis, not the last, although people still feared them because they allegedly had access to the same paranormal powers as an evil witch. Thus, in the 1800s we see a kind of blurring between the powers of 'white' witches and those of the evil old hags who people believed still held sway in some districts.

A few examples of real witch cases serve to show the phenomenon was considered very formidable until quite recently. Typical is the report in the *Western Times* (27 October 1860), which informed its readership that a farmer living on the western side of Drewsteignton had recently employed the services of a white witch called Professor S. The farmer believed he had been 'overlooked' by a local witch, causing him to lose two horses. 'Old incantations were put in practice' and the farmer returned to Drewsteignton, where he exhumed his two horses. Extracting their hearts, he stuck them full of pins and blackthorns, before setting them ablaze in brown paper. Once consumed, he was convinced the spell on him was broken. And in spring 1907 the *Ilfracombe Gazette* reported a contemporary story concerning the famed White Witch of Exeter, stating that she had lately visited a 'bewitched' farm within 3 miles of Ilfracombe. She had been employed upon the death of three of the farmer's horses, which had first sat on their haunches and then lay on their sides and expired. Two veterinary surgeons expressed themselves mystified, so the Exeter Witch was brought in. She confirmed the farmer to be 'witched' and he is quoted as saying, 'And 'twas a good job I went (to see her), or else I should have lost everything! I lost all my horses, and 'twas awful! Awful!'

The Exeter Witch was much famed in her time. Collecting folklore in 1935, the Devonshire Association learned from Mrs Eckett Fielden that 'the Exeter White Witch was, apparently, notorious 50 or 60 years ago, and there was another necromancer, "Old Mother T." at Buryton, and the white witches of Collaton Hill and Chulmleigh'. A Mr Heard added that, not so long ago, another method to overturn a spell involved drawing blood from an evil witch. He noted, 'the last piece of gullibility I have heard in this parish is that the white witch ordered some parties to throw flour around their abode to keep out the witches, and they did it!'

In October 1934 the *Western Morning News* carried a piece on the survival of witchcraft in Devon: 'The modern counterparts of the old women in high hats, broomsticks and black cats are apparently persons of both sexes, possessing no distinctions, except the ability to effect remarkable cures of certain ailments, often to the great bewilderment of "uninformed" medical practitioners.' The newspaper talked to an Okehampton parish clerk, Mr F. Spry, who explained that he knew certain charmers to use quotations from certain scriptural texts, handed down through generations: 'At the present day there are people in Okehampton and district who "bless" for all manner

of things – scalds, strains, haemorrhage, ringworm and king's evil (a cattle complaint), for instance, and in most cases cures have, to my knowledge, been performed.'

Mr Spry also explained that malevolent hags still existed, at least until fairly recently. In 1901, he had accompanied an old woman to the Poor Law pay station near Okehampton, and this lady had claimed that during their visit a reputed 'witch' had cast a spell on them; this she could tell by the other woman's strange gestures in their direction. A few days later, Spry's horse bolted near Hatherleigh, throwing the trap he was in over the bridge and into the river – although without serious consequence. The following day the horse kicked the shafts and the front of the trap to pieces and bolted.

Most remarkably, the *Western Times* (3 April 1899) reported that four days earlier a Mr Hurman, of 'Albany-villa, Dartmouth-road', Paignton, had found the body of his wife Sarah in a pool of blood in an upstairs bedroom. The circumstances of her death were singular: witnesses stated Sarah had believed in her last days that she had been bewitched by a woman whose daughter she had refused the position of servant at Albany. Before her death, Sarah wrote a bizarre, though coherent, note, which she left on a dressing table. In part it read, 'My poor brain is dreadful. Do not blame me for anything. A wicked woman has done all this. She said she would bewitch my poor brain, but do not say her name.' After writing this, Sarah – who had displayed no signs of abnormal fear prior to the servant episode – took a razor and cut her throat from ear to ear. A doctor at the coroner's inquest declared it must have taken an enormous amount of determination to inflict such a wound, and death would have been instantaneous. In fact, such was the violence of the injury it was at first thought a murder had been committed.

If this is what fear could do to a previously well-balanced lady in Victorian Paignton, the terror of witches in earlier days must have been tremendous. Consider the case that came before the Cullompton Petty Sessions in December 1924 when a forty-three-year-old smallholder was accused of assaulting Ellen Garnsworthy in Clyst St Lawrence. Ellen, who we can assume to have been elderly, had been violently assaulted a number of times while she chopped logs a month earlier. Her attacker was a pig farmer called Matthews, who repeatedly grabbed her arms and dug pins under the skin, causing a number of deep scratches that bled badly. Matthews then made a veiled threat that he was going to get a gun and shoot her, and at this the police became involved. Matthews' defence rested on the fact that Ellen was a witch, and she had overlooked him; he wanted to stop her 'evilness' and told the police that if they raided her house they would find a magic crystal she used to bewitch him. The judge jailed Matthews for one month. 'Blooding' a witch, of course, was long held to be another way to break a spell cast upon one.

Stories like this seem to belong to a different century – not an era four generations or so ago. Part of me can't help but wonder if there is a lingering belief still in the more remote parts of the county concerning witchcraft and witches. At Holy Trinity church, next to Squire Cabell's tomb in Buckfastleigh, I was told by a pair of ladies strolling round the church's skeleton that a fire which gutted it on 21 July 1992 was started by witches, which seems a strange turn of phrase for the twenty-first century. Although they probably meant Satanists, the church is but a gloomy shell, with something of

a cursed history: it has been struck by lightning in the past, and suffered some bomb damage during the war. It also suffered from an 'atrocious act of incendiarism', according to the *Western Times* in 1849 when robbers looking for plate set it ablaze. Holy Trinity seems to have been a doomed church, for when it was finally irretrievably destroyed in 1992, (so I was told) word immediately spread that 'a coven of witches had burnt it...'

Middle Earth, Devonshire

In some ways, stories of long-ago Devon can almost depict the county as a kind of Tolkien-esque land of fairytale sprites, ghouls, demons and mythical creatures. Quite naturally, the land had giants: the Brutus Stone, a granite boulder sunk into the pavement, can be pointed out on Fore Street, Totnes. The stone is said to be the one upon which the legendary Trojan leader Brutus stepped upon his arrival in Britain 'on the coast of Totness' prior to taking on a race of giants that inhabited this island at that time in prehistory. The story of Brutus' debarking here and establishing the British peoples began with Geoffrey of Monmouth's *Historia Britonum* around 1147, a fanciful tome derived from sources of very suspicious and doubtful character. The earliest known reference to the stone itself is probably by John Prince, writer of the *Worthies Of Devon* and vicar of Totnes from 1675 to 1681.

Hunt's *Popular Romances Of The West Of England* (1865) draws upon antiquarian sources to tell the legend of the giant Gogmagog, who was captured by the Trojan Army and forced to fight a wrestling match with Corineus, an ally of Brutus, on what is now Plymouth Hoe. Corineus defeated the giant by nimble cunning, exhausting him and then dragging him to the cliff edge and precipitating him into the sea. This is myth, but interestingly Hunt observes 'there are those who say that, at the last digging on the Haw for the foundation of the citadel of Plymouth, the great jaws and teeth therein found were those of Gogmagog'. As early as 1602 the historian Richard Carew had observed that '...upon the Hawe (Hoe) at Plymouth, there is cut out in the ground, the pourtrayture of two men, the one bigger, the other lesser, with clubbes in their hands (whom they term Gog-magog)...' So it appears that at one point belief in this story was genuine.

In the seventeenth century Thomas Westcote recorded that two great stones 'as you descend from the great hill Haldown toward Exeter' marked the place where a giant dropped down dead and was buried, the stones marking his head and his feet. It was averred that no matter how many times the distance between these markers was measured, it would never be the same – leaving the giant's exact length an unknown factor. Shortly before Westcote's time 'these stones were in a night secretly digged up and so the wonder ceased'. Some claimed that the remnants of the giant population retreated onto the wilds of Dartmoor where they died out, and Mardon Down, northeast of Moretonhampstead, boasts a Giant's Grave: a cairn, or tumulus, although this is recorded as having been largely obliterated a long time ago.

As late as the 1830s, Mrs Bray was told during a visit to Wistman's Wood that 'the giants were once masters of the hill country, and had great forests, and set up

their karns, and their great stones and circles, and all the old, ancient things about the moor'. In folklore, saints were often misremembered as physical 'giants', but these two elements literally came together in the early eighteenth century when (what is now) the Bedford Hotel was being built. Mrs Bray records that in the building of the Abbey House the workmen found a sarcophagus containing two human thighbones of extraordinary length. One was 21 inches long, the other 19 inches. It is possible these belonged to the founders of Tavistock Abbey, Orgar, Earl of Devon, and his son Ordulph – who William of Malmesbury expressly declares was of gigantic stature. In Mrs Bray's time one of these bones, at least, was still displayed in Tavistock's church. Their whereabouts at the present time is unclear, despite my enquiries. The parish office at Tavy church tells me: 'It is said that these bones were found in the sarcophagus that used to be in Betsy Grimbalds tower, but has recently been removed.' Some thought the bones had ended up in 'a vault underneath the floor-slab at the back of the church now marked "Ordulf"'. But, although it appears these giant's bones were a factual discovery, for the time being their whereabouts is buried in the church archives.

Other fabled monsters are recorded by Westcote, who wrote around 1630 that a dragon lurked at Cadbury Castle. This is the ancient camp on an isolated hill near the Crediton to Tiverton road. It was occupied by Fairfax's Army in 1645, but prior to this the country people told a strange tale. Southeast of Cadbury is another height, called Dolbury, which is part of Killerton Park, and Westcote wrote:

> A fiery dragon (or some ignis-fatuus in such likeness) hath often been seen to fly between these hills, coming from one to the other in the night season, whereby it is supposed there is a great treasure hid in each of them, and that the dragon is the trusty treasurer and sure keeper thereof … this is constantly believed by the credulous here, and some do aver to have seen it lately.

Another great Devonshire antiquarian and historian, Richard Polwhele, writing in 1793, heard that 'the ancient tin mines of Manaton, it seems, are at this day, haunted by the winged serpent'! And Mrs Bray learned in the early ninteenth century that there was still an ingrained belief among the people on the borders of Dartmoor that the valleys were once full of 'serpents and ravenous beasts'. I wonder if such legends are based on more than mere sightings of the *ignis fatuus*, or Will o' the Wisp, though. For Mrs Bray also wrote that a monstrous snake of gargantuan proportions had been seen in the Tavistock area in the summer of 1828. Witnesses swore that the snake, which first appeared in Pigsey Lane when it flopped onto a little boy's shoulder before slithering off, was immense. It was, they said, as thick as a man's thigh and so long it rivalled a great boa. I have no doubt that, if such wonders were seen in earlier times, they would constitute a 'dragon', particularly so in cases like the two-headed snake the *North Devon Journal* reported in 1915 as being caught 'some years ago' at Great Torrington.

One of the most sinister of beliefs was that an ogre (or some kind of malicious water spirit – its exact status defies categorisation) lurked in the River Ashburn, adjacent to which the town of Ashburton developed. The Devonshire Association's *Reports and Transactions* (Volume 11, 1879) explained that this monster was known as Cutty

Dyer, and 'he was described by persons who saw him as being very tall, standing in the water to his waist, with red eyes as large as saucers, endeavouring to pull them into the water'. Three generations before, Cutty Dyer had been the sincere terror of adults, particularly drunkards making their way across the stream through the dark lanes to their homes. However, when the stream was bridged Cutty Dyer remained only a scare to children, and upon the streets being lighted he disappeared altogether.

The point of mentioning such things as dragons and giants in a work on the paranormal is this: if these sorts of creatures be mythical, then what do we make of the almost equally strange beasts glimpsed and reported in this day and age? Things that aren't supposed to exist in Devon are still reported, as we shall see.

Pixie Lore

Here we digress into the world of pixies, or piskies as they were sometimes called, for although the whole tradition of fairies and elementals is one that many might consider truly antiquated, there are many stories to the contrary. Many of the earliest beliefs concerning pixies were first recorded in a remarkable book by Anna Eliza Bray, *A Peep At The Pixies* (1854), and she tells us that they were a distinct race from the fairies. When the fairies attempted to establish themselves in Devonshire, a terrible war occurred between the two races, with the fairies losing. Mrs Bray also records a curious legend that the pixie army invaded Tavistock, in the days of the abbey, which is worth repeating due to its surreal nature:

> ...these frequently left their own especial domain to exercise their mischievous propensities and gambols even in the town of Tavistock itself, though it was then guarded by its stately abbey, well stocked with monks, who made war on the pixie race with "bell, book and candle" on every opportunity. And it is also averred, that the Devil (who if not absolutely the father, is assuredly the ally of all mischief) gave the pixies his powerful aid in all matters of delusion.

She adds, 'but of late years the good people here affirm ... the pixies are held tolerably fast, and conjured away to their own domains'. This was believed to be Dartmoor, a much haunted and wild waste, although there was an equally strong belief in them in North Devon, in such places as Challacombe.

Pixies played an important role in the rural life of Devon until comparatively recent times. They were sometimes supposed by the peasants to be the souls of children who died without baptism, but others considered them to be an otherworldly species. Their chief pleasures were gained from music and dancing, and folklorist Sarah Hewitt, writing in 1899, tells us: 'The villagers [of Chagford] assert that on peaceful nights they often hear the echoes of delightful music and the tripping patter of tiny feet issuing from the meadows and hill sides.' It was also believed (in the early nineteenth century) that they had appropriated a pit in a field near Down House, west of Tavistock, for use as a ballroom. When their revels were interfered with by humankind, these sprites took great delight in pinching the bothersome person black and blue, and one traditional

Devon story implies that they could be exceptionally malicious. It is said that, centuries ago, a midwife was summoned to a filthy hovel to tend a haggard mother and her newborn offspring; during the visit the midwife applied some ointment to her eyes out of curiosity, after seeing the new mother use it. Instantly, the hovel became a palace, and the worn mother a young beauty. Sometime afterwards, the woman spotted an ugly little figure raiding her store of eggs, and cried out, 'Hilloah, sirrah!' The thief was a pixie, and when he realised he could be seen, he retorted, 'Oh ho! You have been using the ointment!' and struck her eye out.

Strangely, the pixies were believed to attend church. Mrs Bray recalled that there had been in living memory a formation on Dartmoor called Belfry Rock, or Church Rock, until it was dynamited. This was thought to be where pixies worshipped, and 'many old persons have declared that they could recollect a time when, if you placed your ear close to it on a Sunday, you could hear a low tinkling sound like the bells of Tavistock church, and always at the time of warning for the service...' All this was duly ascribed to the pixies, who it was believed loved bell-ringing, and went to church. Hence the rock in question received the name of the Pixies' Church.

They also rode without mercy the little Dartmoor ponies that grazed among the fragrant bog myrtle and flaming gorses of the moors. But pixies were also each given certain tasks by their king, who held court by moonlight on the moors and gave each special assignments: 'Some are sent to the mines to show where lie the richest seams; or else to deceive some poor miner who is out of favour by false fires and hammerings in the parts where the worst ore is to be found.' Others visited households to check the dames within kept the place tidy.

There can sometimes be a blurring of the lines when it comes to the terminology of what might broadly be termed 'the little folk', not to mention a little confusion. *Reports & Transactions For The Devonshire Association* (Volume 2, 1868) notes that the busiest of the 'goblin fairies' was a hobgoblin called Puck, who 'plays his mischievous tricks, frightening the maidens, skimming the milk, stopping the grindstone, bewitching the churn, not allowing the beer to ferment, breaking the threads of the spinsters, and playing hundreds of fantastic tricks'. This description almost sounds like the antics of a poltergeist, which can still be the bedevilment of Devonian homes even now, although it is usually connected with ghostly phenomena.

Pixies also supposedly gained great satisfaction from threshing the corn of farmers they favoured, and one old-time north Dartmoor yeoman is reputed to have surprised them at work with their flails in his barn. His comment was: 'Never did I zee zuch drashers as they was!' When they scattered, one fell, and the farmer was able to catch it and imprison it in a lantern; here, the pixie lived for some time until one day it escaped when the farmer left the lantern door open. What is fascinating about this is that Sir John Bowring, writing for the Devonshire Association in 1868, had been told this as a true event by the brother of the farmer concerned.

Pixies also visited households for another, sinister reason. Sometimes they would sneak into the houses of labourers by night and substitute one of their own race for a mortal child to whom they took a liking. Anna Eliza Bray wrote in the 1830s that 'the wicked and thievish elves ... are all said to be squint-eyed', and even in her time some women pinned 'their children to their sides in order to secure them'. She recounts

one odd tale concerning a Tavistock woman who had died not long ago; this lady solemnly declared her own mother had had an infant taken by the pixies while she was busied hanging out linen to dry in her garden. In its place, a pixie infant was substituted. Though heartbroken, the mother took such good care of the changeling that the pixie mother thereafter came to reclaim the child, and swap the original child back. As well as this, correspondence to the *Exeter & Plymouth Gazette* (22 December 1880) recalled 'there was, in 1859, living in Ilfracombe a woman who was reputed to be a pixie's changeling'.

Towering above the little village of Sheepstor can be found Sheep's Tor, where a natural fissure or narrow cavern among the rocks is called Pixie's, or Piskie's, House. It is notable historically for being the hiding place of a royalist named Elford, who took shelter here while evading Cromwell's soldiers. This was believed to be the palace of the pixies, a singularly difficult place to reach, for according to Mrs Bray: 'How any living thing but a raven, a crow, or an eagle could make his home in such a spot, is to me, I confess, a puzzle.' Mrs Bray mentions in passing that the young women of Sheepstor were strikingly beautiful, and I wonder if mothers genuinely feared for their offspring, living so near a place with such an unenviable reputation; Mrs Bray was herself advised to leave a pin, or some small token, during a visit to the Pixie's House, lest these 'invisible beings' torment her in her sleep.

Another pixie house was at Chudleigh Rocks, rising near Chudleigh, where there is a fissure near Kate Brook. An early report in the *Philosophical Magazine* in 1812 describes it as the 'Pixies' or Piskies' Hole, as it is commonly called, being the supposed habitation of a diminutive race of fairies.' A cavity deep within was called the Pixies' Parlour.

Being 'Pixie-Led'

A sinister trick of the pixies was called 'pixie-leading'. The unfortunate subject of this persecution would wander up and down familiar lanes and roads without once recognising any known landmarks, in a state of utter confusion as to their location. For some reason, to turn one's pockets inside out broke this spell over the subject. Perhaps the most familiar anecdote with this theme is that connected with Fitz's Well, on the very edge of Dartmoor, off Camp Road, which leads to Okehampton Camp. The story is that John Fitz, the old astrologer and astronomer of Fitz-ford, and his lady were once pixie-led while riding on Dartmoor. After much hopeless wandering they felt so fatigued with thirst and hunger that it was with extreme delight they discovered a spring of water, whose powers seemed to be miraculous; for no sooner had they satisfied their thirst than they were enabled to find their way through the moor without the least difficulty. In gratitude for this deliverance old Fitz caused the stone memorial to be raised over the spring around 1568, for the benefit of all pixie-led travellers. (Another version locates this story at Fice's Well, north of the Rundlestone junction near Princetown, which bears the initials I. F. and the date 1568.)

As late as the 1830s Fitz's Well was still believed to possess many healing virtues. Here it might also be observed that it was still common parlance that John Fitz's skill

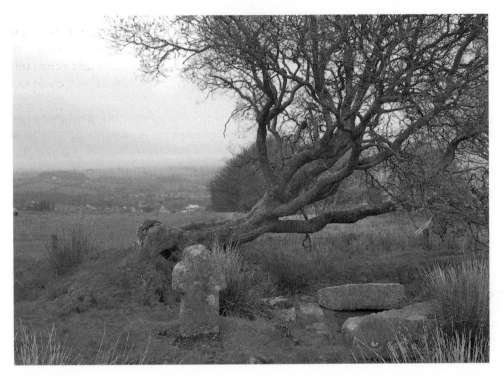

Fitz's Well, on East Hill near Okehampton Camp.

as a stargazing astronomer had enabled him to foretell that his son John, born in 1575, would meet a violent end. As such he pleaded with the midwife to delay his son's birth, but this did not happen. Sir John Fitz, the son, committed suicide after murdering two persons. He was the father of the infamous Lady Howard, who is noted elsewhere.

Upon visiting Fitz's Well, I was astonished to find that the tree behind the cross was bedecked with tokens: coloured string, twine, etc., attached to the branches. Some are very worn, and look as though they have been there years. Clearly this spot was, until recently, venerated by those believers in the elemental spirits, and perhaps this is still the case today.

Many claimed similar encounters with these sprites. Anna Eliza Bray, writing in 1833, was aware of an instance many years earlier when a celebrated singer in Tavistock's church choir was found bruised and black-eyed in a ditch near Horrabridge. This man explained his misadventure by the fact his mule had thrown him after becoming agitated at the sight of 'a company of goblin spirits dancing and frisking all in a ring'. Apparently, Whitchurch Down on the eastern edge of Tavistock was notorious for instances of pixie-leading.

At the turn of the last century, belief in pixies was still flourishing. The *Exeter & Plymouth Gazette* in 1905 noted that they frolicked on the dunes at Braunton Burrows, by the edge of Saunton Sands (now designated a danger zone), and that they were both benevolent and malicious: some would visit North Devon households, leaving tokens of their friendship and sweeping hearths, while others lured travellers into hopeless wandering on the Exmoor moorland. They could assume various forms, but, we learn,

their dress 'whether belonging to an aristocratic elf or one of fewer pretensions, is always green'. They were also thought to hide in Fox Home, a 'quaky bog' on Dartmoor, so called because no huntsman dared to chase a fox here. If you attempted to cross this bog, the pixies would appear and dance in front of you, and although you could not see them they would supernaturally lead you into danger.

A most remarkable story is carried in the *Exeter Flying Post* (7 June 1890). A few days previously, a woodcutter had become separated in the evening from his fellows in woodland some 4 miles from Great Torrington. Stooping to pick up his tools, his surroundings suddenly became surreal and he himself disorientated. Peals of discordant laughter began to echo from within the trees around him, and – completely alone – he began to wonder if he was being pixie-led. By ten o'clock the man's wife went into the woodland to look for him and found him near his work spot, soaking wet and claiming to have been led by pixies in an aimless trek for five hours until he fell in a stream, his accident rousing him somewhat. His wife's unsympathetic response was, 'You girt fule, why didden 'ee turn your pocket inside out?' No liquor had been in the possession of the group at all, and the newspaper noted that a few years prior a tailor named Short had been pixie-led in the same wood, remaining under their spell until daybreak.

True Encounters with the Pixie Race

We are occasionally treated to physical depictions of the pixies by witnesses. *Reports & Transactions For The Devonshire Association* (Volume 2, 1868) records that one member set out to find what remained of pixie lore. Most people he talked to on 'the skirts of Dartmoor' firmly believed the pixies had moved elsewhere, although one old woman confided the following: 'I did zee one once, when I was a little maid – I did zee a pixie man.' The elemental had been about 18 inches tall, and 'he had a little odd hat, and a pipe in his mouth, and he had an old jug in his hand – not like the jugs us uses now... I never zeed but that one, and I du think they've gone to some other part of the world'. A good many other persons did, however, still believe the pixies were responsible for the mysterious tangling of horse's manes on the moor, in such an intricate fashion that it could not be combed smooth and had to be cut out. This last detail is fascinating, as this phenomenon still occurs: a cousin of Theo Brown's noted the mystery of sweating, agitated ponies being found with their manes plaited inside securely locked and bolted stables in Chudleigh Knighton – and as recently as January 2010 the *Telegraph* reported a rash of unexplained horse mane weaving in fields at Hemyock, Culmstock and Clayhidon. Police said they were baffled by the motive for this, at first thinking the horses were being 'marked' by thieves, then, as it continued, they considered that pagans or white witches were behind the mystery. I might add that it may have been persons trying simply to bemuse, or resurrect controversy in the existence of pixies.

Another first-hand account of a pixie appeared in *Reports & Transactions For The Devonshire Association* (Volume 60, 1928). In 1897 Mrs G. Herbert glimpsed a pixie under an overhanging boulder close to Shaugh Bridge, which crosses the Plym near Dewerstone Wood. She had rushed to her mother, who had laughed her; in later years she recalled that the pixie was 'like a little wizened man about (as far as I remember)

Pixy doll (*c.* 1900) in the Museum of Dartmoor Life. Could this be the closest thing to an actual depiction of the pixies?

18 inches or possibly 2 feet high, but I incline to the lesser height. It had a little pointed hat, slightly curved to the front, a doublet and little short knicker things.' In the blink of an eye, he was gone.

As late as 1930 these sprites were still firmly believed in, as correspondence to the *Morning Post* (19 November 1930) implies. In response to a rationalisation of Dartmoor superstitions by a Mr J. P. Park, an outraged Devonian, Paddy Sylvanus, responded with this information:

> I have lived for ten years on the borders of Dartmoor. I could, and I would, introduce Mr James P. Park to a bridge that cannot be crossed at midnight; to a dell where fairies are still seen to dance; to a dangerous locality where an earthbound spirit dwells, causing terrible accidents; (and) to a well-known and universally respected lady who has seen a pixie and heard the wish-hounds. I could take him to visit a witch in her cottage, at the risk of being overlooked.

In 1938, the *Western Morning News* quoted one Mrs E. D. Pethybridge (owner of Hartyland, in the shadow of Hartland Tor, Postbridge) as saying, 'Many people in the village have seen the pixies; even dogs are credited with seeing them sometimes. My home is far too modern, however. I have an electric light plant and a car, so I cannot expect to even glimpse them, you see.'

Clearly, less than 100 years ago belief in strange phenomena we now designate 'folklore' was as strong as ever in Devon. And elementals like pixies, gnomes and fairies are still occasionally encountered. D. A. MacManus' *Irish Earth Folk* (1960) recounts how a Mrs C. Woods, wandering near Haytor Rocks on Dartmoor in June 1952, spotted a little figure about 3 feet tall watching her. The diminutive person appeared to be shielding his eyes from the sun, and as she cautiously approached she perceived him to be elderly, rather than young, wearing a brown smock with a cord round the waist and with a brown cap (or brown hair). She was within 40 yards of the strange figure when he dived out of sight between stones – and never more reappeared. Mrs Woods commented, 'I had no idea at first that he was a little man; I thought rather of some animal until I got much nearer, and then I just stared and said to myself, "This is no animal, it is a tiny man in brown." I felt and still feel so convinced.'

Ruth St Leger-Gordon explains in the *Witchcraft & Folklore of Dartmoor* (1982) that she knew of someone who had seen a group of pixies or gnomes in the twentieth century: four of them had emerged from a bracken stack in one of the little rough field enclosures near Widecombe in the Moor. She writes, 'All four were little men, two being somewhat taller than the others, and less pleasant looking than the smaller couple. All wore the traditional costume of red doublet, red pointed cap and long green hose.' This sighting had occurred in broad daylight.

Today, Ottery St Mary has a tradition that a number of bell-ringers were abducted by pixies in 1454 and taken to the cave called Pixies Parlour on the banks of the Otter. The bell-ringers escaped, and the legend is these days commemorated in a colourful pageant and fundraising event in the town each June, called Pixie Day. The only thing we can say for certain is that if pixies did exist, then they existed here, in the county of Devon. I suspect that, if they ever existed, they must by now have been scared away from habitable areas by noisy and fast-moving automobiles. But from a paranormal researcher's viewpoint, I have never researched a work of this nature without coming across an absolute wealth of pixie/elf/fairy lore, and even today belief in elves, gnomes, piskies, pixies, or whatever name they went by, crops up continually during my research: this is never more so obvious than in Devon. Perhaps they exist still, but have to be seen by a very special person with a very open mind; for when I contacted the famous Gnome Reserve & Wild Flower Garden, at West Putford, I was told by the lady who owns it, 'the Gnome Reserve came into existence in 1979 – after I had "seen" gnomes'. Although this revelation may have been via what some refer to as 'the third eye', rather than glimpses of a 'physical' gnome, I was nonetheless told: 'After seeing gnomes I found the experience meant so much to me that they had to be shared with other people, and hence the Gnome Reserve was born!' So perhaps our concluding statement ought to read (given the wealth of lore) 'if pixies do still exist!'

Cannibals & Cavemen

An otherwise sober and informative article in *Harper's New Monthly Magazine* (Volume 38, 1839) concerning Devon could not resist occasionally dipping into the fascinating lore of the county people, and one story stands out as particularly strange:

Many children in the large towns of Devonshire still regard Dartmoor with superstitious awe; and a century ago (i.e. in the early 1700s) the belief was quite common that on that moor there lived a race of infra-human beings, with long tusks, adepts in witchcraft, who usually passed the nights in dances around mysterious circles, such as Tam O'Shanter saw, and in various other diabolical orgies. These wild beings lived in the region of the famous lead and tin mines.

The author of the article, M. D. Conway, suggested these bizarre creatures might be a relic of the superstitious Germanic settlers, who, in historic times, were the first to work these mines and brought with them the belief in a goblin mine spirit called a Kobbold.

Personally, I wonder if these things were a misremembering of the story of the Gubbings, which is worth considering in passing. Thomas Fuller's *Worthies* (around 1662) tells us that the Gubbings were a unique race of inbred heathens, who lived 'nigh Brent Tor, in the edge of Dartmore'. Some 200 years earlier, 'two strumpets' had fled here, followed by 'certain lewd fellows', who thus created their own degenerate race, which by Fuller's time had multiplied into many hundreds, living like swine in holes, never marrying and exempt from clergy and law. They lived by banditry and sheep theft, and to offend one was to make a dangerous enemy of the entire community. During the civil wars of the 1640s, no soldiers of either side were quartered among the Gubbings, for fear of their being massacred. It was said that the men were so swift they could outrun horses, and they outlived ordinary men; but, even as Fuller wrote, 'now I am informed, that they begin to be civilised, and tender their children to Baptisme, and return to be men, yea Christians again'.

Of groups of people who lived primitive, barbaric lives outside normal society, there is little better than the atrocious legend suggested in a 1789 pamphlet concerning one John Gregg and his extended family. This tells us that this gang:

> Took up their abode in a cave near to the sea-side, in Chovaley (Clovelly), in Devonshire, where they liv'd twenty-five years without so much as once going to visit any city, or town; they robbed above one thousand persons, and murdered and ate all whom they robbed: at last they were happily dicover'd by a pack of blood-hounds, and John Gregg, his wife, eight sons, six daughters, eighteen grandsons, and fourteen grand-daughters, were all seized and executed by being cast alive into three fires, and were burnt.

This was around 1740, and that such atrocity could continue on such a scale undiscovered for so long is, to put it mildly, unlikely; it is now speculated that the case is either a massively exaggerated report of a real incident or, more likely, a story perpetuated by smuggling gangs desirous of keeping nosey locals away from the northern coastline for fear of meeting Gregg's terrifying 'ghost'. However, a stretch of Clovelly Bay is denominated 'Devil's Kitchen', an apt name indeed if there is any truth in the ghoulish story of the Gregg family.

I've heard half-serious rumours of primitive, hairy, pelt-wearing 'wild men' and 'cavemen' inhabiting Dartmoor, although these usually come in the form of stories

Clovelly Bay, alleged haunt of the cannibalistic Greggs.

told by fathers to sons who are now adults; perhaps this is something to do with the prehistoric, primeval landscape of the moor. But the late folklorist Theo Brown noted in 1982: 'On Dartmoor, we have occasional glimpses of little dark men in skins or sacking.' And here we are again in a world of speculation, for what could these be? Modern pixies? Ghosts of the primitive Britons? Visitants from some paranormal dimension? Or relics of a prehistoric past that have somehow survived?

A Wild Man Captured

Evidence for the 'wild man' comes in the form of an anecdote provided by Jonathan Downes, Director of the Centre for Fortean Zoology (CFZ). This is a truly remarkable and unique organization dedicated to cryptozoology – the study of unknown animals. It perhaps the largest organization of its kind, devoted to the professional, full-time scientific study of animals that have so far remained hidden from man; and it is based right here in Devon, at Woolfardisworthy, near Clovelly Bay.

The CFZ was founded in 1992 by Jon, and for over twenty years has attempted to track down all manner of mystery animals in the UK and abroad. However, this story concerns a curious anecdote Jon was told ten years earlier while working to become a qualified nurse at the Royal Western Counties Hospital, a gothic Victorian edifice in Starcross, notorious as an asylum, and at the time in the process of closing; it has now

been pulled down completely. At the time the older staff and nurses would delight in telling each successive generation of young students horror stories, but one learned by Jon stands out as utterly weird.

A remote wing of Starcross had apparently served as a place of internment during the 1940s for captured German aircrew whom had been shot down in the Channel near Devon's coast, before they were re-incarcerated in the prisoner of war camp high on the Haldon Hills. One night around 1942 the Home Guard was alerted to the presence of a strange figure seen charging through woodland in the vicinity of Powderham Castle, and the unit's captain led a ragged army of elderly men and young boys after the fleeing figure. When the fugitive was spotted, a local farmer fired on him with a shotgun, wounding him; however, the group found not a fugitive member of the Luftwaffe, but instead crowded in horror around a wounded 'naked man in his early twenties, covered in hair and mud'. The badly wounded wild, hairy man was taken to Starcross in the middle of the night and kept there until an unmarked black van arrived carrying two uniformed men and a white-coated doctor-type. These manhandled the mysterious prisoner onto a stretcher, loaded him in the van and drove him off without explanation – departing with a veiled threat to abide by wartime secrecy.

Jon was told this by a former member of the Home Guard privy to the search, who later worked professionally at the hospital, although he had retired by 1982. Jon believed he might have discovered a partial explanation to the mystery a year later, when he learned in the files of a nonagenarian patient that she had had relatives who suffered from congenital generalised hypertrichosis, commonly known as 'Wolfman syndrome'. These folk apparently formed a branch of a family of local Devon notables.

The anecdote is a fine one indeed, and features in Jon's extraordinary self-penned story of his life as a pioneering cryptozoologist, *Monster Hunter* (2004). This work, among its chapters, contains a number of anecdotes concerning the often gruesome folklore of the old hospital at Starcross, as well as the surrounding area.

Capture of a 'Mermaid' at Exeter

On 9 November 1737 the *Exposition on the Common Prayer*, a weekly news-sheet, reported this strange discovery:

> We have the following remarkable account from a gentleman of undoubted credit and reputation: that as some fishermen near the city of Exeter drew their net to shore, to their great surprize a creature of a human shape, having two legs, leap'd out of the net and run away with great swiftness; and they not being able to overtake it, knock'd it down by throwing sticks after it: at their coming up to it, it was dying, and groan'd like a human creature. Its feet were webb'd like a duck's; had eyes, nose and mouth resembling those of a man, only the nose somewhat depressed; it had a tail not unlike that of a salmon, turning up towards its back, and is four feet high. It is now publickly shown at Exeter, and is shortly to be brought hither [to London].

Exmouth: was a mermaid really spotted a mile out?

Later we learn, '...the surprising fish, or mermaid, taken by 8 fishermen in September last at Topsham Bar, near Exeter, and so much the wonder of the curious, is now come to town, and will in a few days be exhibited to the publick'.

Nor was this the only such instance. A Mr Toupin published an account of an extraordinary adventure he had had during a sailing excursion on 11 August 1812. 'About a mile to the south-east of Exmouth-bar' the group's attention was drawn to a singular noise, impossible to describe fully but comparable to a wild, tinkling harpsichord melody. Around 100 yards windward they all saw something human-like diving and twisting in the water, and when they hailed it, they received no response. Boiled fish was tossed in the water, which drew the creature nearer: astonishingly, '... it was no other than a mermaid'! Mr Toupin provided a remarkably detailed description of this wonder: it had a long, oval face, seal-like, but more agreeable, and hair seemed to crown its upper and back head. There is no suggestion 'she' was attractive, more like an animal, whose upper quarters were covered with a soft fawn or pinkish down. It possessed two arms, which it used to great agility, which terminated in four webbed fingers on each hand. Its waist tapered gradually to form a tail, which bore the appearance of shiny scales, while its back bore something like feathers. In length, it was about 5½ feet, and it appeared to be cavorting playfully near the vessel – before, after three quick plunges, it swam rapidly away and was lost to sight.

There were bizarre allegations that mermaids still haunted Devon's coast in the twentieth century. The *Nottingham Evening Post* (13 June 1929) remarks that one was lately being reported by holidaymakers:

People have seen her at a place on the North Devon coast which shall be nameless. One eye-witness declared that the mermaid appeared, singing very sadly and solemnly the tune of a funeral hymn, but she looked so sweet that it was "as much as he could do to hold back from going after her".

Monsters of the Sea

Apart from mermaids, perhaps monstrous marine creatures still stray into our waters, dinosaur-like leviathans from a different time that terrify those who see them when they realise they are of no known species – and should not exist. One afternoon in May 1935 a strange creature with 'a head like a calf' was spotted on rocks by visitors to Stoke Beach ('a popular summer-time resort for Plymlothians'). At one point it was only 25 yards from the beach, and one witness described it thus: 'Its head seemed like that of a calf. It had a large body, and I should say it was over 7ft long.' The creature also had nostrils, a 'tremendous back' with a scaly appearance; it also turned to the onlookers when they shouted at it. Various suggestions were put forward: that it was a whale, a seal or a porpoise, big schools of which had lately been spotted in the mouth of the River Yealm. Others suggested it was a basking shark, or thresher shark (with nostrils and a cow-like face?), but its exact species remained a mystery, and one can only assume that if it were some known animal it would have been recognised as such.

The following year, in August 1936, a gargantuan sea animal was spotted off the southern coast by two visitors to Brixham, who spotted 'what appeared to them to be a sea monster' some 60 to 90 feet long. What was possibly the same creature was spotted by a Noss Mayo resident as he drove along Membland Drive two weeks later, who described something over 30 feet long surging to the surface. This was about a mile from Hilsea Point. This monster's species could not be determined, and an official at Plymouth Marine Biological Department blamed 'holiday imagination'. All the reports appeared in the *Western Morning News*. The following month the newspaper reported how a 'sea monster' had been seen eating a seagull in Seaton Bay, a few yards from the shore: 'Suddenly the mouth of a huge fish came into view, lifting the bird several inches into the air, and immediately disappeared, taking the gull with it. Neither "monster" nor bird was seen again.' These sightings coincided with the curiosity centred on Loch Ness, far away in Scotland, and the *Illustrated London News* cryptically noted in 1933 that a Nessie-type creature 'is said to have been seen off the Devonshire coast many years ago'.

Could such animals actually be what everyone secretly wants them to be – genuine dinosaur-like creatures that have somehow survived since prehistoric times? Is it just possible? Who knows; perhaps the gigantic creature called Tantrobobus, which Theo Brown heard was rumoured to lurk in the waters of both north and south coasts, was more than a mythical creature designed to frighten children by their parents ... for even today the national media occasionally gets excited about sea 'serpents' off our coast. As recently as 27 July 2010, an unidentified marine creature was glimpsed, and vaguely photographed, 30 yards off the shore at Saltern Cove near Paignton. Witnesses described the beast as about the size of a sea lion, with large flippers, a 2½-foot neck and a small serpentine head. Greenish-brown in colour, the beast was following a shoal of mackerel, and although the usual suggestions were trotted out – a turtle, or basking shark – in truth the depiction appeared not to fit any creature known to Devon's shores. At the time of writing it is still a mystery.

Leaping Demons

An extraordinary story was reported on 10 February 1908, to the effect that mobs of armed youths and men were roaming Mount Boone, Dartmouth, searching for an awful 'weird ghost' that chased women in the streets. Descriptions of the entity varied, but it was generally believed it wore a mask and false whiskers, and that it had springs attached to its heels. Finally, when a mob of youths trapped 'it' in the cemetery it was found they had actually cornered a blameless tramp, and the police were forced to disperse the crowd. Although – presumably – the whole thing was a misunderstanding, it is interesting nonetheless to observe how the mob, inflamed by their fears of the supernatural, took to looking for such a monster in the sincere belief it existed.

The late Devon folklorist Theo Brown learned that local variations on Spring Heeled Jack (the bounding, fire-belching demon of the metropolis) existed elsewhere in Devon. Her own father had once averred that after dark the road from St Marychurch to Shaldon was haunted by 'Spring Hill Jack', a bogeyman that danced in the road and leapt over the hedges with the greatest of ease. Sometimes this phenomenon manifested itself as a ball of fire that rolled out of the hedges. She notes in *Devon Ghosts* (1982), 'I can think of two other places in Devon favoured by a similar character'.

A Vampire Legend

Sometime in the early 1900s, a gentleman who had recently returned to the capital after three years travelling abroad decided to visit the South West after hearing in his club that a recently married friend down that way had not been heard of for some time.

His destination is not specified, except for the narrator of this story telling us he 'drove an interminable distance … through Devonshire lanes, stopping outside a beautiful house which appeared to be entirely isolated from any other dwelling.' Here, the gentleman observed how sick and wasted his friend looked, although he was astonished when he was introduced to his friend's wife: for she was quite beautiful, if exceedingly thin and pale.

The three shared dinner in the dining room, although the gentleman found himself unaccountably exhausted at an early hour, and so retired to bed. The following morning he awoke languid and giddy, and perceived in the bathroom mirror a curious red mark at the base of his neck. The following night he experienced the same sensation of giddiness, and began to think he may be being drugged during the evening meals; for the following morning he found the wound to his neck even more vivid and inflamed.

On the third night, by now suspicious, the gentleman drank sparingly, but excused himself early once again, claiming to feel groggy. In fact, he intended to remain awake through the night to see what might occur. At midnight, his bedroom door creaked open, and he perceived his friend's wife moving towards him through the gloom:

> …she came towards me, gliding as stealthily and noiselessly as a snake. I waited until she leaned over me, until I felt her breath on my cheek, and then – flung my arms around her. I had just time to see the mad terror in her eyes as she realised I was

awake, and the next instant, like an eel, she had slipped from my grasp and was gone. I never saw her again.

The gentleman left the following morning, and not long after learned his ill-looking friend had died. This yarn was told first-hand to one of Elliott O'Donnell's friends, a Mr South, and is mentioned in the former's book *Byways of Ghost Land* (1911). The suggestion is that the woman was a vampire, who may have killed her husband – but who she was, where she went or what became of her is not recorded.

The Werewolf

Although not an entity traditionally associated with the British Isles, werewolf lore is curiously more prevalent in Devon. Sabine Baring-Gould, writing in 1865, tells us that they roamed the Devonshire moors sometimes in the guise of black dogs, and one story alleges that two such monstrous creatures appeared nightly at an inn in an unnamed county village to drink all the cider. The publican fired a silver button over their heads, and 'they were instantly transformed into two ill-favoured old ladies of his acquaintance'.

According to *Devon & Cornwall Notes & Queries* (Volume 27, 1958), '...it should be noted that Elliott O'Donnell mentions a human figure with a wolf's head seen in broad daylight in the Doone Valley. It was about to pounce on a rabbit, but it was disturbed and faded out.' The implication is that it was the ghost of a werewolf, but the whole account is most unsatisfactory. If this be true, then was the rabbit also spectral? Perhaps it might here be suggested that such creatures are somehow multi-dimensional: creatures from the spaces between spaces that appear in our environment through a gap in the curtain only under certain conditions that we have no way of ascertaining. It might explain the mind-boggling array of things that oughtn't to be ... yet are still reported.

Some later werewolf reports do suggest something even more extraordinary than a flesh-and-blood creature; those who check out American werewolf hunter Linda Godfrey's online forum can learn of the 'reports of werewolf sightings close to the village of Lynton well into the twentieth century. Some of the reports say the creature could pass through fences like a ghost or would just fade away in front of witnesses ... [these] point to an ethereal nature.'

This is the case with the black dog of Newton St Cyres, north-west of Exeter: *Reports & Transactions For The Devonshire Association* (Volume 91–92, 1959) remarks that at some point a girl was murdered in a cottage here by her uncle. Strange to relate, an occupant who lived at the place afterwards reported, '...if the outside door was open a black dog sometimes walked past on its hind legs at a certain time.' In instances like this, the line between the 'physical' werewolf and some kind of ghostly (or multi-dimensional) creature becomes confusingly blurred.

As an addendum to this, more than 200 years ago strange and wild animals terrorised Dartmoor; for the *Monthly Magazine & British Register* (Issues 1–5) reports correspondence from Dartmouth dated 29 March 1796: 'For several months

Valley of the Rocks at Lynton: might people have actually seen a werewolf here?

past, a species of wolf, or wild dog, has been ranging in the forest of Dartmoor, and destroyed 500 sheep.' It hardly needs repeating that wolves are supposed to have been eradicated from England centuries earlier, and one wonders where this ferocious pack came from.

The Alien Zoo

A bizarre circumstance was recorded in the *London Chronicle* (Volume 13) in February 1763: a monkey belonging to a sailor in Totnes, after seeing the sailor's wife washing the couple's baby, took the infant, stripped it and placed it in water over the fire – by which treatment the baby perished when the water boiled. We are not told how a sailor acquired a monkey in eighteenth-century Totnes, although presumably he brought it back from overseas. There are comparable reports of monkey rampages: a monkey brought back to Devonport by a seaman was shot and killed by a constable after escaping and attacking a young girl in July 1927, for instance. Less easy to explain is the creature 'looking something like a red monkey' that jumped out upon passers-by in a certain Colebrooke lane. Ruth St Leger Gordon recorded this belief in 1965; the suggestion being the creature was a ghost, as it would usually disappear at the edge of the village. She commented: 'Perhaps another manifestation of a hairy elemental.'

The juxtaposition between real and phantom animals is perhaps best illustrated by the recent sightings of alien big cats, or ABCs. As the late sci-fi writer Arthur C. Clarke observed, the most successful of all the beasts in the animal kingdom are those that we don't yet know of, or we can't even prove to exist. But for decades now, animals that should not exist in the British countryside are frequently glimpsed and reported in Devon, leading to all manner of speculation. Without doubt, the best-known mystery animal of this type is the now legendary Beast of Exmoor, whose emergence in early 1983 created a national furore. When reports spread that a creature described as a large black panther with a smooth coat, yellow eyes, small ears, muscular haunches, a powerful chest and long hind legs and tail was being spotted along the Devon/Somerset border, there was something akin to a manhunt. This was largely due to farmers simultaneously reporting the discovery of decimated livestock in their fields. The panic was generally confined to South Molton, Drewstone, Lynton and Longstone Wells in North Devon, although the creature sometimes made forays into Somerset: in the Autumn of that year a huge paw print displaying features unique to a big cat was found by a sheep herder at Simonsbath.

For a time the region was almost in a state of siege, with posses of armed farmers, the police, big-game hunters and civilian watching-posts tracking the Beast of Exmoor; even the Royal Marines were drafted in at one point, pursuing their quarry briefly over the border into Somerset towards the end of May 1983. The Marines were kitted out with high-powered sniper rifles, but they fired no shots despite some of those deployed believing they had caught a fleeting glimpse of the animal. It is said that after the Marines were recalled, the rate of attacks on livestock increased, and although such kills have continued sporadically, to all intents and purposes the beast has vanished back into the shadows, to become a phantom or an urban legend – although still a very real mysterious terror to these isolated farming communities, who in some cases lost great quantities of livestock to the creature's vicious attacks.

The possibility of visitors like the Beast of Exmoor to our countryside has been a talking point across the county for years now. The mysterious appearance of exotic, out-of-place animals (mainly felines) appears to be a relatively modern (i.e. last forty years) phenomenon in Devonshire. However, it would perhaps be tedious and self-defeating to list every sighting of a huge, skulking black cat in Devon over the last few decades: suffice to say that some experiences do stand out as being exceptional.

Although there were rumours of strange animals akin to pumas or panthers wandering the moors even as far back as the late 1960s, it was the early 1980s when the first significant reports began to emerge. Missed by the national press, the *Western Morning News* reported on 26 February 1981 that two boys had, the previous weekend, encountered a large, black feline-like creature prowling in woodland near Spicery, a farm northeast of Tedburn St Mary. It was at one point seen to engage two dogs, which it very quickly put to flight. A sequence of tracks found in the vicinity the next day identified the creature as a puma, prompting this aside from the father of one of the boys: 'A farmer's wife was out riding some years ago when she saw what seemed to be a puma.' The same creature was subsequently reported by a Tavistock lorry driver, who thought he had seen it twice (in his headlights) loping across the A30 near the Cheriton Bishop junction. The beast earned the nickname the Tedburn Terror.

Throughout the years, reports of similar animals have steadily accumulated in the local, and sometimes national, media. In January 1992 it was reported (*Daily Telegraph*, 4 January 1992) that a kind of 'intelligence network' had been assembled by a well-known hunter of Exmoor beasts, Nigel Brierly, consisting of local farmers, a zoologist and a newspaper reporter, in response to continued sightings of these mystery animals. It paid some dividends in reported sightings and led to an educated guess that there might be a colony of ten big cats living and breeding on Exmoor.

Worryingly, these animals certainly appear willing to attack livestock and domestic animals sometimes, with a typical incident graphically reported in *Horse & Hounds* on 4 December 2002. It stated, 'West Country horse owners are being extra vigilant after a startling increase in reports of suspected big black cat attacks in the Shebbear area of North Devon'. This followed the almost fatal mauling of a ten-year-old Arab filly called Jessica, who was found with two ferocious wounds the size of fist punches on either side of her neck. Three hours of frantic effort by a veterinary surgeon thankfully saved her life, but her owner was convinced the wounds were due to an attack by a large predatory cat, as was the owner of other horses nearby, which had been mauled and bore deep scratches and wounds from what appeared to be clawed paws. Likewise, national media reported the mauling of a three-year-old palomino pony, Mischief, in a field at South Brent on 21 August 2003. Mischief suffered deep claw marks to his hind legs and punctures to his neck, and seems to have been uniquely unlucky – having been attacked in the same field in the same manner in 2002. There had been two sightings of a puma-like animal in the vicinity in recent weeks, and Mischief's injuries remind one somewhat of the way lions bring down gazelle and antelope in the wild. Mischief's owner summed up the general fear prevalent when this kind of thing happens: 'Next year, I'm worried I'll find a dead pony, or possibly worse, a dead child. That's how I see it.'

The traditional picture painted of these animals is that they are large ('as big as an Alsatian' is often the standard quote, together with 'it definitely wasn't a large domestic cat'), with a short, shiny black coat and a small panther-like head. It might be seen moving stealthily on its muscular haunches through a field or across a moorland hill, and its thick powerful tail usually catches the attention of the witness. But this is not always the case, which utterly confuses the picture and begs the question as to just what kind of wild animals are out there. Doubtless many will recall the considerable excitement caused by reports in the national media that something like a young male lion was spotted by a forty-two-year-old motorist driving near Wrangaton Golf Club after a morning school run on 19 November 1998. He spotted a very large, tawny-coloured animal weighing about 20 stone leap through a hedge; it sported a mane, described in some reports as being bloodied, and the witness immediately alerted the police. The police took the report seriously, warning children not to cycle alone to local schools, and launched an armed search with tracking dogs. But – as in all these cases – nothing was found except a paw print, identified as belonging to a 'big cat' of indeterminate species. As the day progressed, police became more concerned about armed farmers looking for the beast, and the *Daily Telegraph* was just one national newspaper that reported this odd story: when the original witness was asked if he was sure of what he saw, he responded, 'I know a lion when I see one.'

Some of these animals are occasionally posited to be leopards. And lately an animal like a lynx has been reported by a lorry driver, who spotted it while driving along the A30 near Tedburn St Mary in the early hours of 23 November 2010. This was reported in the *Exeter Express & Echo* the next day; the story's chief distinction being that this is exactly where a lorry driver claimed to have spotted a puma nearly thirty years earlier, taking us almost full circle!

This is a continuing phenomenon. That such animals are 'out there' seems reasonably clear; occasionally they are captured or killed somewhere across Britain. But it is a fundamentally weird paradox of the paranormal that even when evidence is presented to us, it is usually explained away. Such is the case with a year-old leopard cat that was reportedly fatally shot by a Widecombe farmer in April 1988 after raiding poultry, which I have been told 'was supposed to have escaped from a group of travellers'. It is either this or they have been let loose by private keepers, or have escaped from travelling menageries, etc. But although this is possibly the case sometimes, why is it that 99.99 per cent of the time they simply vanish, like feline ghosts? Although such creatures would appear to be of flesh and blood, there are a number of traits that place them in the realm of the paranormal, not least the observation that sometimes it is only a single paw print that is discovered in the beast's wake, rather than the true walking pattern of tracks that would very quickly identify the beast beyond reasonable doubt. It is almost as if some supernatural creature has left some tantalising, accidental evidence of its incorporeal existence. But even if they are real, it still wouldn't explain properly where they came from. It is almost as though they have simply 'turned up' in the county.

Concerning the fabled Beast of Exmoor, there was – even during its earliest appearances in 1983 – already a suggestion that it displayed a kind of 'human-like' intelligence that allowed it to stay one step ahead of the Royal Marines – and even (according to folklore) raid a field and make a livestock kill under the noses of those very soldiers during the night. (This last story is probably based on an actual incident.) While driving through Exmoor I have seen a sign, which is of the triangular warning design displaying a black cat with its back arched, and I can think of no reason for it to be there other than to serve as a cautionary warning to motorists that 'big cats' lurk in the area. This is modern folklore in the making, happening now and to people you probably know; one is certainly left with the feeling that out of all the phenomena jotted down in this book, this is the one the average person is most likely to experience.

Who knows, maybe you will be driving along a poorly-lit road somewhere away from a large town, and your car headlights will simply fall on the shiny black coat, muscular haunches and yellow eyes of one of these creatures looking right back at you … as if it were the most natural thing in the world.

PART TWO

Devon's Mysterious Realm

After Death Mysteries

Death is, of course, the ultimate mystery. But a curious story recorded by the Devonshire Association in 1868 implies that a Newton farmer had found the strangest way to cheat death. Many years earlier, when a young man, this farmer had been suffering from a baffling illness that threatened to end his life. One midnight, on the advice of friends, he was gently conveyed to the church and placed in an open grave freshly dug for a deceased young woman. After spending a short time laid in this grim receptacle he was taken out, and from that time on he began to recover, living to a grand old age and often relating his bizarre adventure.

There is a brief report in the *Monthly Magazine* (October 1814) telling how the body of a little boy aged around four was lately taken lifeless from the River Exe and was restored to life after half-an-hour's exertion by the Exeter Humane Society, much to the joy of his parents. In effect, this child had been dead for at least half an hour, and his restoration – in an age when CPR cannot have been an exact science – seems almost miraculous. It also begs the question of when we 'die', how long it might be before we are irretrievably dead and beyond any form of resuscitation…

Axminster boasts a story of an after-death mystery, that of bodily incorruption. When Reginald de Mohun, founder of Newenham Abbey, lay dying in 1257, he dreamt of a humble friar who arrived within a Cistercian monastery. The friar saw a venerable man, clad in white garments, conducting a boy more radiant than the sun towards the altar. When the friar asked who the boy was, he received the answer: 'Reginald de Mohun.' Chroniclers of the time implied that this was evidence of de Mohun's sanctity, and this was borne out in 1333, many decades after his passing. When the pavement of the presbytery was laid, the body of Reginald was found entire in its sarcophagus, completely whole and incorrupt; it even exuded the most fragrant odour. For three days his body lay on public display, while many people gathered to look at, and even touch, the corpse. Not much remains of Newenham now, and what does is incorporated into farmsteads on private land at the end of Abbey Lane, just south of Axminster.

Here I might mention a strange story concerning 'life' after death, or rather a possible brief instance of reincarnation. The curious anecdote was recorded by the Devon Archaeological Society and concerns one of their members, who took her seven-year-old grandson to the ruins of Frithelstock priory, west of Great Torrington.

The visit occurred prior to excavation work there in 1932. The boy, despite never having visited the place before, apparently suffered some sort of reincarnation episode, wandering about the grounds in a melancholy reverie and claiming to have been there in the past 'when I was a very old man'. He described how he used to climb twisty stairs to toll the bell in the tower, but at the time there was no reason to believe the priory had ever had a bell tower. The episode ended quite quickly, with the little boy suddenly coming round and then dashing off in his normal playful manner. Curiously, when the society began their excavations, they did indeed find evidence of a bell tower at the west end of the ruin – exactly where the boy had stood and declared it had been, while apparently the voice of some ancient spirit spoke 'through' him.

Voices of the Dead and Missing

Is it possible that some can consciously channel this ability? Those promoting themselves as a spiritualist, or medium, claim that they can. These undoubtedly provide comfort and reassurance in some quarters, although to make the impressive claim that one can actually converse with the dead – or the dead will use the spiritualist as a conduit to pass messages – means that in order to believe in the truth of this ability, one (broadly speaking) must believe in the phenomenon of an afterlife first. The subject can provoke a multitude of opinions, particularly when the medium claims to know something about a missing person or strange death: vital information often learned via the astral plane from the very victims themselves. It is only natural that examples of people alleging this ability turn up in Devon, and the tradition is an old one, often having gone by different monikers. A report in the *Argosy* (1 January 1870), for example, confirms that Exmoor 'conjurers' claimed to possess the ability to divine information about missing people: 'The farmer who loses a colt goes to the conjurer to learn where the animal has strayed; the mother whose sailor-boy has not been heard of for years finds consolation in what the dealer in magic reveals to her concerning him.'

There is an early example of this ability, concerning the disappearance of a Higher Barton farmer called Alexander Puddicombe. He vanished without trace after leaving the Black Horse Inn, Barnstaple, at Christmas time in 1819, although the colt he had ridden turned up by itself at its home the next day with a broken bridle. The missing man's hat was found in the River Taw, and a man named Carter was suspected of killing him for the money he carried from market. In 1830, a mysterious man arrived in Barnstaple, claiming to have come from Bristol in consequence of a dream he had experienced, in which he had been 'told' that the missing man's body was buried in a field in Fremington, underneath a tree.

The spot was dug up by Puddicombe's relatives; without success as it happens, but it illustrates that such claims were at least investigated. (Incidentally, it was claimed as evidence of Carter's guilt that he had declared at some point that his arm might wither if he had killed Puddicombe: this had indeed happened, when he injured his arm at work, disabling it and rendering it nearly useless until his death.)

Three decades later those who professed to possess this clairvoyant ability were denominated spiritualists and, later, mediums or psychics. Spiritualists claimed to have

received a message from a missing woman in 1898. Three years earlier on Christmas Eve, elderly Mrs Jane Brooks had vanished entirely while proceeding to her home in Raleigh. It was generally considered she had been lost in the River Yeo, although later reports stated she had been spotted alive and well in Barnstaple. This proved to be a case of mistaken identity, but a strange development followed. The *North Devon Journal* received a letter from 'a Christian spiritualist' in South Molton, who had been privy to a séance a few weeks earlier in which the spirit of the missing woman 'came through' to elicit the fact that she had met her fate 'by ruffianly hands' and had as such been murdered. Members of the woman's family had long suspected she had not been lost to the river, Mrs Brooks having known her route exceedingly well, but this appears to be the last we hear of the mystery: Jane Brooks' spirit was seemingly sensible enough to impart this information, yet not to be more specific in her details.

The controversy that this paranormal ability could elicit is clear from a bizarre instance in 1925. The case was baffling enough at the start. On 11 September, an elderly widow named Mary Harvey had simply disappeared while out picking blackberries in Coxleigh Wood, east of Barnstaple. She had become separated from a younger companion, Mrs Hart, who reported her missing. Hundreds aided in the hunt for Mrs Harvey, scouring the woodland and the surrounding district, but to no avail. Her body was not found until 26 January 1926, considerably decomposed in a thicket; but by that time a Barnstaple spiritualist had already declared that he knew via 'a revelation that had come to him respecting the case' that the old woman had been murdered. More dramatically, a Cardiff medium of fifteen years' standing, Mr George Eshelby, visited the missing woman's Richmond Street home (in the company of Mrs Hart) and held her pension book until he 'received' a message from Mary Harvey: this message was to the effect that, after wandering off by herself, she had encountered a stranger who had struck her on the head with a heavy stick and buried her body in the vicinity of the wood.

When this was reported the case became the talking point of North Devon, with many pointing the finger of accusation at an acquaintance of the two ladies. When Mrs Harvey's body was found, it appeared inconceivable that the searches had missed her: she must have been dumped there later by her killer, who had even hacked off her hand to get at her rings! However, the coroner attributed the missing hand to woodland wildlife, and ruled that Mrs Harvey, an octogenarian, had simply become separated, had fallen and then died. The opposing views of the role of the spiritualist, Mr Eshelby, in all this are neatly summed up when we learn that the *Western Times* pondered:

> It would be easy to pooh-pooh his story as honest, but deluded, imaginings. But this at the moment we are not prepared to do … whereas many are disinclined to believe in it, there are, on the other hand, many who do believe in these manifestations, and they include some of the world's leading scientists and thinkers.

The coroner, however, advised Mr Eshelby to confine himself to spirits from a bottle with a label on it.

There are also later examples of this practice being employed to find missing persons. The *Daily Mail* (12 November 1973) reported that a psychic had become involved in the mysterious disappearance of Mrs Doris Symonds, who vanished while shopping

in Plymouth in 1963, leaving behind a four-year-old son and all her possessions. In February 1973 her husband was cleared at Exeter Crown Court of killing her, and later that year a medium came forward to tell police that he had 'spoken' to the missing woman while in a trance. Mrs Symonds imparted that she had been strangled and thrown in a flooded quarry on the edge of Dartmoor, and the police subsequently declared, 'there are certain aspects in the report which may interest us'.

Fires from Nowhere

Fire, by its very nature, can be difficult to track to a source. Devon's newspapers frequently reported intriguing stories of 'mystery' fires: for instance, two inexplicable fires combusted within a fortnight at the Royal Naval Barracks, Devonport, in spring 1948. The fires ignited (or were lit) first in the attic of Exmouth block, then in the attic of nearby Grenville block. Both caused considerable damage, and caused much speculation among Plymouth citizens; the *Western Morning News* reported 'the authorities are faced with the alternatives of an electrical wire fusing [twice?], a cigarette end [in the attic?], lightning [twice?] or sabotage [why, after the war?]'. The same newspaper reported in May the same year that five simultaneous 'window fires' had broken out at the Imperial Hotel, Barnstaple. These took hold on the frames and curtains of windows in the sun lounge, vestibule, dining room, reception and a bedroom. It was suggested the sun was to blame – but why just here, and not at other buildings in Barnstaple where windows happened to face the same direction? The newspaper noted: 'Neither firemen nor police could give a reason for the fires,' which had ignited in full view at different places in the hotel even as the emergency services were trying to quell others. Firefighters actually watched curtains ignite in front of them. Can the spring sun really be so intense that it causes things to combust? If so, why does this not happen more frequently?

Another mysterious fire baffled a coroner's jury during an inquest in the Drill Hall, Newton Poppleford, near Sidmouth, in June 1913. The previous year, a twenty-month-old infant named Winnie Howe had been left asleep in a cot upstairs at a labourer's cottage by her mother, the rest of the family having gone to work or school. Not much later that morning, alarm was created when it was noted smoke was pluming from the cottage, and villagers rushed to break in. Dense smoke filled the house, and a rescuer was forced to enter the upstairs bedroom via a ladder propped outside the window. Inside, they discovered the choking, thick smoke was coming from a small fire in the vicinity of the infant's cot, with the infant being found dead within. But although it was clear the child had died from shock, burns and smoke inhalation, how the fire had started was a complete mystery. No matches were found in the bedroom, or anywhere else, and although there was a fire grate in the kitchen downstairs, the mother testified that it had not been burning when she left the house. The infant had been the only one inside the building at the time, and could not have left her cot by herself, then climbed back in. The parents and six other children were demonstrably somewhere else at the time. Despite grave concerns that the child should have been left alone, the affair remained a total mystery, with the coroner, Mr E. W. Tweed, summing up everyone's mystification by cryptically commenting: 'It is extraordinary. It is very serious. This, gentlemen, is the fifth death from burning I have had before me during

the past four weeks. Three have been due to wearing flannelette.' And this is as near to an explanation as was forthcoming.

Another mysterious incineration baffled a coroner in 1885. Anne Hill, an elderly market trader, was found burnt almost to ashes in the smoke-filled kitchen of her home in Bull Court, Barnstaple, on the morning of 25 March. Bizarrely, very little incidental damage was found in the room, there also being no fire in the grate and the coals being perfectly cool. Anne had been drinking the night before, but she had not been heavily intoxicated, and although it was speculated that a small 'benzoline lamp' found upturned and charred 4 feet from the body could have some significance, the sequence of events leading to her death was a mystery. The *North Devon Journal* (26 March 1885) reported: 'A verdict of "Death by burning" was returned, the Coroner remarking that how the body became ignited there was no evidence to prove.'

Is it really possible that human beings can simply ignite spontaneously under the right conditions? This is a mystery that has not yet been dismissed conclusively, and it is worth pointing out here that some people have claimed to suffer 'fiery persecutions' – that is, inexplicable fires combusting in their vicinity through no apparent cause. The *News of the World* (19 October 1975) reported the case of Mrs Barbara Booley, near whom seven mysterious fires had ignited over a four-year period – usually when she was frustrated or annoyed. One blaze early in October had ignited at the Torbay Hotel, Sidmouth; the owners had sacked Mrs Booley the previous day. When bedding on a stair combusted she appeared as shocked as everyone else and helped put out the flames. Mrs Booley was naturally questioned by the police on numerous occasions, but not charged. She declared, 'Fires seem to follow me around. But I swear on any child's head that I didn't start them.'

Sometimes, particularly in poltergeist cases, small fires plague bedevilled households, but there is no suggestion of this here. Mrs Booley declared the Sidmouth fire 'one hell of a coincidence'! In view of the inexplicable nature of these combustions, some might consider 'coincidence' too mundane a word for it.

Automobile Mysteries

In 2010, details of some of the weird and wonderful calls made to Devon and Cornwall Police over the last fifteen years were released into the public domain under the Freedom of Information Act and reported in the national media. Among the strange observations was that of a 'ghost driver' on the A38 in July 2004 – which the police report rationalises as: 'Two old ladies in white Fiesta – come onto the A38B carriageway on the off slip facing the wrong way. Stopped on the hard shoulder, trying to reverse back up the off slip.'

Recently, a rather more eerie piece of folklore concerning a 'phantom car' was passed to me by a member of the Moretonhampstead Development Trust, whose good work is dedicated to the promotion and regeneration of this ancient market town.

Their story goes back over forty years, to the spring of 1969. The incident happened on that most haunted of roads, the B3212 between Moretonhampstead and Postbridge, in the small hours of a foggy morning when a man driving his family was forced to swerve off the road, coming to a halt in a ditch. The reason for his panicked maneouvre

was the appearance of another car that had suddenly emerged out of the fog, bearing down on him and on the wrong side of the road.

In the hours after the emergency, when the driver's car had been towed from the ditch to a nearby garage (and his shock had subsided), he was informed by the garage mechanic, very definitely, that no car that could have been the reckless joyrider had passed by. Furthermore, a local AA recovery man stated that there had been a fatal accident near where the driver had been forced off the road. And now, in the aftermath of it all, the driver recalled with a clearer mind that he had not seen the mysterious car pass by him; he had only seen it zooming towards him, as though on a deadly collision course…

What is it about automobiles and this stretch of road? After all, this is where the Hairy Hands wrestled steering wheels from the grips of drivers. But perhaps the most interesting detail of the encounter is this piece of incidental, pointless information. While the car rested in the ditch, the driver had attempted to start the engine again, but found the battery flat, despite having only driven 50 miles. The garage confirmed that his car had been completely drained of power somehow. I wonder what the significance of this added detail is; were the 'phantom car' and the battery failure connected? If so, then perhaps it would suggest a ghostly entity was responsible for another singularly mystifying event in 1914. According to the *Western Times* (6 October 1914) a motor car parked in Holsworthy 'started off on its own account' shooting along the kerb, before winging a lamp-post and changing direction. The vehicle finally came to a halt when it smashed through the plate-glass window of a draper's shop.

Joyriding ghosts? Even in the world of the paranormal, some things stretch credulity; but there you have it, as told and reported.

The Invisible Attackers

Perhaps the most sinister of Devon's mysteries is the unexplained maiming, mutilation and even killing of livestock and other animals in remote parishes on lonely, inhospitable nights. The mystery here is not the physical fact of the injuries, but the means and motives behind them, with everything from insane potential serial killers and vampire Satanists to UFO occupants, unknown wild animals and poltergeists being blamed.

Needless to say that, under whatever conditions these attacks might occur, they are singularly worrying for those in the local community. On 3 September 1920 the *Western Times* reported that Mr F. C. Hunter, of Bystock, near Exmouth, had found both a fine chestnut horse and a bay pony he owned had been stabbed near their jugular veins by someone who appeared to be wielding a sharp but jagged instrument. At nearby Thorne Farm, Lympstone, a mare grazing in a field near Harefield House suffered a wound, similarly delivered on the right side of its neck. Badly wounded, the animals had all bled plentifully; but in each case, 'no traces of blood were found on the ground, which only adds to the perplexity of the police'. Indeed, who would do such a thing? And how was it accomplished without leaving significant traces?

Strange and disturbing mysteries of this nature take place against the bleak backdrop of the moors. An incident in mid-July 1977 provoked much controversy in the national papers. This was when the grim discovery was made of fifteen dead ponies clustered at

Cherry Brook Valley, between Two Bridges and Postbridge. A strolling family spotted the group of bodies, all lying within a hundred yards of each other, with the carcasses described as mangled, torn and crushed. Although the heights of Bellever Tor are nearby, there were no cliffs or anything in the immediate vicinity down which the ponies could have catastrophically fallen *en masse*. According to a spokesman for the Dartmoor Livestock Protection Society, the ponies had suffered injures like broken bones (in one case a broken neck) and torn arteries; but, stranger, their bodies appeared to have decomposed at an abnormally high speed. Many were the theories put forward for this bizarre incident: malnutrition, deliberate poisoning or shooting were eliminated fairly early on. Some suspected the ponies had died after eating bog asphodel … but then what had caused the injuries, described as 'fairly violent' at the time? Some thought lightning was the cause. Another suggestion was that a four-wheeled vehicle driven by rowdies had terrified the horses into an insane, collective tumble, but the terrain would have made such driving impossible – although some thought a highly skilled biker might have had the same effect. The most popular suggestion at the time, put forward by John Wyse of the Torquay-based Devon UFO Centre, was that a UFO had been flying low over Bellever Tor, creating a vortex that had sucked the ponies up and hurled them to their deaths. This is a mystery that has not been satisfactorily explained, largely due to the inexplicable rate of decomposition; although there is a general agreement something frightened the ponies into a collective manoeuvre. The only observation that I might add is that this is the exact spot where the Hairy Hands crawled up the side of a caravan in the twenties, as seen by Theo Brown's mother.

Other sad mysteries point towards some sort of ritual, but whether satanic or homicidal is unclear. In January 2005, for instance, seven garrotted sheep were discovered arranged in a circle near Sampford Spiney, east of Tavistock on the edge of Walkhampton Common. The RSPCA believed at least two people were involved in this madness, which subsequently went on to claim more animals in the area, their carcasses laid out, necks broken or eyes gouged out, in shapes like pentacles. On 26 June 2006 three sheep were found laid out in a line on moorland near Whitchurch Common, north of the previous incidents. These had had their necks broken, tongues cut out and eyes gouged. It was thought they might have been slaughtered at the time of the full moon the previous night. And such atrocities continue, for as reported in the *Daily Mail* (16 May 2011) four goats were found over Easter at Tipton St John, each with their heads twisted backwards or necks cut. Again, it appeared to be some kind of ritual.

Unfortunately, it is the 'invisible' nature of these attacks that lends them such an air of mystery and opens such a field for speculation. The climate of fear is akin to those urban panics that from time to time centre on Devon's cities around 'phantom' social workers, or alleged child abductors dressed as clowns – whereby the scare is considerable but no evidence ever really emerges to substantiate any culprits and the whole matter is never really properly explained. Concerning the animals attacks, the worry generated is considerable, and might be passed off as another urban legend gone awry except that the animals have physical injuries, that (in many cases) are never accounted for.

Here I might draw attention to a rumoured practice said to have occurred in parts of Devon many, many years ago. The Revd Sabine Baring Gould, writing in 1866, noted this chilling ritual, which is disturbingly similar to today's outrages:

Moor ponies near North Molton, on the heights of Exmoor.

I have been told that on Midsummer Day, on Buckland-in-the-Moor, a number of people assemble in a field called the Ploi-field, in the midst of which is a huge granite block. The young men then range the moor in quest of a sheep, which when caught is brought to the stone and there stabbed to death with their knives, after which they sprinkle themselves and others with the blood...

Nature's Wonders

Many are the natural wonders of Devon: for example, there is a modern example of that most Fortean of mysteries, the 'toad in the hole', mentioned in a letter to the periodical *Animals* (April, 1972). A gas fitter noted that, in widening the Barnstaple to Ilfracombe Road some years prior, around twenty-three live frogs were released from a thoroughly solid concrete gas meter floor beside the road. There was nowhere they could have squeezed in, and the workers could only ponder the possibility that these were 'living fossils' – entombed in the concrete when it was set years before, and yet somehow still alive and active when finally freed by the men's sledgehammer.

As bizarre as this is, some stories linked to the natural world contain eerier paranormal themes and are very old indeed; Thomas Fuller's *Worthies* (1662), for instance, speaks of a dry basin, not fed by any spring, that would spontaneously and miraculously overflow upon the death of a prince, an insurrection or any other event of national importance. By 1648 this had happened – without any rain to help it – four times. The pool is called the Bathe Pool, and can still be sought out in North Tawton, although it is on private land at De Bathe Farm.

An amazing, frightening display of natural wonder occurred on 7 October 1811. At 3 p.m., several persons took shelter in the porch of St Andrew's church in Sampford Courtenay when rain threatened. They were assaulted by a 'great fire ball' that appeared among them and threw them in various directions. Inside the church, bell-ringers found

the bells so unaccountably heavy that they desisted and climbed the belfry to look down into the church. They perceived four distinct dancing fireballs, which spontaneously burst, filling the church with fire and smoke. These fireballs caused physical damage, breaking a heavy beam on which one of the bells hung and thus dropping the bell violently to the ground. One man received a blow to the neck from one of the fiery globes, which made him bleed plentifully at the nose and mouth, and when it was all over villagers found that 'one of the pinnacles of the tower ... was carried away, and several of the stones were found near a barn door, at a considerable distance from the church'. This event, noted in *The Cabinet Of Curiosities* (1822), was presumably an example of ball lightning, an as-yet unexplained atmospheric electrical phenomenon, which some scientists even refuse to recognise as a physical possibility; not least because ball lightning, as in this case, seems to possess a kind of life force of its own – at least that is how it often appears to the witness. Consequently there is much folklore attached to ball lightning and related phenomena, such as the *ignis fatuus*, or Will-o'-the-Wisp.

These days, one of the most puzzling of nature's mysteries is the crop circle, and what agent might be responsible for these sometimes intricate patterns in agricultural crop fields up and down the country is an enigma that continues to split opinion. But in one case at least, there is a suggestion that the crop circle is a mystical, paranormal event that almost has a dark life force of its own. The periodical *Fortean Times* (Issue 65, November 1992) carries a report from Berry Pomeroy, where a crop circle was discovered around 10/11 June in a barley field at Berry Farm. This comprised two 24-foot circles connected by a 22-foot corridor through the barley, but mystery was piled upon mystery when certain local people began referring to the pattern as 'the Scythe'because of a series of bizarre events that same week. These included two hay barns 5 miles away combusting simultaneously, and the deaths of three motorbike passengers on green Kawasaki bikes who were killed in accidents at Berry Pomeroy, Dawlish and on the Plymouth to Totnes road.

Along similar lines, no pun intended, come claims that Devon is crossed with 'ley lines': arrow-straight alignments of mystical earth energy that pass through tors and natural landmarks and on which humans have subconsciously built long barrows, pagan burial sites, churches etc. throughout the centuries. Many hauntings nationwide have been observed to be on the site of a supposed ley, although in August 2012 I was told by a former employee of the Castle Inn, Lydford, of a variant on this. She understood that one ley ran through the stables near Was Tor, and this had a bearing on the inordinately high suicide rate among people who unwittingly lived along this trackway of psychical energy. Suicide has indeed been a problem at the gorge near the stables; as long ago as 1830 one traveller's guide refers to 'dreadful anecdotes ... told by the guides, of several persons having chosen this wild and sequestered scene for the commission of suicide'.

Strange Rain

Sometimes the sky can throw things at earth that we can only wonder at. According to the *Evening News* of 9 November 1950, a farm near North Molton was found to be littered with chunks of ice the size of dinner plates. Clearly they had hurtled out of the

sky like ice meteorites, for one 14-pound missile had killed a sheep when it had struck its neck before embedding itself in the nearby ground.

While not immediately explicable, such a fall at least resembles the elements. Not so other strange rainfalls, however. In April 1837 the *Literary Gazette & Journal* cited the *Plymouth Journal* as its source for the story 'that, during a recent snow-storm, a large number of black worms, about three-quarters of an inch long, fell in the village and neighbouring fields of Bramford (Brampford) Speke, Devon. They are said to be quite different from the turnip-worm or any other known to agriculturalists in that quarter.' Similarly, the *East Devon Reporter* (12 October 1869) reported that a vast number of spiders (and webs) fell from the sky near Tiverton, while three days later prodigious quantities of spider's webs rained down on South Molton. This continued all afternoon, covering fields, houses and people. This phenomenon was repeated in November 1977, when Mrs Joan Davie of Myrtle Cottage, Goodleigh, told the *North Devon Journal* she and a friend had witnessed thousands of tiny black spiders falling from a clear, windless sky early one morning. Fields in the vicinity appeared to be literally covered in cobwebs, although this merely added to the puzzle without really explaining it.

In summer 1932 a group of haymakers working in a field at Deptford, near Barnstaple, watched in utter astonishment as a whole row of hay, about 260 yards in length, apparently lifted itself bodily from the ground, only to sweep half a mile into the air and sail away of its own accord. Remarkably, other similar rows of hay were left undisturbed by this mysterious agency, and the abducted hay was deposited *en masse* onto a group of tennis players at Ellerslie School, about half a mile away. When it came down, the hay was not in the fashion it had been collected in, but in 'queer ball shapes', according to the *Western Times* (1 July 1932). The only explanation possible was that a small, localised whirlwind had stolen the bunch of hay, this being an argument both for and against strange rain; on the one hand it evidences that while such a natural wonder might account for raining hay, how could it account for raining worms: for how could a natural occurrence like a whirlwind 'know' to only collect a specific type of worm in its random course through the countryside?

If anything points towards miniature vortexes depositing strange rain, it is the experience of a Topsham lady who in early March 1983 found strange pink beans mysteriously scattered in her garden. They were quite fresh, despite being out of season, and the bemused witness was reported as saying, 'They could not have been thrown because our house is surrounded by three walls and a courtyard.'

Heavenly Oddities

The *Gentleman's Magazine* (1787) recorded the tradition that on Ascension morning, villagers around Exeter sincerely believed that the figure of a lamb appeared in the eastern heavens, and later Victorian folklorists recorded the continuance of this belief. William Henderson noted that 'poor women' on Dartmoor watched the sun rise on Easter morn, looking for the lamb in the sun's disc through darkened glass: 'Some always declared they saw it.' Why should it be that these maidens thought a miraculous heavenly lamb existed in the skies, and, indeed, what might they have witnessed that started this tradition?

There has, of course, always been a fascination with curious observations made in the Heavens, hinting as they do at other worlds, other beings and even the very Gods themselves. Although there is no suggestion of a UFO, one of the earliest reports of an extraterrestrial oddity certainly hints at some 'higher power' in the cosmos, and is nothing if not singularly strange. According to a contemporary tract, on 14 November 1642 a blazing star was witnessed shooting through the sky above Totnes.

Simultaneously, it was reported, Master Ralph Ashley, 'a deboyst Cavalier', was attempting to rape the virginal daughter of Mr Adam Fisher, who resided near the town. At this instant, the 'fearefull comet' shot over the town, terrifying everyone in the surrounding countryside. Such a spectacle could not detract the wicked Ashley from his assault, however, and he persisted – until he was 'struck with a flaming sword which issued from the comet, so that he dyed a fearefull example to all his fellow Cavaliers.'

Clearly there is a political dimension to this story, but it does at least evidence the awe that strange and unfamiliar natural phenomena generated when it was seen in the Heavens over our county. The local newspapers of the early twentieth century are full of reports of meteorites, green flashes in the sky, and in one remarkable case, a brilliant light in the shape of a cross seen in the South Devon sky early on the morning of 11 December 1938. An Exeter resident, Miss E. Stephenson, described it as 'a Celtic cross low down in the heavens. It was much too large to be a star, and there were distinct rays emanating from it ... It was one of the most wonderful sights I have ever seen.'

The *Western Morning News* wondered if this might have been the star Sirius. And in many ways this is a good point to move on. Here we depart terrestrial mysteries and head ever further into the unknown. For all the cosmic and atmospheric oddities in the known sphere would pale into insignificance if just one of the following tales genuinely concerns what is implied – visitations to Devon by people and 'things' from other worlds, other universes ... perhaps even other dimensions. It might, just possibly, be a glimpse at a revelation: that we might not be alone in this universe, and may even be being monitored by higher beings.

A Brief History of Unidentified Aerial Phenomena in Devon

In the minds of the rationalists, when Devon's pixies retreated into the fog and mist of a superstitious past, it would have been an imaginative Devonian who could have conceived that, a century later, a pixie equivalent would appear for a more advanced, technical age. This was the UFO, and numerous similarities can be seen between these two realms of the paranormal – it is almost as if they are the same phenomenon, only in one case observed by the very much grounded county folk of old, and in the other by a Devonian familiar with concepts such as international flight and rocket launches.

The fundamental difference, of course, is that UFOs are commonly perceived to be visitors from outer space, or even from other dimensions, and the following is the briefest history of this most modern of mysteries.

What might have been an early UFO sighting was reported in the *English Mechanic*, when a person witnessed a great number of highly coloured objects like little suns in

the skies over South Devon on 10 May 1902. But the mystery of the UFO (or, more properly these days, Unidentified Aerial Phenomena) really reached Devon in 1950. This was the year that a 'flying saucer' was spotted and subsequently reported to a bemused county population. At around 11 p.m. on the night of 30 October 1950 Arthur Bearne, a fifty-five-year-old Paignton resident, was driving home with his wife and daughter from a badminton tournament, when, looking skyward, he spotted 'two large circular objects travelling south in a horizontal position looking something like large white flames'. So alarmed was he by these objects that he contacted South Devon Police, and later asserted, 'I would swear that I have said exactly what I saw.' Mr Bearne's claim was borne out by the crew of a Liberty boat plying between Flagstaff Steps, Devonport Dockyard, and HMS *Defiance*. These described 'two circular objects travelling at an incalculable speed and emitting a trail of fire'.

The mystery was reported in the *Western Morning News* of 1 November 1950. The following day, the *North Devon Journal* backed this up by reporting that a Mr J. Stewart of South Bank, Woolacombe, had spotted a very bright light (twice as bright as any star) shooting through the sky north of Lundy Island at about 10.50 p.m. The 'object' was between 6,000 and 10,000 feet in the night sky, and blazed brilliantly for a few seconds. It left a trail, and was noiseless, but Mr Stewart 'reputed emphatically the suggestion that the object might have been a comet'. His impression led him to believe he may have witnessed a craft of some sort. Approximately twelve minutes later what was presumably the same object was seen from Instow, again only for a few seconds 'as it flashed across the sky' in a south-westerly direction. It is interesting that those in the south perceived two objects, while those on the North Coast saw only a singular, their different vantage points perhaps accounting for the discrepancy. But clearly something, at least, shot through the skies above Devon that night, baffling all who saw it. The end of 1950 was a period of intense celestial activity over Devon, and whether or not what was seen belonged to the realm of inexplicable natural wonder, the media had a field day with suggestions it heralded the arrival of alien beings.

On 2 December hundreds of Christmas shoppers and spectators at football matches in North Devon saw a bright object in the afternoon sky at about 3.45 p.m. It was variously described as a large bright star with a tail of flames and sparks, a giant skittle pin with a luminous tail, an aluminium rocket with a pink, blue or yellow exhaust, and a 'flying tadpole' that left a trail of purple smoke; but the unnerving thing was that it appeared to fly so low – almost roof top height. Some affirmed that there was a distant noise like thunderous gunfire a few minutes after it had passed. The media reported: 'Many of them are now convinced they have now seen a flying saucer.'

In 1967 there were two now well-known UFO mysteries. At around 11.30 a.m. on 28 April, hundreds of people in Torquay (as well as the Berry Head coastguard) watched a silvery-coloured object pass over Tor Bay in the direction of Brixham. Here, it obligingly hovered at a height of around 16,000 feet, allowing people to observe it in great detail. Some believed they were looking at a huge, dome-shaped object, with a door in its side; after about an hour, it climbed rapidly and vanished.

Later that year two policemen hit the national headlines when they chased bright lights in the shape of a pulsating cross at about 4 a.m. on 24 October. Constables Roger Willey and Clifford Waycott were on patrol when they spotted the 'object' at

Torquay; where hundreds spotted a 'UFO'.

Anvil Corner, 2 miles east of Holsworthy. According to reports at the time, they drove over to investigate – but the light moved off at an alarmingly high speed near treetop level, prompting an insane 10-mile chase reaching speeds of up to 90 mph. The nearest they got was about 40 yards from the thing, when the object appeared to stop in a field. The men got out of their car, but the strange light vanished. At a press conference, Willey stated: 'It looked like a star-spangled cross, radiating points of light from all angles … It seemed to be watching us and would not let us catch up. It had terrific acceleration and knew we were chasing it.' The Ministry of Defence later declared the object had been a giant jet tanker of the USAF on a refuelling mission, although it was quickly established that none of the tankers was airborne at the time. Other explanations concerned stars and planets distorted by atmospheric conditions, and we have seen a like phenomenon already reported in 1938; but this is a mystery that continues to fascinate in Devon, not having been explained to everyone's satisfaction.

Visitors from Other Worlds

But what of the occupants of these mysterious craft, if that is indeed what they are? An intriguing UFO affair is alleged in Eileen Buckle's *The Scoriton Mystery* (1967), claiming this tiny place west of Ashburton, on the edge of Scorriton Down, was the scene of an extraterrestrial experience. The so-called 'contactee' in question was one Mr Bryant, and Ms Buckle describes one of his encounters vividly. Mr Bryant had been out walking on the Down in the early evening of 24 May 1965 when a huge object descended in front of him, oscillating psychedelically and hovering about 3 feet from the ground. An opening became visible, and three figures dressed in diving-gear-type outfits beckoned to Mr Bryant to come forward. They next took off their helmets (one

wonders why they needed them if they could breathe in our atmosphere), revealing very high foreheads, blue eyes and fair hair; although one, a youth who stated his name was something like 'Yamski', had brown eyes and hair. When he spoke, it was in a kind of Eastern European and American-inflected English, and Yamski claimed the group came from Venus; their ship, it seems, flew by 'ideomotor movement'. Yamski commented enigmatically that it was a pity a certain 'Des' or 'Les' was not there to see them, as he would understand their visitation. When the trio left, they presented Bryant with some pieces of metal as proof of his encounter, although this was not the last he saw of them. Bryant was a gardener and handyman at an old people's home in Newton Abbot, and his tale beyond this is a veritable science-fiction fan's fantasy of Machiavellian proportions that most have labelled as a hoax; although Ms Buckle got an assertion that it was all true, even as Bryant lay dying in hospital on 24 June 1967.

There were more claims of alien abduction reported in February 1978. A woman, identified only as Mrs G., approached a British UFO investigative organisation, Contact UK, with a surreal story. She claimed that while pegging washing out in the garden of her home in Ermington, east of Plymouth, thirteen years earlier, she spotted a shining blue shape in the sky, approaching from the north. The thing frightened her, and (dropping the washing) she suddenly found herself completely enveloped in bubbles of light. Three humanoid figures were suddenly before her in the garden. They appeared to be male and wore blue metallic-type clothing. They remained silent, and were around 5 feet tall. These figures grasped her arms, and in an instant they were lifted via a beam of light into a kind of room, where more of these figures milled about. Mrs G. telepathically felt she would come to no harm. An indeterminate time later she suddenly found herself on her lawn. She was momentarily stunned by a sharp blow on the back of her neck, and when she looked up the airborne blue shape was already disappearing off at great speed. Leaving aside the obvious solution to this episode – that Mrs G. suffered some kind of unaccountable blackout, followed by a vivid dream – a senior representative of Contact UK, Bernard Delair, nonetheless publicly explained: 'We take this report very seriously. Her story is very graphic and fits many others.'

A different type of encounter perhaps implies visitors from realms that we can barely comprehend – for what on earth do we make of this next mystery? Briefly, the sighting came to light in correspondence submitted to *Fortean Times* (Issue 243, December 2008) following an article on rocket men and possible aeronauts from the future. It concerned a couple, both lecturers, who during a social engagement a decade earlier in Fremington, by the River Taw, both very definitely saw a flying human figure about 100 feet in the air. This person wore some kind of backpack and he swept steadily and silently through the evening sky in an upright position – despite having no visible signs of propulsion, or anything that might account for his movement, such as a parachute. The report makes it clear that there was no suggestion this was a balloon or some kind of airborne flotsam. It was, quite simply, a flying man.

Even stranger was the fact that no other guests at the party appeared to see the flyer. This story caught my imagination at the time, and I have often cited it during discussion as an example of how weird the modern world can be; for, during said discussions, the best explanation that anyone can come up with is that it 'must have been a backpack like James Bond uses in Thunderball' or it 'must have been something

to do with Fremington Army camp', which closed in 2009 – neither of which seem very impressive to my way of thinking. It is other, paranormal, suggestions, occasionally posited, that truly take us out of this world: that such a figure might represent a humanoid extraterrestrial struggling with our gravity, or even stranger, that they are future humans who have mastered dimension jumping and/or time travel and are having a quick peek at a different reality. The weirdest suggestion is that sightings like these (and there are others: Barnoldswick, Lancashire, in 2003, for example) are 'future echoes' – ghosts of people yet to exist and things yet to be designed...

A Continuing Phenomenon

Returning to UFOs, their mythology is now such a part of our shared consciousness that the crash of a 'flying saucer' was utilised as part of an innovative class writing project at Bolham Community Primary School, north of Tiverton, in October 2010. Great effort was required to keep the project secret from the children, who – after spotting a wandering 'alien' lost and alone in a neighbouring field – were required to write newspaper-style reports of the incident. The local police also helped in this imaginative project, with the site being cordoned off with police tape: surely an event that these children will remember well into adulthood, whatever becomes of the UFO mythology in the popular imagination in years to come. Perhaps class projects like this will consign the UFO to the same realm as the fairies – that of wonder and fancy – during the next generation or two.

Devon has been the epicentre of a UFO flap more than once, and some stories as reported have undoubtedly sensationalist elements. The *Independent*, for instance, reported on 20 June 2008 how thirteen days earlier a police helicopter had had to bank sharply to avoid a 'flying saucer shaped' object that appeared beneath them as they were hovering at 500 feet above the Ministry of Defence base at St Athan, near Cardiff. The three crew gave chase to this object across the Bristol Channel as far as the North Devon coastline before a lack of fuel forced them to turn back. A spokesman for South Wales Police commented, 'We can confirm the Air Support Unit sighted an unusual aircraft. This was reported to the relevant authorities for their investigation.' The *Sun* reported this event the following day, adding, 'airline pilots have spotted hundreds of UFOs over the nearby Bristol Channel this year'; but if this were the case, surely we would have more definite proof of extraterrestrial visitors by now?

Newspaper archives and calls logged by the Ministry of Defence contain scores of reports of ordinary (in UFO terms) jumping stars, miscellaneous silvery discs, pulsating bright lights, hovering triangles and orange globes – some of which, at least, must surely have natural or logical explanations. For instance, aberrant clouds can cause misidentification sometimes, as a letter to the *Mirror* in February 1977 observed. A witness in Bideford had watched in amazement as a procession of cube-shaped clouds swept over the horizon at incredible speed – against the wind. However, classic, inexplicable UFO encounters have not quite vanished from Devon, even in this post-*X Files* era. The *Exmouth Herald*, among others, reported in February 2010 how a retired engineer out walking his border collie in Phear Park, Exmouth, at about 10 p.m. was confronted by something he had never seen before in his life. A circular object, 30 feet

in diameter and 100 feet long, with flashing blue and red lights on its perimeter, seemed to descend at the park's top end by the bowling green. It presented a whitish shape, and, worryingly, began to move towards the witness. It made a kind of droning noise like 'mymymy', and at this he fled with his highly agitated pet dog, twisting his ankle in his haste to get away. Shortly afterwards the craft hovered over the bowling green's hedge before oscillating – and then shooting off at high speed at a 45-degree angle.

Most recently, the *Independent* (23 January 2012) has published a very clear picture of a supposed UFO snapped over Plymouth at 9 p.m. one night earlier in the month. The photograph, taken by a night shift worker at the Royal Albert Bridge, presents a glowing red object with bright flashing lights, and the witness is quoted as saying: 'It must have been a UFO – and I cannot believe I am saying that, because I don't believe in them usually. I am always sceptical.' At the time of writing, this is a mystery without an explanation put forward. Nor has one been made for the sighting made by a retired Lt-Col.and his wife in Witheridge, who saw three red lights follow each other horizontally through a cloudy and starless night sky over the Jubilee bank holiday. This witness was sensible enough in an interview with the *North Devon Journal* (14 June 2012) to repeat that this was not a misidentification of a Jubilee firework.

For all the detractors, I suspect the mystery of unidentified aerial phenomena will be a long time dying out – much like many of the other long-held superstitions and paranormal beliefs outlined in this book. From time to time the local and national media report the latest revelations from newly disclosed Ministry of Defence documents (made available under the Freedom of Information Act 2005), such as the unexplained wave of sightings throughout the night of 31 March 1993 of a large triangular craft with lights at its points seen over North Devon. The object, as reported in the *North Devon Journal* (06 September 2009), was in one instance perceived by two police officers near Lynton to be three lights attached to one large object. It was followed by two beam-like vapour trails, and approached the coastline from the Bristol Channel. As with many UFO cases, the myriad explanations put forward were not satisfying; the American forces had not been testing a revolutionary prototype aircraft that morning, nor can a Russian rocket re-entering earth's atmosphere at the time account for all the sightings and reports. The *North Devon Journal* explains that a Ministry of Defence minute, previously restricted, noted: 'In summary, there would seem to be considerable evidence that a UFO of unknown origin has been operating over the UK.' More than seventy persons saw this object, according to a report on the same incident in the *Mail* of 18 August 2009.

At the time of writing, the latest (August 2011) batch of Ministry of Defence records released to the National Archives have revealed that a huge white and silver UFO was spotted moving slowly over Crediton by a former member of the WRAF on 5 November 1995, and, although the date in question very quickly suggests an answer to this, a member of the WRAF has to be assumed to be capable of distinguishing between a craft and an elaborate firework. Perhaps aliens use this night as a useful time to 'scout' under the cover of Guy Fawkes celebrations? Also revealed is an object like a flying telegraph pole seen over mid-Devon on 21 February 2005, and one wonders what other extraterrestrial marvels are hiding in the Ministry of Defence archives, waiting to be released to an ever fascinated Devon public.

Afterword

There is much that we have had to leave unexplored. Many are the names of saints in Devon, and numerous are the legends of miracles supposedly wrought at sites connected with them: the eccentric dream of the fourth-century Italian saint Branock, at Braunton, for instance, who was persuaded that he must build his church upon the first spot where he should meet a sow and her progeny; or the apparition or dream which directed Sir Richard Gurney to search for a rock in the middle of the River Torridge at Bideford, which should, and did, afford a firm foundation for the Bideford Long Bridge. *Black's Guide To Devonshire* explains that work on the thirteenth-century bridge originally began half a mile upriver, but in the night invisible hands carried the stones downstream to their present location:

> Sir Richard Gurney, parson of the parish, going to bed one night in sore perplexity, and fear of the evil spirit who seemed so busy in his sheepfold, beheld a vision of an angel, who bade build the bridge where he himself had so kindly transported the materials, for there alone was sure foundation amid the broad sheet of sifting sand.

Likewise, the abbey at Tavistock owed its existence to a brilliant vision beheld by its founder, Ordulph, at the site: 'A glory that seemed to reach from earth to heaven, surpassing the brilliancy of the sun.' That night Ordulph and his wife shared a simultaneous dream of 'a shadow like an angel, whose countenance was of exceeding brightness', which accosted them with these words: *Ne timeas, vir Deo Dilecte.*

Southeast of Barnstaple can be found the village of Chittlehampton, the 'farm of the dwellers in the hollow (or cietel)', and a centre of Saxon colonization in the eighth century. The church here is unique in its dedication to St Hieritha, or, to use the more accepted form, St Urith. She was perhaps a Christian convert of St Kea, St Fili and St Rumon, missionaries from Glastonbury who came this way in the early sixth century and who have left their names in neighbouring parishes. Westcote speaks of Chittlehampton as a village famous for St Hieritha, 'whose miracles are able to fill a whole legend, who lived and was there buried'. Risdon (1630) and Price (1701) both speak of a book of her miracles as extant in their day, the former saying that she was born at Stowford, a mile to the north of the church.

Her legend says that Hieritha was a young maiden devoted to the religious life who was put to death with haymakers' scythes at the instigation of a jealous and probably

heathen stepmother. Where she fell a spring of water gushed forth and flowers blossomed. (Mention of the dry earth suggests a drought for which the Christian girl was blamed.) When I visited her church in January 2012, a helpful administrator here pointed out her stone likeness gracing the magnificent tower exterior, and, more impressively, what is in all probability her resting place beneath a chalk-white medieval slab near the altar. The traditional place of her martyrdom, St Teara's (i.e. St Urith's) Well, is at the east end of the village, where a large stone slab (formerly the lip of the open well) has been preserved in a modern wall. A local resident explained to me that the waters here were, or are, believed to be curative, and people still make pilgrimages here to bottle the water. There is lately a suggestion that the site, tucked away opposite private dwellings, might be restored to make it more pleasing to the eye, as the village is still proud of this well to this day.

Oddly, there are other stories with a similar theme. According to tradition, the first church at Stoke was built by Gytha, the Danish wife of Earl Godwin, who dedicated it to Saint Nectan, a fifth-century Welsh martyr. Her motive stemmed from the belief that the saint had exerted his influence to preserve her husband from shipwreck during a storm off the North Devon coast. Nectan is believed to have come to Hartland, and one 17 June early in the sixth century a troop of ruffians chased him through the woods and hacked his head off at Newton, a little to the south. The saint, though dead, miraculously remained mobile enough to collect his severed head and take it to (what is now) St Nectan's Well, where he placed it on a stone and expired. Long after, bloodstains on the stone attested the truth of this miracle, and foxgloves sprang up where his blood had sprinkled the earth. The arched stone well, with its barred front, can be found built into the steep incline of the land in a gully off a road near the church, although there is a more easily accessible well dedicated to Nectan in nearby Welcombe.

In Exeter, St Sativole, or Sidwell, is believed to have lived around 740. We are told she was born in the city, of noble British parents. She had a brother called Bana, and three devout sisters, and her end came when her father, Benna, married his second wife, a cruel and covetous woman also of a noble lineage. Sativole had estates in the eastern suburbs, and would retreat there for the purposes of pious contemplation. Benna dying, his widow – eager to obtain Sativole's lands – hired a mower to assassinate her, and this he did by decapitating her with a scythe. On the site where she was slain, the church was afterwards erected and dedicated to her, and many miracles were allegedly performed at her tomb. Here also there was a fountain or well situated in (what is now) Well Street, but which has long been built over and destroyed. Of Sativole's holy sisters, St Eadwara and St Wilgitha, no information remains, but the fourth sister, St Juthwara, was also murdered. She was killed by her enraged brother Bana on a false charge of incontinence, and at the instigation once more of the stepmother.

Wells across the county in general were also often credited with miraculous healing powers. Parker's Well near St Leonard's chapel in Exeter was one such place, often crowded at early morn even in the nineteenth century by people who wished to bottle its 'healing water.'

More evidence of belief in miraculous healing came to light in 1943, when repair work was being carried out on the air-raid damaged cathedral in Exeter. Extraordinary

St Hieritha's tomb.

St Nectan, in Stoke's church.

Exeter Cathedral.

wax models were found in a cavity on top of the stone screen surrounding the choir, and these depicted human and animal limbs. These were thought to be votive offerings placed by pilgrims who came to the tomb of Bishop Edmund Lacy (*d.* 1455), where they would pray for their illnesses and sickness to leave them or their animals. A pious pilgrim probably hid these offerings during the sixteenth-century Reformation.

In fact, one of the most common things I have heard in Exeter is that it was truly miraculous that the cathedral was not utterly destroyed during the war, and many view this as proof that God's hand can sometimes still intervene in human affairs. Such was the belief in the miraculous powers of the cathedral's very walls that around 1846 a Teignmouth man is recorded by folklorist William Henderson to have walked all the way to Exeter merely to commit vandalism for his sick wife. This fellow had pelted the figures on the west front with stones until the arm of one of them broke off. This he took home, chipping a piece off and pulverising it before mixing it with lard to apply to his wife's afflicted area.

Sabine Baring Gould writing in 1866 even refers to a Christ-like reverend in the county:

> The present incumbent of B_____ has the reputation of performing remarkable cures with his hand. He cured a child at Okehampton of a wen in the throat by touch, when the doctor had been of no service.

This evidences the fact that the spiritual can be seen by some in everyday, tangible places and people.

Although much of the content of this book may at first glance strike the reader as fantastical, many inexplicable (and non-religious) mysteries are, without doubt, rooted in the real world. Some are undoubtedly factual. The *North Devon Journal* (26 December 1907), for instance, reported the release from prison of John Lee, who had been convicted in February 1885 of murdering his employer, Miss Keyse, at Babbacombe. After he was sentenced to death at the Exeter Assizes, three times was he placed on the scaffold – and three times the drop refused to act. After the third attempt to hang him, the prison surgeon intervened and Lee's death sentence was later commuted. While in prison, Lee continually protested his innocence, and one odd circumstance of the whole episode is reported in the *North Devon Journal*. Prior to his hanging, Lee had told a warder that he had dreamed he would be taken to the scaffold, but not executed, and that he would be taken back to his cell via a different route. The warder recalled this after the failed hanging, and also that Lee had indeed been taken back to his cell a different way. It was believed the weight of the condemned man on the platform caused the bolt to bend, and in consequence it could not be drawn back; this was despite the trapdoor being tested with weights in between the attempts, and working perfectly. Lee insisted afterwards that it had been God's wish that he should not die that day. But why should God's providence or blind, random fate if you like, prefer to save Lee that day, rather than the woman he was convicted of murdering? It is this type of scenario that leads many to think there is a 'bigger picture' that some are privileged to glimpse occasionally, be it in the form of miraculous escapes from death, or supernatural encounters.

Some stories of the paranormal certainly have a weird ring of truth about them, and such an instance concerns St Bartholomew's church in Yealmpton, a village in the South Hams. One Saturday in the late 1940s the Revd Alfred Byles was approaching the doorway in the south side of the chancel (his wife was inside, arranging flowers) when he observed a great hole in the path in front of him. His first thought was of subsidence, and he manoeuvred round the hole to fetch his wife from indoors. She stood with him outside and they both looked into the abyss – which had, amazingly, become wider and deeper during the reverend's brief absence. Byles resisted the temptation to climb in, for they could not discern the bottom, and a stone tossed in seemed to clink off brickwork some way down that was just visible. Going into Yealmpton, Byles

Why would a deep hole suddenly open up here ... then later vanish?

brought back a local builder – only to find that the yawning hole had, astonishingly, disappeared completely and the path was thoroughly unbroken and intact. As Mr Byles explained on Arthur C. Clarke's *World of Strange Powers* (aired 10 July 1985): 'I don't suppose I should have said much about it, if I didn't have my wife's corroboration! We both of us saw the original hole, and never found any adequate explanation.'

Here again, we must ask the question: if the reverend was going to invent a story of the supernatural, why not come up with something more crowd-pleasing? The story is singularly dull – and yet at the same time completely mystifying. What on earth could the Byleses have seen? A 'phantom hole'? If this were the case, would such a ghostly landmark lend credence to such alleged phenomena as the phantom cottages? Or could it even have been a link, briefly visible, to some other dimension, like the domain of the pixies, or even the 'unmentionable place' of demonic folklore? Might it even have been some sort of ineffectual terrestrial black hole, or vortex? Where would Mr Byles have disappeared to if he had climbed in?

Concerning spectral phenomena, I have no doubt that some people have seen ghosts as they claim. Many people are past the point of scepticism, for I have talked to numerous people who have looked me in the eye and swore that they saw a ghost. For these people, no doubt remains about the reality of ghosts.

What does remain is the mystery of what they might be – supernatural tape recordings? Visitors from the afterlife, who are actually 'aware' of their journey and surroundings? Or the embodiment of the soul or spirit, doomed to wander in eternal confusion because of some transgression or through a disbelief that they are actually dead? Maybe some souls do literally get lost on the way to Heaven. To return to an earlier chapter, I (personally) happen to believe that the answer to the riddle of ghosts (excluding poltergeists) seems to lie with the person who actually saw it, by which I mean that ghost-hunters could set up camp for 100 years at a place where a ghost had recently been seen and still not see anything themselves. The answer lies exclusively with the person who says they saw it: either they imagined it, misinterpreted something else or they invented it, or else they possess a special ability that the rest of us do not. Or else they do not possess any special ability but happened unwittingly to be in a specific place at a specific time during which an exact set of million-to-one circumstances – atmospheric, supernatural and cosmic – combined for the ghost to be seen or heard.

Some people certainly strike me as 'sensitive', such as the lady who told me of the Roman soldier she spotted in Okehampton. There is no doubt of her sincerity, and she appears 'sensitive' to sensing spirits, as she had had more than one ghostly encounter. In her younger days, while living in a row of converted cottages in Okehampton, she remembers a 'presence' on the stairs that never manifested itself but kept the two family dogs at the foot of the staircase and afraid to mount the stairs. Downstairs in the drawing room she would sometimes observe a rocking chair gently moving by itself, and could also detect the faint smell of pipe smoke in the room from no source. Both these presences were thoroughly benign, and my informant recalls that – somehow, and without actually seeing anything – she formed the opinion that the presence on the stairs was a Victorian lady, and the pipe smoke belonged to a man, also Victorian but lower on the social scale. Strangely, these presences left the house on the point of my informant's very sceptical mother dying, and she likes to think that her mother might

have told these spooks to leave the house upon her own flight from this mortal coil. Again I ask myself why she would invent such a story; she asked that her name be kept from the acknowledgements, and has gained nothing from telling me of her Roman encounter – other than the reassurance that comes from discussing a story that has baffled her for nigh-on forty years.

Encounters like this make me think that it really only takes one 'ghost story' out of all of those in this book to have been a true and real event in time and space … and instantly everything we know about life and death would be transformed forever.

That fascination with the paranormal is still an inescapable fixture in Devon can be classed as a fact; one only needs to consider the report in the *Telegraph* (26 April 2010) concerning the statistics collected by the indefatigable Revd Lionel Fanthorpe, which declares, 'Devonshire rated second in the study with 57 reports of sinister activity, mainly from encounters with or sightings of demons with devil like qualities'. One entity singled out is described thus:

> On Dartmoor there have been reports that the demonic shape of a man named Stephens who committed suicide still appears and bodes ill for those who encounter it at his grave. The apparition is described as hideously skeletal and dressed in the ragged remnants of a grey robe.

This I suppose relates to the lonely little memorial found out in the wilderness near White Tor, east of Peter Tavy: Mrs Bray records that for generations children grew up

Stephens' Grave.

with the story that the stones were called 'Stevens' Grave' and they marked the spot where a melancholy young man poisoned himself in consequence of the infidelity of his mistress. Even in her day, the 'condemned spirit of the suicide [was] still believed to walk from midnight to cock crowing'. Over time, Stephens' ghost seems to have become more dramatic and frightening, if the later reports are to be believed.

Some modern paranormal sightings simply make no sense in any kind of conventional way. A number of online forums – originating from Jon Downes' article 'Born to be Wild' in *FT* (No. 84, 1996) – observe a weird encounter in woodland at Kings Nympton, north of Chulmleigh and still a largely rural farming community. Three boys were put to flight by a large ape or bear-like creature with green catlike eyes, broad shoulders and large muzzle. This occurred in 1978, but what it might have been is a complete mystery: an escaped animal, or the ghost of some Neanderthal, or some bizarre elemental that has slipped through the cracks in the façade of reality? Even in the realm of the paranormal, some things defy categorisation, let alone explanation.

Wonders will never cease, as they say. Hopefully, complete scepticism of the wondrous, the baffling, the supernatural and the paranormal will not overtake us too soon. In Devon, where I have talked to so many people who presented me with their versions of old stories or have told me mysterious new ones, I sincerely believe this is highly unlikely: we leave where we came in, with the observation that Devon is (and will always be) an extremely rewarding place for a researcher of the paranormal.

Dartmoor: 368 square miles of myth, legend and modern paranormal tales.